Also by Hunter Drohojowska-Philp

Full Bloom: The Art and Life of Georgia O'Keeffe

REBELS IN PARADISE

Hunter Drohojowska-Philp

REBELS IN PARADISE

THE LOS ANGELES ART SCENE AND THE 1960S

A John Macrae Book Henry Holt and Company New York

Henry Holt and Company, LLC
Publishers since 1866
175 Fifth Avenue
New York, New York 10010
www.henryholt.com

Library of Congress Cataloging-in-Publication Data

Drohojowska-Philp, Hunter, [date]
 Rebels in Paradise: The Los Angeles Art Scene and the 1960s / Hunter
Drohojowska-Philp.—First Edition.
 pages cm
 Includes bibliographical references and index.
 ISBN 978-0-8050-8836-6
 1. Art, American—California—Los Angeles—20th century. 2. Los Angeles (Calif.)—
Intellectual life—20th century. I. Title.
 N6535.L6D76 2012
 709.794'9409046—dc22 2010043025

Designed by Meryl Sussman Levavi

Printed in the United States of America
3 5 7 9 10 8 6 4 2

To David, again

"People cut themselves off from their ties to the old life when they come to Los Angeles. They are looking for a place where they can be free, where they can do things they couldn't do anywhere else."

 —TOM BRADLEY, the grandson of slaves, whose
 1973 election as Los Angeles's first black mayor
 resulted in an unprecedented twenty-year tenure
 and the establishment of the city's Museum of
 Contemporary Art

Contents

Timeline: 1955–1969

1955

Walter Hopps organizes Action I, exhibition in the Merry-Go-Round building on the Santa Monica Pier. Announcement is designed by his childhood friend, artist Craig Kauffman.

Ed Kienholz shows his work at Von's Café Galleria, Laurel Canyon. Meets his future wife Mary Lynch.

Later opens his first gallery in the lobby of the Coronet Theatre Cinema.

Wallace Berman publishes first issue of his magazine of poetry and pictures, *Semina*.

Peter Voulkos teaches ceramics at the Los Angeles County Art Institute (future Otis College of Art and Design). Students include Billy Al Bengston, Ken Price, and John Mason.

The film *Rebel Without a Cause*, directed by Nicholas Ray, stars Dennis Hopper, James Dean, and Natalie Wood.

Dean, 24, dies in a car accident.

1956

Lorser Feitelson begins his TV show, *Feitelson on Art,* which runs until 1963.

Kienholz opens his Now Gallery.

John Altoon returns to Los Angeles from New York and Europe and teaches at Chouinard Art Institute.

Ed Ruscha and Mason Williams arrive in Los Angeles. Ruscha enrolls in Chouinard. Williams discovers folk music clubs in L.A. Joins the Navy.

Walter Hopps and Ed Kienholz organize the "4th Annual All-City Outdoor Art Festival" in Barnsdall Park.

Jack Kerouac's *On the Road* published.

First polyurethane surfboards go on the market.

1957

Llyn Foulkes, Judy Gerowitz (later Chicago), and Irving Blum move to Los Angeles.

Wallace Berman and Robert Alexander open Stone Brothers boutique and printing press.

George Herms presents *Secret Exhibition,* his assemblage sculpture on a vacant lot in Hermosa Beach.

Robert Irwin has first solo show at Felix Landau Gallery.

Walter Hopps and Ed Kienholz open Ferus Gallery. Wallace Berman exhibition is closed and artist is arrested for obscenity. John Altoon is given solo show.

1958

The TV police series *77 Sunset Strip* debuts.

Everett Ellin opens first gallery and Chez La Vie café, which closes after a year.

Ruscha shares a house with fellow Chouinard students and Oklahomans Jerry McMillan, Pat Blackwell, and Don Moore. Joe Goode joins them in early 1959 and enrolls at Chouinard.

Larry Bell enrolls at Chouinard.

Billy Al Bengston, Craig Kauffman, and Ed Moses have first solo shows at Ferus.

Robert Alexander and James Newman open Dilexi Gallery in San Francisco and show many Ferus artists including Moses, who starts using the name Ed Moses Y Branco.

Irving Blum buys out Kienholz and becomes co-director of Ferus at new location on La Cienega Boulevard.

Publication of *The Holy Barbarians*, with John Altoon on the cover, an account of the Beat scene in Venice by Lawrence Lipton.

Peter Voulkos ceramics, sculpture, and paintings shown at the Pasadena Art Museum.

Democrat Edmund ("Pat") Brown elected Governor of California.

Lenny Bruce performs monologues inspired by improvisational jazz and left-wing politics.

Richard Neutra builds the Singleton house in Bel Air.

1959

Craig and Vivian Kauffman travel to Europe from 1959 to 1961.

Ken Price returns to L.A. from graduate school in Alfred, New York.

Virginia Dwan opens her gallery in Westwood.

Four Abstract Classicists, a show of geometric abstract painting by John McLaughlin, Lorser Feitelson, Fred Hammersley, and Karl Benjamin at the L.A. County Museum of History, Science, and Art.

A show by abstract artist Lee Mullican is held at the UCLA art galleries, organized by curator Frederick S. Wight.

1960

The contraceptive pill comes on the market.

John Lautner designs the "Chemosphere," or Malin residence.

Opening of the LAX theme building designed by Charles Luckman, William Pereira, Welton Becket, and Paul Williams.

Julius Shulman photographs *Case Study House No. 22* designed by Pierre Koenig. The nighttime view of fashionably dressed young women seated in a glass-walled living room cantilevered over a hillside with a grid of lights in the distance defines the exotic, modern Southern California lifestyle.

Everett Ellin opens his second gallery on North La Cienega Boulevard.

Billy Al Bengston paints his Dracula series with a small orchid shape in center of canvas.

Larry Bell begins paintings of nested hexagons.

Ferus shows Jasper Johns with Kurt Schwitters; Ken Price's first solo show.

The Pasadena Art Museum presents the clay sculpture of John Mason in May, followed by Robert Irwin in July, and Richard Diebenkorn in September.

1961

Beach Boys *Surfin' Safari* album is released, launching a surf music trend. About 30,000 young people are surfing California beaches each weekend.

Willem de Kooning at the Kantor Gallery and Helen Frankenthaler at Primus-Stuart Gallery. Ferus artists are packaged as something entirely different: Ken Price's exhibition announcement depicts the artist surfing; Bengston's shows the artist driving his motorcycle.

A forest fire destroys more than 500 houses in Bel Air, Brentwood, and Malibu, including that of Dennis and Brooke Hopper.

Dwan Gallery's Yves Klein: Le Monochrome opens on May 29.

Ed Kienholz is given a show at the Pasadena Art Museum in May and included in the Museum of Modern Art's The Art of Assemblage organized by William Seitz the following fall.

In May, Huysman Gallery, founded by art historian Henry Hopkins, puts on War Babies.

1962

Kienholz shows his first life-size installation of a bordello, *Roxy's,* at Ferus. It is followed in March by the geometric abstract paintings of Larry Bell. In May, Robert Irwin presents line paintings. In July, Andy Warhol's first show features the *Campbell's Soup Cans* paintings.

In September, Hopps presents New Painting of Common Objects at the Pasadena Art Museum. The show includes Jim Dine, Robert Dowd, Joe Goode, Philip Hefferton, Roy Lichtenstein, Ed Ruscha,

Wayne Thiebaud, and Andy Warhol. Ruscha has the announce-
ment printed at a workshop that usually makes boxing posters.
Dwan Gallery shows Robert Rauschenberg in March, the same time that
Everett Ellin Gallery shows Niki de Saint Phalle and Jean Tinguely.
Ed Moses shows at the Alan Gallery in March and Billy Al Bengston
shows at Martha Jackson Gallery in May, both in New York City.
Ken Kesey's *One Flew Over the Cuckoo's Nest* is published. Peter, Paul
and Mary make popular the Bob Dylan song *Blowin' in the Wind*.
Death of Marilyn Monroe in Los Angeles.
Ken Price moves to Japan, then to Ventura, 1963–1965.
Pasadena Art Museum gives solo shows to John Altoon and Llyn
Foulkes.
Beginning of Monday night art walks on North La Cienega Boulevard.
Walter Hopps appointed curator of the Pasadena Art Museum. Over-
sees Kurt Schwitters retrospective, June 20–July 17.
Joe Goode's first solo show is with Dilexi Gallery.
The first issue of *Artforum* published by John Irwin in San Francisco.

1963

Dwan Gallery shows Martial Raysse, Franz Kline, who had died in
1962, Larry Rivers, Jean Tinguely and Niki de Saint Phalle, and Ed
Kienholz. Claes Oldenburg shows soft sculpture at Dwan in Octo-
ber and stages Autobodies, a Happening involving dozens of cars
and a parking lot.
At Ferus: Irving Blum shows New Yorkers Andy Warhol, Frank Stella,
and Roy Lichtenstein, as well as L.A.'s John Mason, Ed Moses,
Larry Bell, and Ed Ruscha. Ruscha creates his first artist's book,
Twentysix Gasoline Stations.
More galleries open on North La Cienega Boulevard: Rolf Nelson, direc-
tor of Dilexi, leaves to open his own gallery and present a Fluxus
event *Blink*. He shows Joe Goode, Llyn Foulkes, and George Herms.
Ceeje Gallery shows Charles Garabedian and Edmund Teske. David
Stuart Gallery shows Tony Berlant and Dennis Hopper.
Everett Ellin closes gallery and moves to New York to be director of
Marlborough Gallery.
Edward G. Robinson's highly regarded collection of Impressionist art
is rejected by the trustees of the L.A. County Museum, fearful of

his left-leaning politics. It is shown in his Beverly Hills home as a charity event before being auctioned after his divorce.

The L.A. County Museum exhibits Six Painters and the Object, organized by Lawrence Alloway—who coined the term "Pop Art"—for the Guggenheim Museum. It features Dine, Johns, Lichtenstein, Rauschenberg, Warhol, and James Rosenquist. The L.A.'s version includes Six More: Bengston, Goode, Hefferton, Ruscha, as well as Thiebaud and Mel Ramos from San Francisco.

Marcel Duchamp retrospective is held at the Pasadena Art Museum organized by Hopps. Hopps named director in August. Hires James Demetrion as curator and Harold (Hal) Glicksman as assistant and preparator.

Pasadena Art Museum shows paintings of John McLaughlin.

The Cinerama Dome Theater, designed by Welton Becket, features a wraparound screen inside a geodesic dome on Sunset Boulevard.

Tom Wolfe publishes his essay "Kustom Kar Kulture in Southern California: The Kandy-Kolored Tangerine-Flake Streamline Baby."

Lenny Bruce arrested for obscenity at the Unicorn.

Death of Aldous Huxley in Los Angeles.

Ed Moses travels to Europe, 1963–64.

George Herms directs *Moonstone*, with Dean Stockwell.

Wallace Berman makes first Verifax collages.

Andy Warhol films scenes for *Tarzan and Jane Regained . . . Sort Of.*

1964

Kienholz joins the Dwan Gallery. Dwan also shows James Rosenquist and Lucas Samaras.

Ferus shows Studs, with Moses, Irwin, Price, and Bengston, a show that underscores the macho reputations of these artists.

An exhibition of Post-Painterly Abstraction with a catalog written by critic Clement Greenberg opens at the L.A. County Museum of Art in April. Irwin refuses to participate.

David Hockney visits Los Angeles. Paints first swimming pool paintings using acrylics. Meets Christopher Isherwood, Don Bachardy, and Nicholas Wilder.

Founding of Watts Towers Art Center by Noah Purifoy and Sue Welsh.

Douglas Wheeler makes first light paintings.

Frank Gehry builds the Danziger house and studio in Hollywood.

The Beatles' first concert at the Hollywood Bowl.

Roger McGuinn forms the Byrds.

Opening of the Whisky a Go Go on the Sunset Strip.

Death of Rico Lebrun in Los Angeles.

Dorothy Chandler uses her social and political clout as wife of *L.A. Times* publisher to develop downtown performing arts complex the Music Center.

L.A. is second most populous city in the nation. Rapid Transit District is established with little result.

1965

The L.A. County Museum of Art opens in April in a modern building designed by William Pereira on Wilshire Boulevard. One of its first shows is New York School: The First Generation—Paintings of the 1940s and 1950s, organized by LACMA's curator of modern art, Maurice Tuchman.

Nicholas Wilder Gallery opens on North La Cienega Boulevard, giving Bruce Nauman his first solo show. Shows Joe Goode's staircases leading to blank walls. Hockney lives with Wilder as a roommate and paints his portrait in the swimming pool.

The Pasadena Art Museum shows Jasper Johns retrospective.

The Dwan Gallery shows Rauschenberg and Mark di Suvero. Dwan has become such a force in the city that UCLA shows the Virginia Dwan Collection in September.

Dwan opens gallery in New York, where Ed Kienholz presents *The Beanery*.

Ferus shows Richard Pettibone's miniature copies of paintings and sculptures as seen in the homes of L.A. collectors L. M. Asher, Donald Factor, Dennis Hopper, Ed Janss, Robert Rowan, and Frederick Weisman.

Artforum magazine relocates from San Francisco into offices above Ferus Gallery.

Hopps is curator of the American Pavilion of the 8th São Paulo Biennale, September 4 to November 28, and features Bell, Bengston, Irwin, Donald Judd, Barnett Newman, Frank Stella, and Larry Poons. Ruscha is included in the Guggenheim's exhibition *Word/Image*.

Rolf Nelson Gallery gives first solo show to Judy Gerowitz (Chicago).

Sam Yorty is reelected L.A. mayor; race riots in Watts result in 35 dead, 4,000 arrested, and $40 million in property damage.

Irving Petlin organizes Artist Protest Committee.

Mark di Suvero designs the Artists Peace Tower built by volunteers on the corner of La Cienega and Sunset Boulevards. Vija Celmins's paintings of fighter jet planes shown at David Stuart Gallery.

Larry Bell moves to New York for a year, where the Pace Gallery shows his glass cubes.

1966

A retrospective of Ed Kienholz opens to great controversy at the L.A. County Museum of Art, with the board of supervisors calling the show "revolting and pornographic," urging its removal.

Robert Irwin and Ken Price are given shows at LACMA with a catalog by Lucy Lippard and Philip Leider. The museum mounts a retrospective of Surrealist Man Ray.

The influential movement of Abstract Expressionist ceramics, including Bengston, Mason, Price, and Voulkos, is surveyed at the UC Irvine art gallery in October, while John Mason is given a solo show at LACMA in November.

Warhol's Exploding Plastic Inevitable, with the Velvet Underground, play to unenthusiastic audience in L.A.

The Doors are banned from the Whisky a Go Go for using the word "fuck" on stage.

Neil Young moves to Los Angeles and helps form Buffalo Springfield.

Ken Kesey and Ken Babbs organize the Watts Acid Test for 600 participants.

LSD declared illegal substance.

John Chamberlain, visiting Malibu, is inspired by squeezing a sponge in the bathtub to produce sculptures of foam rubber bound with a cord that are shown at Dwan Gallery.

Ferus Gallery closes with Warhol's *Silver Clouds* and *Cow Wallpaper*.

Hopps is asked to resign from Pasadena Art Museum and moves to Washington, D.C. James Demetrion becomes director of PAM. Hopps returns briefly in 1967 to oversee installation of his Joseph Cornell retrospective.

Shirley Hopps divorces Walter and marries Irving Blum.

Rolf Nelson shows the sculpture of Judy Gerowitz and starts calling her Judy Chicago, the name of her native city. She adopts the new name.

In New York, the Primary Structures show of minimalist sculpture at the Jewish Museum includes Bell and Chicago. In London, Robert Fraser Gallery shows Bell, Berman, Kauffman, Ruscha, Conner, and Hopper.

1967

Ferus/Pace Gallery shows Craig Kauffman with Roy Lichtenstein, and Donald Judd.

LACMA shows American Sculpture of the '60s with 165 works by 80 artists organized by Maurice Tuchman.

An ephemeral environment called *Dry Ice* is created in Century City by Judy Chicago, Lloyd Hamrol, and Eric Orr.

The Pasadena Art Museum, with John Coplans curating, shows Mason Williams's *Bus*, Allan Kaprow's Happening of stacked ice blocks, *Fluids*, and James Turrell's installation of projected light.

The newly formed print workshop Gemini GEL invites Robert Rauschenberg to produce *Booster*, the largest print made up to that time.

1968

Pasadena Art Museum shows light installations by Robert Irwin and Doug Wheeler.

LACMA shows Wallace Berman retrospective.

Molly Barnes Gallery gives John Baldessari his first solo show in L.A.

Blum, who severed business relations with Pace, reopens as the Irving Blum Gallery and shows Ruscha's painting the *Los Angeles County Museum on Fire*.

LACMA organizes Late Fifties at Ferus. LACMA also mounts first retrospective of Billy Al Bengston.

Dwan closes L.A. gallery and moves to New York. Douglas Chrismas opens Ace in her former gallery space.

The L.A. artists are seen in many group shows, including The West Coast Now, with 62 artists at the Portland Art Museum; Los Angeles 6 at the Vancouver Art Gallery; and Documenta 4 in Kassel, Germany, including Bell, Davis, Hockney, Irwin, Kienholz, and Nauman.

Andy Warhol shot by Valerie Solanas.

Robert F. Kennedy assassinated at the Ambassador Hotel in Los Angeles after winning the California Democratic Primary. Jordanian Sirhan Sirhan arrested and later convicted of the crime. Riots and police brutality mark the Democratic National Convention in Chicago, where Hubert Humphrey wins nomination. Richard Nixon, promising to end the Vietnam War, elected 37th president by narrowest margin since 1912.

Death of Marcel Duchamp in New York.

1969

Perceptual and Conceptual art addressed in The Appearing/Disappearing Object with John Baldessari, Michael Asher, Allen Ruppersberg, Barry LeVa, and Ron Cooper at the Newport Harbor Art Museum.

Judy Chicago is featured at the Pasadena Art Museum. Lloyd Hamrol shown at Pomona College Art Gallery.

West Coast 1945–1969 organized by John Coplans for the Pasadena Art Museum.

Dennis Hopper's *Easy Rider* released.

John Altoon dies of a heart attack.

Sharon Tate and others murdered by gang led by Charles Manson.

Introduction

L orser Feitelson moved to Los Angeles in 1927, after living in Paris and New York. "Here I found I couldn't sell my work," he told *Artforum* in 1962. "I had no audience, therefore I painted for my own satisfaction and what a wonderful thing that was!" By that time, the painter of geometric abstractions was an elder statesman whose art lectures were broadcast on television in Los Angeles. Many younger artists had come to the same conclusion: When you've got nothing, you've got nothing to lose.

In 1960, Los Angeles had no modern art museum and few galleries, which was exactly what renegade artists liked about it: Ed Ruscha, David Hockney, Robert Irwin, Ed Kienholz, Larry Bell, Joe Goode, Bruce Nauman, Craig Kauffman, Judy Chicago, Vija Celmins, and John Baldessari among them. Freedom from an established way of seeing, making, and marketing art fueled their creativity, which, in turn,

changed the city. Today, Los Angeles has four museums dedicated to contemporary art, hundreds of galleries, and thousands of artists. This book tells the saga of how the scene came into being—how a prevailing permissiveness in Los Angeles in the 1960s brought about countless innovations: Andy Warhol's first show, Marcel Duchamp's first retrospective, Frank Gehry's unique architecture, Rudi Gernreich's topless bathing suit, Dennis Hopper's *Easy Rider*, the Beach Boys, the Byrds, and the Doors. In the 1960s, Los Angeles was the epicenter of cool.

This decade was so dense with activity, much of it overlapping if not actually connected, that a strict chronology proved impossible. The book is organized according to groups of people who knew one another as well as key events. I've included a timeline for clarification.

Since this book is not encyclopedic, I apologize in advance to all of those who feel they should have been included or whose work deserved more attention. I agree with you. So many artists, so little time! Despite that possible failing, please accept this as a love letter to Los Angeles, still a place of perpetual possibility and infinite invention.

CHAPTER ONE

1963: Andy and Marcel

The seven-foot Elvis in the Ferus Gallery window was star-
tling, even by Los Angeles standards. In the gallery's back
room, paintings of Elizabeth Taylor, with her outsized red
lips and slashes of bright blue eye shadow, greeted visitors.
Andy Warhol was fixated on celebrities and it wouldn't be long before
he would become one himself.

A feeling of excitement charged the balmy evening air outside, and
North La Cienega Boulevard traffic slowed as drivers gawked at the
scene. Inside, stylishly coifed women in sleeveless dresses mingled
with Los Angeles artists, awkward young men outfitted in thrift-store
splendor. Warhol entered the filled-to-capacity gallery wearing a car-
nation in the lapel of his Brooks Brothers blazer.

In 1963 Los Angeles became a mecca for those who rejected the
old and embraced the new in art, film, fashion, and music. For many

artists, the city's tenuous attachment to history and tradition translated as openness to fresh ideas. Warhol's show contributed to the dawning realization that Los Angeles itself could be the next big thing.

Warhol was nervous as his exhibition opened on the evening of September 30. He had had just two previous exhibitions, the first held the previous summer at Ferus. Though Warhol today is considered the quintessential New York artist, he received his first break in Los Angeles when the suave—some would say fawning—Irving Blum and the perspicacious but flighty Walter Hopps took a chance on the young artist. Warhol's paintings of Campbell's soup cans, thirty-two to be exact, each painstakingly lettered with the appropriate flavor, were arranged on a shelf that girdled the walls, turning the gallery into a grocery store of sorts. Hopps's wife, Shirley, recalled, "It was one of those times when we knew we were onto something."[1]

Not everyone agreed. The show was ridiculed in a *Los Angeles Times* cartoon of two barefoot beatniks in the "Farout Art Gallery" looking at the paintings of soup cans and musing, "Frankly, the cream of asparagus does nothing for me, but the terrifying intensity of the chicken noodle gives me a real Zen feeling." Nearby, David Stuart mocked Ferus by arranging a pyramid of Campbell's soup in the window of his gallery with a sign: "Get the real thing for only 29 cents a can."[2]

Blum convinced some collectors to purchase Warhol's soup-can paintings for $100 apiece. After a chat with art critic John Coplans, one of the first to recognize the importance of serial imagery, Blum agreed that Warhol's everyday Pop art signaled the end of the individual masterpiece; he was determined that the pictures remain together as a set. He persuaded collectors to return the half-dozen soup-can paintings that he had managed to sell. Then he asked Warhol if he could buy all of them on a layaway plan: $1,000 for the entire set to be paid over the next year.[3]

Warhol didn't need the money. For years, he had been one of the most successful illustrators in New York City, known for his shoe drawings for I. Miller, easily making around $50,000 a year. But this was different. This was art. Warhol was sufficiently pleased to agree to the deal and sign up for another show with Ferus. He also silk-screened four portraits of the energetic entrepreneurial owner.

What a difference a year could make in the 1960s, a decade of seismic shifts. In August 1962, Warhol, working with studio assistant Gerard Malanga, abandoned the paintbrush for the silk screen. His first silk-screened canvas was turquoise and covered by rows of Troy Donahue head shots, each face of the Hollywood heartthrob framed in a yearbook-style oval. Four months later, due to an unexpected gap in her schedule, Eleanor Ward gave Warhol his first New York show at the Stable Gallery, where Robert Rauschenberg and Cy Twombly had had their first shows. It sold out.

Pop was gaining momentum as a movement of sorts by the time Warhol, to save on shipping, sent a roll of silvered canvas to Ferus with instructions to cut out as many images of Elvis as needed. Shirley Hopps remembered that Warhol sent no directions so she, Blum, and the gallery artists spent an evening cutting them into twos or threes in a rather haphazard manner, not unlike the assembly line technique at Warhol's East Forty-seventh Street studio, the Factory, in New York.

To get to the opening, Warhol and Malanga, along with Taylor Mead and Wynn Chamberlain, drove across country for three days in a station wagon with a mattress in the back and the radio blaring songs by Leslie Gore, the Ronettes, and Bobby Vinton. Everything along the highway looked like Pop art to them. "We were seeing the future and we knew it for sure," Warhol observed.[4]

They never suspected that Los Angeles could be booked. Because of the World Series, most hotels were full so Warhol called actors Dennis Hopper and his wife Brooke Hayward. She, in turn, called her father in New York, producer Leland Hayward, and convinced him to give them his suite at the Beverly Hills Hotel. Los Angeles started to look promising.

Warhol had met Hopper in New York through Metropolitan Museum of Art curator Henry Geldzahler. Warhol once said, "Henry gave me all of my ideas" and made a film consisting only of Geldzahler smoking a cigar for ninety minutes. Impressed by this duo, Hopper immediately bought one of Warhol's double silk screens of the *Mona Lisa* and invited him to come with Geldzahler to the soundstage to watch his guest-star performance on the TV show *The Defenders*. Not long after, Hopper flew to New York and went with Hopps and Blum to the studio of Roy Lichtenstein, where he immediately bought

the artist's comic book–style sunset painting for $750. "Everybody was talking about the return to reality," Hopper recalled. "This is our reality—the comic books and soup cans, man."[5]

Lean and edgy in appearance, Hopper was drawn to advanced art from the day he saw his first Jackson Pollock painting at the home of actor Vincent Price, who had used his profits from scary movies to amass an impressive collection. "When I saw that, I got it immediately," Hopper said.[6] His instincts would prove impeccable. A former poor boy from Dodge City, Kansas, Hopper was the only collector to wind up with one of Warhol's soup-can paintings because, in an effort to save $25, he managed to buy one for $75 from the Westwood gallery owned by Virginia Dwan.

The daughter of Margaret Sullavan, Brooke Hayward was a classic beauty. As Hollywood royalty, she should have been out of Hopper's league. Hayward had grown up in Greenwich, Connecticut, with Henry Fonda's children and had even been kicked out of Girl Scouts with her friend Jane. But Dennis Hopper was more than just another actor. He was wildly creative, and his charisma was undeniable in movies such as *Giant*. Together, the Hoppers were considered glittering examples of the new Hollywood, perfect hosts for a party for Warhol and friends. The very night of the artist's arrival, they invited the Ferus contingent and other young actors to their West Hollywood home at 1712 North Crescent Heights, where they had moved after losing their mansion in the 1961 fires that destroyed their Bel Air neighborhood. Their Mediterranean-style home was bohemian and furnished with circus posters, a Mexican clown sculpture, and Hopper's own collages. The *Mona Lisa* silk screen hung next to the Lichtenstein sunset. Warhol met Hopper's colleagues Robert Dean Stockwell, Russ Tamblyn, and Sal Mineo, who was Hopper's costar in *Rebel Without a Cause*, as well as actors Suzanne Pleshette, Peter Fonda, who looked like a "preppy mathematician," and Troy Donahue. Joints were passed and people danced. Artist Craig Kauffman was a little shocked by the Warhol crowd. "They were all giggling and pouring sugar on the backs of each other's hands. I thought this was a little far-out."[7] Whether or not this was really sugar, Kauffman never discovered.

"This party was the most exciting thing that had ever happened

to me," Warhol said.[8] He only regretted that he had left his Bolex movie camera in his hotel room. Warhol embraced everything about Los Angeles that tended to irritate the intellectual, the cultured, or the well-bred. "Vacant, vacuous Hollywood was everything I ever wanted to mold my life into. Plastic. White-on-white. I wanted to live my life at the level of the script of *The Carpetbaggers*."[9]

The opening on September 30, 1963, was less star-studded than his party, but Warhol was philosophical. "Anyway, movies were pure fun, art was work."[10] Still, he was amazed by the impact of all the Elvises in the front room and the Liz Taylors in the back, as he'd never seen them all together. He made a four-minute movie of his installation. Los Angeles rising art stars attended the opening, some of whom were involved in their own versions of Pop: Ed Ruscha, Joe Goode, and Billy Al Bengston, as well as those developing their own versions of what, in a few years, would be termed "Minimalism": Larry Bell, Craig Kauffman, and Robert Irwin.

The short, slight Warhol had a congenital skin condition that he covered with pale makeup. He wore an outlandish silvery white toupee atop his own mousy brown hair, which he had been losing since 1953. His pasty face and skinny frame contrasted dramatically with the virile physiques of the L.A. artists in their twenties, all of them golden and muscular from surfing, swimming, or simply driving around in convertibles. He was slightly awed by their backslapping, cajoling, and sarcastic humor and though he was quite obviously gay, he felt completely at ease in their macho company, an artist among artists. They embraced his art as though it were both welcome and inevitable. Ruscha immediately felt "a great kinship. . . . It was like a logical departure from the kind of painting that was happening at that time."[11] Warhol, in turn, supported their totally synthetic aesthetic. "The artificial fascinates me, the bright and shiny."[12]

Sales were brisk. In just one year, the general populace on both coasts seemed to have embraced Pop art. A columnist for the *Los Angeles Times* called for "Pop decorating" by suspending colored Life Savers on strings in doorways or using painted egg cartons as wall reliefs. On the other hand, *Los Angeles Times* art critic Henry Seldis called it "non-art" and declared that "questions of aesthetic quality have been declared irrelevant by pop art impresarios." Warhol found

this irritating. Citing that year's blockbuster film *Cleopatra*, he retorted, "I always have to laugh, though, when I think of how Hollywood called Pop art a put-on! *Hollywood*?? I mean, when you look at the kind of movies they were making then—those were supposed to be *real*???"[13]

Warhol longed for acceptance by anyone associated with the film industry, and Hollywood inspired him to make movies of his own. He had previously filmed friends in the act of kissing, but during his time in Los Angeles, he and his entourage started filming their first movie with a plot, of sorts, in the bathroom of their suite at the Beverly Hills Hotel. Taylor Mead played Tarzan, and Naomi Levine, a friend visiting from New York, played Jane. Warhol continued to film at the home of Beat assemblage artist Wallace Berman, who acted in it along with his young son Tosh, artists Claes and Patty Oldenburg, and Hopper. Like some sort of avant-garde progressive dinner, the filmmaking continued at Watts Towers and then at the home of actor-producer John Houseman with actor-writer Jack Larson, who had played Jimmy Olsen on television's *Adventures of Superman*. Levine stripped off her clothes and jumped into their pool while Mead tried to climb a tree. The movie, with its opening shot of the freeway exit ramp for the suburb of Tarzana, was released the following year as *Tarzan and Jane, Regained . . . Sort Of.* "The Hollywood we were driving to that fall of '63 was in limbo," recalled Warhol. "The Old Hollywood was finished and the new Hollywood hadn't started yet."[14]

As if movie stars and warm weather were not balm enough, Warhol also met Marcel Duchamp, the Dada artist whose work provided the art historical validation for Pop. On October 7, 1963, the gala opening for a retrospective of Duchamp was held at the Pasadena Art Museum (PAM), a Chinese-style mansion with an ornate arched doorway and dragons poised on its green tile roof. The absurdity of the venue appealed to Duchamp, the man who was famous for painting a mustache on a reproduction of the *Mona Lisa* and giving it a French title, *L.H.O.O.Q.*, phonetically translated as "She has a hot ass."

Duchamp is the most influential of the artists associated with the Dada movement, which arose throughout Europe as an acerbic response to World War I political chicanery. He claimed that anything could be art if an artist said so. After a decade of shocking the bour-

geoisie with such claims, in 1921 he withdrew from the art world to devote himself to the game of chess. This contrary action only accelerated widespread interest in his art and ideas in the 1960s as young artists everywhere began questioning the dominance of Abstract Expressionist painting in galleries and art magazines.

It was not simple perversity that led Duchamp to agree to his first-ever retrospective in the conservative province of Pasadena, a prosperous city east of Los Angeles with lovely 1920s buildings and tree-lined boulevards. It was the perseverance of Walter Hopps, cofounder of Ferus, who had become the museum's curator. Hopps had been introduced to modern art by Walter and Louise Arensberg, Duchamp's major patrons.

During the early decades of the twentieth century, the Arensbergs had amassed one of the world's largest single collections of art by Duchamp and used him as the conduit for buying work by Constantine Brancuşi, Man Ray, Giorgio de Chirico, Salvador Dalí, Joan Miró, and other modern artists. For health and financial reasons, they had moved from New York City to Los Angeles in 1927. They maintained their relationship with Duchamp by post, regularly buying work by him and his peers and hanging it from floor to ceiling on the walls of their Italianate Hillside Avenue home. At the outset of World War II, they aided Duchamp's immigration to the United States from his native France. Duchamp visited his patrons in 1936, 1949, and 1950 and described Southern California "as a white spot in a gloomy world."[15]

This feeling was not due to a welcoming atmosphere for his type of art. When dealer Julien Levy rented a gallery on Sunset Boulevard in 1941 to exhibit Duchamp's *The Bride Stripped Bare by Her Bachelors, Even*, along with pieces by Salvador Dalí and others, the actor John Barrymore got so drunk at the opening, he unzipped his pants and unceremoniously urinated on a work by Surrealist Max Ernst.

When Hopps had visited the Arensbergs' home as a teenager on a high school field trip in 1949, he had experienced a *coup de foudre*. He asked so many questions, the Arensbergs invited him to come back, which he did often, sitting in their library, reading books about modern art, and asking yet more questions. Walter Arensberg, who dedicated much of his time trying to prove that Francis Bacon wrote

works attributed to William Shakespeare, recognized the tall, gawky teenager's budding eccentricity.

That connection secured the retrospective. Hopps would write later, "The fact that I grew up with their collection, and considered it to be my basic art education, seems to have something to do with this coup."[16]

In 1962, Hopps, then thirty, flew to New York to meet the septuagenarian Duchamp at the apartment of William Copley, the wealthy adopted son of the owner of Copley Press in San Diego, who was an arts patron and Surrealist painter familiar with Hopps's role at Ferus. Duchamp was astonished by Hopps's familiarity with his work and agreed to the show without restrictions.

Duchamp doubtless enjoyed staging his retrospective far from Manhattan, the center of the art world. Half a century had passed since his Cubist painting *Nude Descending a Staircase* had been the scandal of the 1913 Armory Show, which introduced European modern art to New York. By 1963, the once scandalous Cubists and Dadaists were categorized as movements in art history. Duchamp told MoMA curator William Seitz: "My 'Nude' [Descending a Staircase] is dead, completely dead."[17]

Though Duchamp believed the weight of art history oppressed cultural controversy, he resurrected his outlaw reputation in Pasadena. For the exhibition poster, Duchamp recycled a 1923 placard stating "Wanted/$2000 Reward" and inserted photographs of himself along with a long list of possible aliases. In his own scratchy handwriting, he penned the name of the museum and the show's title: "by or of Marcel Duchamp or Rrose Sélavy." That pun on the French observation of life and love, "Eros, c'est la vie," was the pseudonym that Duchamp had adopted for a series of costumed photographs of him taken by Man Ray.

A week before the opening, Duchamp and his wife Alexina, known as "Teeny," who was married previously to Henri Matisse's son, the art dealer Pierre Matisse, stayed at Pasadena's Hotel Green. Every morning, Duchamp would stride through the ornate Moorish lobby and amble five blocks east, inhaling air scented with the blossoms of nearby orange groves, until he reached the Pasadena Art Museum, where he would spend the first hour of his day speaking in French to the gardener, who recited verse by Surrealist poet Paul Éluard.

The Duchamps had flown from New York to Los Angeles on the same plane as the dashing dark-haired Copley and the flamboyant young British Pop artist Richard Hamilton, who described himself as the only Duchamp scholar who had never seen an actual Duchamp. For Hamilton, like many of the young artists embracing Pop art, Duchamp was an ideal.

Duchamp's art and life exemplified rebellion against the establishment though, at seventy-six, he stood erect and slender, with immaculate clothes and manners and the angular features and sleek hair of a matinee idol. He had lived in New York since World War II but still epitomized French reserve.

Hopps, who was never very practical about money, spent double the exhibition budget of $12,000. Instead of creating a new catalog, Hopps tore out the relevant sections of Robert Lebel's authoritative new book on Duchamp, added his own handwritten marginalia, mimeographed the pages, and stapled them together.

The Arensbergs had given their collection to the Philadelphia Museum of Art in 1954 after decades of futile and frustrating negotiations with first the L.A. County Museum of History, Science and Art and then with UCLA. At Duchamp's urging, many of the larger pieces were shipped back to Los Angeles while numerous ready-mades were re-created for the show. Most of the younger generation of Los Angeles artists and collectors had never seen any of the work before.

The installation was not without its challenges. Since many of the gallery walls were covered with brown burlap, Hopps and his preparator Hal Glicksman designed a series of zigzag panels covered in the same color used on Duchamp's *Green Box*. They stood them in the center of the galleries to support Duchamp's 1912 Cubist paintings. Other galleries contained his optical experiments and his ready-mades. These were everyday objects that the artist had transformed into his own sculpture simply by renaming and reorienting them, such as the upturned urinal titled *Fountain* that had caused a scandal when shown in 1917 under his pseudonym R. Mutt. Duchamp had signed a bottle rack and given it to Robert Rauschenberg, who loaned it to the show. Another gallery was dedicated to chess with a regulation set on display as well as the pocket-sized boards that the artist

*Andy Warhol, Billy Al Bengston, and Dennis Hopper at the 1963 Duchamp
retrospective at the Pasadena Art Museum*

Photograph by Julian Wasser, © Julian Wasser, courtesy of Craig Krull Gallery, Santa
Monica

had designed for his own use. The old Chinese mansion contained
114 pieces that established Duchamp as the unwitting pioneer of
Pop art.

For the second time in a week, Los Angeles was the place to be
for denizens of the modern art world. Dealers, collectors, and artists
arrived from New York and Europe. The dinner held before the open-
ing was hosted by patrician art collector and museum board president
Robert Rowan and his wife Carolyn and attended by trustees and old-
guard arts patrons. However, it was the party after the opening that
was remembered by anyone who scored a coveted invitation.

That landmark fete was held in the ballrooms of the nineteenth-
century Hotel Green. The black-tie dress code meant another trip to
the thrift store for artists Larry Bell and Billy Al Bengston, both of
whom had more dash than cash. Craig Kauffman, son of L.A. County

Superior Court judge Kurtz Kauffman, didn't have to scavenge. Ed Ruscha imported an attractive girlfriend from his hometown of Oklahoma City, and the couple looked like they were ready for their Hollywood close-up. Julian Wasser, a contract photographer for *Time* magazine, snapped Bengston and Hopper clowning with Warhol in front of Duchamp's 1914 *Network of Stoppages*.

Warhol was in black tie but Taylor Mead was denied entrance for wearing Wynn Chamberlain's sweater, which was so large it came down to his knees. Hopps sorted it out but then Wasser pushed past them to get a photograph of Duchamp, which prompted Mead to start screaming, "How dare you! How dare you!" Warhol dryly observed, "The idea that anybody had the right to be anywhere and do anything, no matter who they were and how they were dressed, was a big thing in the sixties."[18]

When Duchamp realized that Mead was an underground actor and poet, he cordially invited him to his table. But Mead soon took off dancing with Patty Oldenburg. She and Claes Oldenburg were living in Los Angeles for a year while creating performances and sewing the giant soft sculptures of everyday objects that Claes showed at the Dwan Gallery. Warhol was left to spend time talking to Duchamp and drinking too much champagne, which meant pulling over to the side of the road on several occasions on the drive home. "In California, in the cool night air, you even felt healthy when you puked—it was so different from New York."[19]

Hundreds of artists and hipsters and hangers-on overindulged in pink champagne into the late hours. Duchamp's old running mate Man Ray had moved from Los Angeles back to Paris, but a few other old friends came to the affair, including Beatrice Wood, a seventy-year-old ceramist whose purported love affair with Duchamp and writer Henri-Pierre Roché was the basis for the 1962 film *Jules et Jim*. She exhausted three much younger partners by dancing all night long at the party, claiming that chocolate and young men were the secrets to her longevity. (The day before, she had hosted a luncheon for Duchamp at her home in Ojai, wearing Indian robes and serving food on her own golden lusterware.)

Hopper, predisposed to being the life of the party, recalled, "I stole the sign that said 'Hotel Green' with a finger pointing. When I

saw it, I recognized that it's the same shaped finger as from Duchamp's painting *Tu M'*. I got some wire cutters and went to get it. He signed the finger with 'Marcel Duchamp, Pasadena, 1963.' So Hopper and Hopps made the last ready-made!"[20] (This "Signed Sign" sold for $362,500 at a Christie's auction on November 11, 2010.)

Getting Duchamp's signature quickly caught on. Joe Goode pulled the pink cloth from one of the dining tables and asked Duchamp to sign it. He happily obliged. Hopper recalled, "We all signed it. Andy signed it as 'Andy Pie'; Jasper Johns, Ed Ruscha, Larry Bell, Kenny Price."[21] Goode, who was subletting an apartment from Hopps, later managed to convince him to accept the souvenir in exchange for two months of back rent.

In an interview with *Los Angeles Times* art critic Henry Seldes, Duchamp said he wanted to avoid being "the victim of the integration of the artist into society." He saw the direction of contemporary art as "very dangerous," because it had become fashionable, while he believed that "great art can only come out of conditions of resistance."[22]

Such resistance in the realm of contemporary art was about to disappear altogether, and even Duchamp dropped his Gallic reserve to admit, "Life begins at 70. This show is fun. It gives me a wonderful feeling."[23]

That wonderful feeling was borne out in the following few days when he and Teeny were transported to Las Vegas by Copley, who had operated a gallery in Los Angeles in 1947 to show Surrealist and Dadaists such as Max Ernst, Man Ray, and Joseph Cornell, whose boxes were priced then at seventy-five dollars. Sales were so scarce, the gallery survived only six months.

The small plane had a curved seating area where collectors Betty Asher and Betty and Monte Factor took turns with Hamilton and Hopps in sitting next to Duchamp. After checking in at the Desert Inn, they dined at the Stardust Lounge, where Marcel and Teeny were treated to long-legged showgirls performing a risqué version of the Folies Bergère. A photograph of the event reveals everyone smiling broadly, apart from the Duchamps, who looked stunned. The group then drove downtown to see towering neon signs and glowing casinos, evidence of American extravagance beyond even their expectations.

When the others started gambling, Duchamp returned to his role

At the Stardust Lounge, Las Vegas, 1963: Teeny Duchamp, Richard Hamilton,
Betty Factor, William Copley, Monte Factor, Walter Hopps, Betty Asher, and
Marcel Duchamp

of archvoyeur. Though he was fascinated by games and had devised
a system of gambling in the 1920s that allowed him to break even dur-
ing his stay at Monte Carlo, he refused to play. When Hopps pleaded
with him to demonstrate the system, Duchamp slyly responded,
"Wouldn't you rather win?"[24]

Duchamp saved his gamesmanship for chess. After they returned
to Pasadena, he visited PAM on October 18, 1963, to play on the
board set up in his own exhibition. The event was to prove the truth
of Man Ray's observation that "there was more Surrealism rampant in
Hollywood than all the Surrealists could invent in a lifetime."[25]

Eve Babitz, a curvaceous nineteen-year-old, was Walter Hopps's
girlfriend, a fact that he was trying to keep from the notice of his wife
Shirley. He had refused to invite Babitz to the museum opening or the
grand party. When Babitz got a call from photographer Julian Wasser
inviting her to play chess with Duchamp she leaped at the opportunity
for revenge. "I was going to be pissed off for the rest of my life or pay
them back," she said.[26]

Duchamp was dressed for the chess match in a dark suit and a

straw hat that he had acquired in Las Vegas. At nine in the morning, the museum was not yet open to the public, and Duchamp seemed unruffled when Wasser set up his equipment and told Babitz to remove her blue artist's smock. Nearby stood two large sheets of glass containing Duchamp's play on sexual frustration, *The Bride Stripped Bare by Her Bachelors, Even*. Babitz had just started taking birth control pills so her 36 DD breasts were larger than usual. "I thought they should be photographed really . . . for immortality," she said later.[27] Duchamp seemed more impressed by the fact that Babitz was the goddaughter of Igor Stravinsky, whose *Firebird Suite* he and Beatrice Wood had seen in Paris in 1910.

Babitz's lackluster chess didn't discourage Wasser from shooting roll after roll of film. Babitz, who later became a successful writer, knew the photographs would be a triumph, something that Hopps would look at for years. "I always wanted him to remember me that way," she said.[28]

Babitz was hungover and perspiring under the hot lights, but she felt it was all worthwhile when her unsuspecting lover walked in. The nude Babitz coolly greeted him, "Hello, Walter." He turned ashen and dashed into his office. Raised voices could be heard. Babitz recalled, "It made him return my phone calls, which is what I wanted out of life."[29] (Their affair resumed the following week when he flew with her to San Francisco to see the debut of *The Beard*, Beat poet Michael McClure's play about Jean Harlow and Billy the Kid.)

While Wasser took dozens of photographs, the one that became a celebrated poster depicts Babitz seated on a wooden chair and leaning her elbows on the table so that her breasts dangle and her hair hides her face; Duchamp, with a neutral expression, holds a cigar and focuses on the board. For Duchamp, it was completely unplanned and therefore a perfect coda to his retrospective.

The back-to-back receptions in honor of Warhol and Duchamp invigorated the feisty Los Angeles art scene. Warhol said, "For a while there in the early sixties, it looked like a real solid art scene was developing in California. Even Henry Geldzahler felt he had to make a trip out once a year to check on what was happening."[30] A few months later, one of the city's few progressive critics, Jules Langsner, wrote in *Art in*

Eve Babitz and Marcel Duchamp play chess at Pasadena Art Museum, 1963
Photograph by Julian Wasser, © Julian Wasser, courtesy of Craig Krull Gallery, Santa Monica

America, "In the space of a half-dozen years, the state of the Los Angeles art community has changed from the nuts who diet on nut-burgers to a living and vital center of increasing importance."[31]

A lively consensus emerged that these shows represented some sort of shift in terms of the city's viability as a contemporary art center. Duchamp scholar Dickran Tashjian said, "The L.A. artists, who were outsiders, saw the success of Duchamp, who was an outsider, and thought, 'Hey, if this guy can do it, so can we.'"[32]

Encouragement from a rising star such as Warhol gave a boost to the artists who believed that their own unique contributions deserved to be recognized in New York and Europe. Most of those artists showed at Ferus, the first gallery in Los Angeles to capture the zeitgeist.

Ferus Gallery

Before Ferus, art galleries owned by Felix Landau, Earl Stendahl, Dalzell Hatfield, Frank Perls, Paul Kantor, David Stuart, and others imported Impressionists, Cubists, Surrealists, and New York School Abstract Expressionists and occasionally showed some L.A. artists with modern leanings. However, this awareness and practice of modern art did not constitute much in the way of a scene. The city's distinctive Modernist enterprise in art, as in architecture and design, attracted spirited individualists. Hopps explained, "Although a quasi-official Los Angeles avant-garde, centered around the post-Cubist painter Rico Lebrun, was visible throughout the city, alternative modern art could be seen in only a few experimental movie houses or the walls of bohemian cafés."[1]

Ferus, founded in 1957 by Hopps and artist Ed Kienholz, represented a group of Los Angeles artists who were friends—who hung

The Ferus Gallery gang: John Altoon, Craig Kauffman, Allen Lynch, Ed Kienholz, Ed Moses, Robert Irwin, and Billy Al Bengston, Los Angeles, 1958
Photograph by Patricia Faure, © The Estate of Patricia Faure

out and supported one another in their attempt to create something that departed from the immediate past and embraced the aesthetics of the sixties. Their synergy with one another and with musicians, actors, photographers, fashion designers, and architects would eventually transform Los Angeles. Robert Irwin later said, "The idea of a career wasn't an issue for any of us because if it had been we would've left and gone to New York like all the generations before us, because that's where careers were made. The reason that generation of artists is so seminal to L.A. is because it was the first one that didn't leave and made a commitment to stay in L.A."[2]

Virtually all of the artists who showed at Ferus in the early years were enamored of Abstract Expressionist artists Jackson Pollock, Willem de Kooning, Mark Rothko, Franz Kline, and others. These artists had toiled in poverty and obscurity for decades before finding support from patron Peggy Guggenheim or critics Clement Greenberg and Harold Rosenberg. The Ferus founders and artists admired the

stubborn determination of the New York painters to make something original and authentic. For a few years, most of them emulated that gestural abstract style of painting, though it was difficult for them to accept the New Yorkers' soul-searching angst. Also, on the West Coast, they were slightly behind the curve in their understanding of such painting, which they knew initially from black-and-white reproductions in magazines such as *ARTNews* and *Studio International*.

In 1956, Pollock killed himself in a car crash. Within two years, his paintings and those of the other Abstract Expressionists started selling for large sums, and the outsiders were suddenly insiders. The Abstract Expressionists were practically establishment in the opinion of young Jasper Johns and Robert Rauschenberg, who challenged virtually all of the ideas Rothko, De Kooning, and company held dear. Hopps and Kienholz, neither of whom had been to New York at that point, were not yet aware of such shifts and proudly showed gestural abstract painting from Northern and Southern California. For conservative Los Angeles during the Eisenhower years, such work was viewed as pretty radical.[3]

They were quite the odd couple: The square-jawed, sandy-haired Hopps was so often outfitted in a suit and tie, sporting black, square-rimmed glasses, that his friends used to tease him about being in the CIA. In contrast, Kienholz was a cherubic farm boy and aspiring Beat with a receding hairline, a goatee, and an expanding belly. Both were autodidacts who were seemingly incapable of getting along individually in the conventional world. Together, they had a chance. "We couldn't have been more different sorts of people," Hopps said, "but it was clear to both of us that we had an agenda to further the kind of art that interested us in our own ways."[4]

Hopps insisted that the name of the gallery derived from *Ferus hominus*, which he believed to be an anthropological term for pre–*Homo sapiens* man. "They were described as being very hardy, irascible, dangerous beings and I thought that was an apt description of the artists I was involved with," he explained.[5]

On another occasion, Hopps said the gallery was named in honor of James Ferus, a talented teenager at Eagle Rock High School, Hopps's alma mater, who had committed suicide. "It was two edged, something

Walter Hopps
Photograph courtesy of Nancy Reddin Kienholz

very involved about what we felt was living art and how it would be named after someone who was no longer alive."[6]

Irving Blum insisted later that it meant "for us," a gallery conceived as a support system for artists. In name as in all else, Ferus was many things to many people, and it gained a mythic reputation.

Walter Wain Hopps III, born in 1933, was a fourth-generation Californian raised in comfortable Eagle Rock, a small city to the west of Pasadena. His father was an orthopedic surgeon and his mother trained in Jungian psychology, though she never practiced. Hopps was adept at math and science, and his parents expected him to become a doctor. They suggested Yale, but the lure of jazz clubs and modern art led him to choose Stanford University near progressive San Francisco. With his open-faced friend James Newman, he formed a venture called Concert Hall Workshop that booked jazz gigs at colleges. (Since the age of sixteen, using fake driving licenses, Hopps and Craig Kauffman had seen Charlie Parker, Miles Davis, and other jazz musicians performing at the clubs along Central Avenue in Los Angeles as well as in San Francisco.)

After contributing a bawdy submission to a campus magazine, Hopps fell afoul of Stanford authorities. He transferred to the University of California–Los Angeles in 1951. Though he took the appropriate courses for medical school to please his parents, he was consumed by curiosity about modern art and its history.

His inability to conform continued after he was called up to serve in the army in February 1953. At Fort Ord, on Monterrey Bay in Northern California, his attitude was so defiant that he was made to repeat the basic training course until he came close to a nervous breakdown, which later led to his release.

One of Hopps's first and most telling curatorial events was the 1955 Action I, taken from art critic Harold Rosenberg's term "Action Painting." He was still in boot camp at Fort Ord when he came up with the idea. After he was released from the army, Hopps, Kauffman, and painter Ed Moses drove a car with a trailer up to San Francisco to collect large abstract paintings by Clyfford Still, Richard Diebenkorn, and others. Hopps had zero credentials but unbeatable patter. The artists trusted him completely and lent their work to this unprecedented event. As they sped along a winding road in the San Fernando Valley, the car swerved and the trailer broke loose, veering across the street and tearing up some lawns before staggering to a halt. Against all odds, the good fortune of the enthusiastic amateurs prevailed. After righting the trailer, they managed to get to Santa Monica with the paintings and themselves undamaged. Together, they hung the paintings on a sheet of canvas that they had stretched around the perimeter of a merry-go-round on the pier. The exhibition revolved slowly to the sounds of the calliope, jazz records, and John Cage's score for twelve radios to a vanguard audience of artists, Beat poets Allen Ginsberg and Jack Kerouac, and bewildered passersby.

Hopps's parents were not supportive of these extracurricular art endeavors so he was obliged to work part-time as a university janitor and as an orderly in the psychiatric ward of the university hospital. Around this time, he became involved with a lithe and lovely blonde, Shirley Neilsen, whose parents were doctors and friends with Hopps's parents. The young couple had known each other since childhood.

While Hopps went to UCLA and staged art events, Shirley doggedly completed her undergraduate degree in art history at UCLA and her master's degree in art history at the University of Chicago, specializing in art of the Northern European Renaissance and modern eras. Hopps audited one of Shirley's courses in art history, but he never completed a degree, though he concealed this fact. "Walter appropriated my education," Shirley said dryly.[7] He told people that

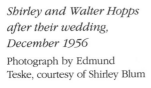

Shirley and Walter Hopps
after their wedding,
December 1956

Photograph by Edmund
Teske, courtesy of Shirley Blum

he'd attended the same schools as Shirley, implying that he had the same qualifications. "He was so brilliant, he should have advertised the fact that he hadn't even taken classes," she said.[8]

In 1955, Walter and Shirley were married at Watts Towers, the soaring concrete sculptures covered in shards of glass and ceramics that the Italian immigrant laborer Sebato "Simon" Rodia had devoted most of his life to completing. Hopps's parents did not attend. Pictures of the ceremony were taken by the experimental photographer Edmund Teske, who later shot an album cover for the Doors.[9]

Hopps sold his stamp collection and some war bonds to open his first gallery, Syndell Studio, in a storefront he rented for seventy-five dollars a month in a building made of concrete and telephone poles at 11756 Gorham Avenue in Brentwood. The newly married couple moved into a small apartment in the back. Syndell was the name of a farmer who had died by running across the highway in front of a car driven by Hopps's Stanford classmate James Newman. A suicide. No charges were filed against Newman, but it was so upsetting to him that he suggested the gallery be named in Syndell's memory; Newman soon took up residence to help run the place. Hopps and his friends made and exhibited artworks under the guise of a fictional artist, Maurice Syndell.

Ed Kienholz
Photograph courtesy
of Lyn Kienholz

Artists Ben and Betty Bartosh helped, as did Shirley when she wasn't taking or teaching courses in art history. Open by appointment, the gallery showed abstract paintings by Hopps's friends Kauffman, Kienholz, and others to an unappreciative audience. Shirley said, "The people who came in were essentially hostile."[10]

In 1956, Kienholz invited Hopps to stage a second show of abstract painting, Action², at his Now Gallery in a theater on North La Cienega Boulevard. A small room with the gallery name posted in letters made of rough sheet metal, it attracted Beat artists Wallace Berman, Robert Alexander, and George Herms and hipster actors Dennis Hopper and Dean Stockwell. (A few years later, in 1966, Stockwell and Herms would collaborate on the art film *Moonstone.*)

It had been quite the winding career path for Kienholz. Born in 1927, he spent the first seventeen years of his life on a 350-acre wheat farm eight miles from Fairfield, Idaho, where he learned from his father how to build fences, milk cows, and repair cars, as well as other practical farming skills. At the rural high school he attended,

his burly build was a natural for the football team, where he played center. He also designed sets for small plays, sang in the choir, played French horn in the band, and excelled in shop and art classes—but flunked math. He could not reveal his enjoyment of drawing and painting, which, in his words, "were considered feminine." There were no museums in the area. "A picture to me would be an engraving of George Washington hanging above the blackboard in school," he said. "From my childhood, I mostly remember isolation, being separate and apart. . . . I used to sit in the barn and milk the cows and look out through the barn doors and see the aura of the lights above Spokane, which was some forty miles distant, and know that people were not milking cows in Spokane."[11]

Hard bargaining was his method of survival. He refused to become a farmer and left home at age seventeen after a fight with his father. For several years, he moved so frequently that he managed to avoid being drafted for the Korean War. He worked odd jobs: proprietor of a rural hamburger stand in Washington, helper in a Spokane bar, foreign car salesman and painter in a sign shop in Reno. (After a drunken evening in Reno, he came back to his car and found that someone had left him a tombstone engraved "Chico Pete, d. 1952." He later gave it to Hopps, who was known as "Chico" to his friends after various wild vacations south of the border. Hopps kept it at Syndell Studio, then returned it to Kienholz, who moved it to his studio in Hope, Idaho, in 1975, where it remained.)

In Las Vegas, he scored a curious job teaching art at the Taffy Hill School of Self-Improvement, which turned out to be a front for an escort service. After a quick departure from that job, he earned money making window displays for liquor stores.

Kienholz did not attend art school, but, in 1947, he put in a couple of semesters at Whitworth College in Spokane, where his fling with a young woman resulted in marriage and a son. They moved to Cheney where Kienholz briefly studied architecture at Washington State College while working nights as an attendant at a mental hospital. "Conditions were bad, like *One Flew Over the Cuckoo's Nest*," he said. One of his wards committed suicide by strangling himself with his sheets. After about a year and a half, he had divorced and gone back to roaming in his 1932 Buick coupe, which with its top removed

from the trunk, served as a makeshift pickup. "I had a black Great Dane; I had a Puritas bottle full of goldfish; I had some books. I had a tombstone; I had probably fifty or sixty early constructions—a couple of pair of pants and a Botany 500 raincoat—that was about the range of my worldly possessions," Kienholz recalled.[12]

He could not conceive of living in New York. "How can you live in a place where you can't just walk out the door where you live and take a piss in the backyard?"[13] So, in 1952, he drove to Los Angeles to pursue his notion of being an artist. "I had nothing, so in a way I risked nothing, except my time, in the early years. It was a big city—I was away from the small-town look-over-your-shoulder, know-your-business syndrome—and I had nothing to risk, so I could do anything I wanted. And that sense of freedom probably produced some of the early directions that I took on in ignorance, certainly."[14]

Shortly after moving to L.A., Kienholz had a life-changing toothache. He was too broke to pay a dentist and complained of his plight to a car dealer in the Valley who said that his brother-in-law, a dentist, was an art collector who might be willing to barter. Kienholz drove out to Van Nuys and met the couple. He leaned all of his enamel-on-wood abstract paintings against the berm of their front lawn. After a while, the couple selected one, and the next day, Kienholz went to the dentist's office and had his tooth pulled out. "Jesus, I've come to heaven," he recalled. "I mean, you know, to be an artist is really worthwhile because I got rid of that tooth which hurt. I was very very pleased with that. It's the main reason I stayed in Los Angeles. I figured, 'Boy, I've found the right place.'"[15]

He put a few of his lumpen abstractions in the window of the vacant store where he lived on Ventura Boulevard in Sherman Oaks. Beat poet and sometime heroin addict Robert Alexander knocked on the door and said he wanted to exhibit the paintings in his nearby Contemporary Bazaar, an arts and crafts boutique where poetry books were sold and readings were held. Alexander also wanted to borrow some abstract paintings by Richards Ruben from the Felix Landau Gallery. Together they drove in Kienholz's truck through tree-lined Beverly Glen and across the broad boulevard of La Cienega. "I saw this gallery," Kienholz said, "and everything was white and clean and

pretty." He whistled to himself and thought "that is the way it should be. That's the kind of a gallery I should have."[16]

In 1954, Kienholz rented his first studio on Santa Monica Boulevard between Crescent Heights and Fairfax next to that of Howard "Dutch" Darrin, a car designer who had created one of the first sleek fiberglass sports cars, the Kaiser Darrin. Kienholz didn't have the ten dollars for rent but noticed the space came with a "pretty good couch." He borrowed ten dollars to pay the landlord, put the couch in his truck, drove twenty blocks west to La Cienega Boulevard, and sold it to an antiques store for eighty-five dollars. He paid back the ten dollars, paid his landlord seven months' rent, and had five dollars left. "And five dollars was, like, incredible," said Kienholz, who budgeted himself to live on $1.09 a day.[17]

Kienholz hauled his paintings around to a few dealers but encountered only rejection so he turned to the manager of a Laurel Canyon coffee shop frequented by local musicians and artists. Acceptance at last! His show at Von's Café Galleria was reviewed, sort of, by someone who wrote that his watercolors were "almost as excellent as the wonderful food at this spot."[18]

There he met eighteen-year-old Mary Lynch, who had hitch-hiked south from the Bay Area with her friend, the aspiring but inexperienced actress Diane Varsi. Soon after their arrival, Varsi landed the lead role of Allison Mackenzie in the 1957 movie *Peyton Place*, for which she received an Academy Award nomination. Afterward, she dated her costar Russ Tamblyn, a one-time child star who had gravitated to the Beat scene. Meanwhile, Mary married Kienholz in 1956 and worked as a claims processor for Blue Cross while he pursued his art and his ideal of building an art scene. They lived in a falling-down house on Nash Drive in woodsy Laurel Canyon that they bought for $5,000. "I was open," Mary said. "I came from the Beatnik situation in North Beach so anything new was good."[19]

Kienholz took over as impresario of the Café Galleria and arranged shows of Edmund Teske's photographs and the work of other artists. "Then I decided I'd open my own gallery so I'd have a place to show," he said.[20] He contacted Raymond Rohauer, who had rented the Turnabout Theatre at 716 North La Cienega Boulevard, named for two

stages where different puppet shows could be held simultaneously. Kienholz proposed removing one proscenium to make it into a theater for Rohauer to show avant-garde films in exchange for a separate space for his Now Gallery; Kienholz also hung an occasional show in the lobby of the Coronet Theater down the street at 366 North La Cienega Boulevard, where Rohauer also screened foreign and art films such as Kenneth Anger's *Fireworks* and Jean Cocteau's *Blood of a Poet*, both of which were seized by the police in 1957.

By that time, Kienholz had bought a proper pick-up truck and had the driver's side door lettered: ED KIENHOLZ: EXPERT. City officials must have believed his self-promotion when they hired him as contractor of the all-city art show held annually at Barnsdall Park with a budget of $12,000. That is where the hustler Kienholz first met the ethereal Hopps, who volunteered his help in the staging so that Now Gallery and Syndell Studio could have booths along with the more established galleries of Landau and Stuart. A few months later, after Rohauer defaulted on his theaters' rent, Kienholz lost Now. Hopps suggested to Kienholz that they combine their galleries into one.

Midwesterner Streeter Blair painted bucolic scenes in a folksy style and sold antiques from a large building on North La Cienega Boulevard. Kienholz had bought furniture from him and even pitched a few games of horseshoes with the transplanted Kansas farmer. Blair's wife, Camille, also an artist, offered to rent the back of their building to Kienholz and Hopps. Ferus first opened at 736a North La Cienega Boulevard. "We had a strange gallery and showed strange things, but we paid our rent," said Kienholz.[21]

Hopps borrowed $200 and Kienholz started renovating the small gallery with a storage area concealed by a curtain. Hopps selected abstract paintings by a dozen artists from Northern California for the first show, rather pretentiously titled Objects on the New Landscape Demanding of the Eye, and set to run from March 15 to April 11, 1957. Kienholz had gotten his friends together and rented a paint sprayer so they could stay up all night working on the gallery, but Hopps didn't show up. "I'm absolutely pissed that he doesn't show," recalled Kienholz. "Well, it turns out that he was out borrowing a Clyfford Still for the first exhibition. And the truth of it is, it's not important that the gallery was white, but it is important the Clyfford Still was in the

gallery. I had no idea who Clyfford Still was, you know; I didn't have the knowledge at all."[22]

Critic Gerald Nordland called that Still painting a "great ochre masterpiece." Nordland wrote for *Frontier*, a magazine published by art collector Gifford Phillips, the nephew of Duncan and Marjorie Phillips, who had established the first modern art museum in America, the Phillips Collection, in Washington, D.C. Nordland continued, "The first exhibition was vigorous and forceful and has set a pace which may well be difficult to maintain."[23]

Riding the First Wave

I n the summer of 1957, Ferus opened with assemblages by Wallace Berman who, a few days after the opening, was unceremoniously led away in handcuffs by the vice squad of the Los Angeles Police Department. L.A. police made a point of harassing Beats, which is one reason they congregated outside the city limits in Venice or Topanga. Berman was very much a Beat artist, but he had not created the erotic drawing that had offended some viewers. It was a coital fantasy concocted by Marjorie Cameron, the sultry artist who had played a Babylonian goddess in Kenneth Anger's 1954 film *Inauguration of the Pleasure Dome*. Berman had included it along with a crucifix in a wooden crate titled *Temple*. "Somebody came into the gallery and saw that cross and . . . they called the police," Kienholz recalled. "When the police arrived, they demanded, 'Okay, where's

the dirty stuff?' So they closed up the gallery and prosecuted Wally on the basis of that drawing."[1]

Charles Brittin, who documented the artists and musicians of the period, photographed the arrest. An indignant Berman hoped to capitalize on the publicity, but the *Los Angeles Times* had no interest in scruffy artists complaining of censorship. Berman was charged with obscenity, convicted by Judge Holloday, and fined $150. His friend Dean Stockwell, the handsome actor who had been a child star in *The Boy with Green Hair* and been inspired by Berman to make collages of his own, paid the fine.

Slender and bearded, with a pronounced nose and high cheekbones, Berman cultivated the aura of the mystic hipster. Hopps's first impression was awe: "Young, hawk-face intensity, straight ahead stare, super cool. . . . I knew somehow then that I must come to know him."[2]

This was not Berman's first dustup with authorities. Born in Staten Island in 1926, Berman was brought to Los Angeles by his Russian immigrant parents when he was ten. He felt like an outsider even in the supportive Jewish neighborhood of West Hollywood. Fairfax High School alumni from that period include a number of success stories: trumpeter and A&M Records cofounder Herb Alpert, songwriter Jerry Leiber, and Sidney Felsen, cofounder of the lithography studio Gemini GEL. Berman, however, was expelled in his first year for gambling—though he continued to deal drugs at the high school. He took art courses at Chouinard and Jepson art institutes but was arrested in 1944 for possession of marijuana. Offered the choice of jail or the navy, he enlisted. He had a breakdown six months later and was given an honorable discharge.

Hanging out at the Central Avenue jazz clubs, Berman befriended many musicians, including a young Sammy Davis Jr. In 1953, Berman married Shirley Morand, and the couple bought a house on Crater Lane in Beverly Glen that became a haven for Beat poets, musicians, and artists who wanted to smoke pot or crash for an evening.

Berman's devoted friends thought he had a distinctly spiritual charisma, and he lettered much of his work with the mantra "Art is Love is God." His collages incorporated the first letter of the Hebrew alphabet, aleph, regarded by Kabbalists as the spiritual root of all

other letters. Popularized in the 1950s by the discovery and publication of the Dead Sea Scrolls, Berman painted the Aleph on his motorcycle helmet. With Robert Alexander, who had become a mail-order preacher in order to open his own Temple of Man, Berman published *Semina*, a small loose-leaf magazine of art, poetry, and prose written by and for fellow seekers. Hopps subsidized the rent of a storefront on Sawtelle Boulevard for their publishing venture, Stone Brothers Printing.

Alexander was "involved with drugs and art and poetry and printing, and not necessarily in that order," observed Kienholz.[3] Alexander and Berman hosted readings and jazz gigs at Stone Brothers, something of a precursor to Ferus. One night Dennis Hopper, who had just appeared in *Rebel Without a Cause*, came with his costar and friend James Dean and met Kienholz and Hopps. He returned many times after, calling Hopps "the intellectual godfather of the underworld," and began making his first assemblages.[4]

After his arrest at Ferus, Berman moved with his wife and son to San Francisco, believing, correctly, that he would find a more liberal community in Northern California. Then it was on to Larkspur, where he was followed by a stream of acolytes, including artist George Herms.

Kienholz and Hopps had no finite criteria for selecting Ferus artists apart from attitude. Friends recommended friends. Berman suggested showing Ed Moses, who rented studio space in the back of Stone Brothers. Raised by his mother in Long Beach, where he was born in 1926, Moses spent summers with his father in Hawaii and became an avid surfer, if not an entirely avid student. In 1943, knowing he would be drafted for service in World War II, he enlisted in the navy and got into the medical corps. He was surprised to discover that he enjoyed his work as a surgical assistant, and when he got out of the service, he enrolled in premed at Long Beach City College. "For three years, I got Ds, Fs, and Cs," he said. No more medical school. As an elective, he took a class with the eccentric abstract painter Pedro Miller. Moses knew nothing about any kind of art and sat in the back of Miller's class utterly perplexed as his classmates painted still lifes. As Miller approached, he quickly slapped a brushstroke of red and

another of white on the canvas board. "That wasn't any good, so out of desperation I put my fingers in the paint jars and scratched over the board. . . . I was doing it as a joke," he said.[5] When Miller got to Moses, he looked carefully, picked up the canvas and put it on a ledge in front of the class. "Now here's a real artist," he declared. Moses was stunned. "Changed my life right then and there. I became the hero of the class."[6]

Moses transferred to UCLA's art department, then to the University of Oregon, then back to UCLA. Then he dropped out to work as a messenger at Twentieth Century Fox. After years of surfing, Moses was tall and muscular, with a puckish appearance, a flirtatious manner, and a mass of brown hair combed back in a ducktail. As he pedaled around the studio lot making deliveries, he caught the eye of a bored Marilyn Monroe. She invited him into her trailer for a diversion. "Her shoes were all run down at the heels, she had hair all over her black sweater but what an ass!" Moses sighed.[7] There followed a *Cannery Row*–inspired stint on a sardine ship in Monterey, where he met a young woman separated from her husband who suggested they move to Las Vegas, where she got him a job as a lifeguard at the Flamingo. Six months later, she went back to her husband and Moses went back to UCLA.

In 1957, he met Hopps and Kauffman. They talked to him about De Kooning and Pollock and validated his intuitive approach to abstract painting. He completed his master's degree at UCLA in 1958. "It took me eight or nine years to get an MA there," Moses said. "I insulted all the faculty members all the time. One of them said, 'How would you like not to graduate?' I said, 'How would you like dealing with me for another year?'"[8] That was the attitude that got him a show at Ferus, exhibiting the gestural abstract paintings that he had completed for his graduate degree. The following year, Moses moved to New York, where he absorbed the remnants of the Abstract Expressionists ethos by drinking at the Cedar Bar and hanging out with Milton Resnick.

Moses once said that Craig Kauffman's face was so angular that he looked like Dick Tracy. Indeed, like Hopps, Kauffman had clean-cut good looks that belied a subversive intelligence. His abstract paintings

were structured and considered, influenced by his interest in modern architecture. Kauffman was a shoo-in for Ferus, given his long friendship with Hopps. At his rowdy opening reception, where an inch of cheap wine floated across the gallery floor, Robert Alexander and painter Arthur Richer got drunk and started to fight. Alexander stripped off all of his clothes and was standing in his jockstrap when Richer looked at him and said, "Hey, man, I don't wanna ball you I wanna fight you."⁹ Both men exploded with laughter and went back to drinking. Meanwhile, Kauffman's well-dressed mother, complaining of the mess, was pulling up little pieces of grass that were growing through the broken concrete of the patio. Thanks to his decorous upbringing, Kauffman seemed less overtly defiant than his friends, but he rebelled covertly. One night, after a few drinks, he powered his Jaguar roadster in muddy circles on the well-manicured lawns of the Valley.

An artist who was far from covert in his wild behavior was John Altoon, swarthy and sensual with a hooked nose, full lips, and soulful eyes. His reputation was such that a photograph of him, naked to the waist in his Venice studio with a fetching young woman and a young man lying on the floor, was used as the cover of Lawrence Lipton's account of the Beats, *The Holy Barbarians*. Born in 1925 to Armenian parents living in Los Angeles, he attended Dorsey High School, where his drawing talent became apparent. He joined the navy and served in the Pacific through the end of World War II, then attended L.A. County Art Institute (now Otis College of Art and Design) and Art Center College of Design to study commercial art on the GI Bill. Though making a good living as an illustrator, Altoon yearned to be a serious painter. After taking classes at Chouinard, he moved to New York in 1951 where he was smitten by the abstract painting of fellow Armenian Arshile Gorky.

After four years there followed by a year in Spain and France, Altoon returned to Los Angeles in 1956. A charismatic personality who called his dog "Man" and brought jazz ensembles to play in his classroom at Chouinard, where he then taught in the evening, Altoon attracted the attention of the sultry B-movie star of *The Beat Generation*, Fay Spain. They married in 1959.

Altoon also suffered from a severe bipolar disorder that led him

John Altoon
Photograph by Joe Goode, courtesy of Joe Goode

to commit himself on more than one occasion to Camarillo State Hospital. He was both soothed and tormented by the process of painting.

He heard about Ferus. "He walked in and announced that he was there. He liked us; we liked him," Kienholz said. "We all went up to Barney's [Beanery] and, you know, drank for a month or so, and he was part of the gallery. It was sort of casually informal."[10]

Likewise, Billy Al Bengston did not require an introduction. He strolled in and proclaimed, "I'm going to be the world's greatest artist. . . . I'll take you all to lunch." Hopps and Kienholz thought that was a reasonable proposition. As they all walked out of the gallery, Bengston jumped out in front of a car on La Cienega, flung out his arms, and cried, "Halt!" Kienholz recalled, "The car screeches to a halt . . . and we thought that was neat, you know, that was okay. He

said he was going to be the world's greatest artist, and he wasn't afraid to jump in front of a car, and that qualified him somehow."[11]

In addition to this handful of Los Angeles artists, Ferus initially showed the San Francisco painters who had been in Hopps's Action shows: Jay DeFeo, Sonia Gechtoff, Frank Lobdell, Arthur Richer, and Julius Wasserstein. Many also showed work in San Francisco at the Dilexi Gallery, run by Hopps's old friend James Newman. "We were switching shows back and forth," Kienholz recalled, "running stuff by canvas-covered trailer up the coast and installing it for Jim and bringing stuff down and all that."[12]

In short, the approach to showing art at the first incarnation of Ferus was anarchic. "It wasn't intended to be a fuck you," Kienholz said. "It was . . . an alternative route. And it wasn't cooperative. . . . It was Walter's and mine. It was a place where other things could be tried. . . . The community response, with the exception of a very few special people, was either ridicule or laughter or the classic 'My kid could do that.' "[13]

Ferus did not prove to be a magnet for art collectors, but the actor Vincent Price bought one of Kienholz's paintings for $100. Kienholz took the check to Barney, proprietor of the nearby bar Barney's Beanery, who hesitated, unsure whether the check would clear. Price didn't buy anything else from Ferus until 1964, when, as a spokesperson for Sears, Roebuck and Co.'s department of fine art, he bought about twenty folksy paintings by Streeter Blair.

The Tail-o-the-Pup, a La Cienega hot dog stand constructed in the shape of a hot dog, was a regular lunch stop for Kienholz and Hopps. One afternoon in 1956, they had drawn up their contract on a paper wrapper: "We will be partners in art for five years." After the first year, Kienholz wanted out.

"I very quickly realized that I couldn't do a gallery thing because I can't remember faces and names. People would come in and they'd say, 'Hi.' I'd say, 'Hi.' They'd say, 'How are you?' I'd say, 'Fine.' They'd say, 'What's the matter?' I'd say, 'Nothing.' They'd say, 'Well, do you know who we are?' I'd say, 'No.' They'd say, 'We bought the "something-something" yesterday.' I'd say, 'Oh shit, yeah, I'm sorry.' "

Kienholz added, "But that just turns people off like hell."[14]

According to Kienholz, he sold his share of Ferus to Hopps for $1,500, then lugged all manner of cast-offs and supplies up the seventy-two steps to his house. He built a studio in his overgrown backyard to concentrate on his own art, which had grown in complexity and scale to include parts of mannequins and bits of furniture. Mary quit her job to take care of their two toddlers, Noah and Jenney.

It soon became apparent that Hopps was incapable of sitting in an art gallery day in and day out. His strength was talking to artists in their studios and spotting talent. Shirley contributed her free time and some of her paycheck from the University of California–Riverside, where she was then teaching art history, but it was clear that he needed a new partner.

Ferus Goes Forth

Hopps was working in the gallery one day in 1958 when Adolph Gottlieb and his wife Esther walked through the door. The New York Abstract Expressionist was teaching that semester at UCLA. Hopps was about to welcome them, when, "All of a sudden this guy comes in whom I'd seen several times before but never met," Hopps said. "He had a booming, bogus Cary Grant accent, a very special style. Anyway, he walks in, flings his arms wide, and says, 'Adolph! Esther! It's Irving Blum. How are you?' At this point, he throws me a wink. 'Isn't this an extraordinary place?' He says, 'Best gallery in Los Angeles! Let me introduce you to the proprietor.' And he walks over and says, 'Walter, I'd like you to meet Adolph and Esther Gottlieb.' Well, I say to myself, 'This guy is something else.' The Gottliebs leave eventually, and I say, 'Irving Blum, I think you and I should go across the street and have a drink.

We may have business to discuss,' And Irving, in that accent, says, 'I think we do have business to discuss. I hear you're looking for someone.' And that's the way it happened."[1]

Blum, his dark hair trimmed short, with heavy brows and down-turned eyes, was a native New Yorker. His father owned three Astor Furniture stores in Brooklyn. When Blum was twelve, his parents retired to the dry heat of Phoenix, Arizona, for his father's health. Blum was an English major at the University of Arizona in Tucson with a minor in drama. After joining the air force, he became an announcer for Armed Forces Radio, thanks to his resounding baritone voice. Discharged after three and a half years, he returned to New York to pursue a career in theater. Through his friend David Herbert, who worked for an art gallery, he met furniture manufacturer Hans Knoll. "He was just incredibly charismatic," recalled Blum.

Knoll became something of a role model and surrogate father for Blum, introducing him to the work of modern furniture designers Ludwig Mies van der Rohe, Eero Saarinen, and Harry Bertoia. Blum had never seen anything like it. Knoll invited Blum to work in his showroom for a year and if he didn't like it, Knoll would give him a bonus to help him pursue his interest in theater. "They were absolutely formative years for me in that I very quickly began to assist Mrs. Knoll, who . . . was in charge of designing corporate offices."[2] Florence Knoll sent Blum around to New York galleries such as Stable, Betty Parsons, Sidney Janis, and Sam Kootz to pick up paintings to accessorize the modern furniture in Knoll-designed offices, including those of the newly opened Seagram Building.

Through Herbert, who worked for Parsons and Janis before opening his own gallery, Blum enjoyed the Manhattan art scene of the early 1950s, when the first-generation Abstract Expressionists Pollock, Rothko, Kline, and De Kooning were having regular shows. When Betty Parsons, an artist turned dealer, lost Rothko to Sidney Janis, who was an organized businessman, Blum took notice. "I learned that lesson," Blum said. "You had to have an eye so that you could really select the right people. And then you had to service them in a very professional way."[3]

Blum had worked for Knoll for two years when his mentor was killed in a car crash. It was a difficult time for Blum, and he decided to

make a fresh start in Los Angeles by opening an art gallery. Over drinks at Barney's Beanery, Blum told Hopps that he would insist on reducing the number of artists from forty to fifteen. Hopps agreed. "Much as I hated it, I knew you had to seem exclusive, and get behind a small number," he said.[4]

Although Kienholz recalled selling his share of Ferus to Hopps for $1,500, Blum maintained that he bought Kienholz out himself for $500. Regardless, Blum took over Kienholz's share. Blum wasn't wealthy, but he had a $2,500 bonus from Knoll, and another $1,500 from selling his share in the soft-core pornographic film *The Immoral Mr. Teas*, for which he had contributed the story and the narration. The story of a timid fellow who is able to see through people's clothes with a pair of magical glasses, Russ Meyer's directorial debut became the first porn movie to gain widespread theatrical release. Blum would have profited substantially if he hadn't sold out.

But his dream at that time concerned Ferus, which had potential, but "it was as much a club as anything else. . . . I thought it unprofessional."[5] To transform it, he needed more money. He was introduced to Sayde Moss, whose late husband Oscar had funded Los Angeles's respected new music series, Monday Evening Concerts. Moss, who was friends with art collector Lucille Simon, the wife of wealthy industrialist Norton Simon, bought a one-third interest in Ferus for $3,333. Over the next five years, she gave the gallery some $8,000 a year. Amused and flattered by the debonair Blum and reassured by the scholarly presence of Shirley Hopps, Moss even made up the gallery deficit at the end of each year.

In 1958, the newly capitalized Ferus moved across the street to 723 North La Cienega Boulevard. The space was renovated to reflect Blum's experience at Knoll. Large and small galleries were painted blinding white, with an overhead lighting system, carpeted floors, rear storage, and a large plate-glass window facing the street where the art on view could be seen easily by passing cars. Hopps and Shirley lived in the attached rear apartment. Altoon was called in to negotiate the $100 monthly rent with the Armenian landlord.

Kienholz did not approve of the tidy ambience and boycotted the place for three months. After a cooling-off period, Blum called and asked him to come down and fix the front door because it wouldn't

close. Kienholz said he would only go if Blum would write him a letter about his role at the gallery being extremely special. On crisp new Ferus letterhead, Blum wrote, "The undersigned does hereby make generally known that one Edward Kienholz (known in this local area as an artist, forager, balladeer, and crack pistol shot) is granted by vested powers an extraordinary dispensation to enter the sacrosanct premises occupied by the Ferus Gallery at 723 N. La Cienega Boulevard in the city of Los Angeles, said intended object of design of above grant perpetuated solely to permit the competent repair of one busted hinge. Signed, on this 7th day of June, 1959, before God and all, Irving Blum."

This theatrical gesture of the former actor said much about Blum's approach, which was good for business if alien to the laid-back sensibilities of the artists and to the patrician Hopps. "Irving was always comfortable. If you wanted to have a party, you invited Irving Blum. He made the party because he was always on. But the truth of it is, what he did was curb a really raw direction and influence a lot of artists in the new Ferus Gallery, and round off a lot of rough corners for the sake of sales," said Kienholz.[6]

Under Kienholz and Hopps, Ferus had presented only West Coast artists, a strategy Blum felt to be provincial. In January 1960, Ferus showed New York school paintings by De Kooning, Kline, Pollock, Rothko, Barnett Newman, and others. That market, however, was too competitive for the novice Hopps and Blum. Paul Kantor and other established dealers had ties with most of those artists and their collectors. It became apparent that Ferus would have to focus on the uncertain future of emerging artists.

There followed shows by Bengston, Ken Price, and Bay Area abstract painter Jay DeFeo, who would work on a single canvas, tellingly called *The Death Rose*, for seven years until it was eleven inches thick and weighed three thousand pounds.[7]

Blum wanted Jasper Johns, but dealer Leo Castelli had a waiting list for Johns's paintings of flags and targets. Castelli suggested that Blum call Johns directly and visit his studio in New York. While there, Blum spotted a collage on the wall by German Dadaist Kurt Schwitters, and as Johns arranged a selection of his new small sculptures *Light Blub*, *Flashlight*, and *Ale Cans*, Blum said, "Why don't we

do a show in California of your sculpture and include collages by Schwitters?"[8] Thanks to Hopps, he knew that expatriate German dealer Galka Scheyer had left her collection of Schwitters to the Pasadena Art Museum. They could borrow some pieces. On that condition, Johns agreed to a September 1960 show.[9]

That October, Blum brought in a show by Josef Albers, a Bauhaus Modernist whose paintings he had sold at Knoll. In his series Homage to the Square, Albers had dedicated himself to the study of color by using simple geometric shapes. Up-and-coming collectors Stanley and Elyse Grinstein paid $2,800 for a canvas on the installment plan. "It was the first major thing we ever bought and I still love it," Elyse said. "We found we could afford this stuff by paying ten dollars a week."[10] That purchase launched them into collecting and, more important, socializing with artists.

Kienholz's 1959 show at Ferus proved how effective it had been for him to remain in the studio. His critical outlook on society mixed with gallows humor in pieces of freestanding sculpture that incorporated parts of mannequins, such as *John Doe*, the top half of a nude adult man resting in a baby stroller, his head and chest dripping with blood-colored paint.

As a guest curator, Hopps arranged a Kienholz show at the Pasadena Art Museum in 1961, the same year that his work was included in the Art of Assemblage, a historical survey organized by William Seitz for the Museum of Modern Art in New York. Seitz's exhibition was unusual in its inclusion of West Coast art by George Herms and Bruce Conner, as well as a mention of the Watts Towers. Kienholz's larger-than-life personality led producer David Wolper to create an episode about him for: *The Story of . . . ,* a television biographical series.

Wolper followed Kienholz around junkyards and flea markets as he found the pieces to complete his first life-sized tableau, *Roxy's.*[11] He transformed Ferus into a bleak replica of what had been, in 1943, a notorious Las Vegas whorehouse. With pieces scavenged from an old theater on Central Avenue, the open-sided, dimly lit rooms were furnished with worn sofas and chairs and a jukebox. A portrait of General MacArthur hung on the wall. A vanity table was covered in

cosmetics. The madam who stands guard had a head made of a bleached deer skull, and an altered mannequin named "Five Dollar Billy" lay on her back on an old sewing machine treadle that could pump her up and down. Other mannequin whores had names such as "Cockeyed Jenny," and each was fiercely repellent in appearance. To complete the environment, period music played on the Wurlitzer jukebox and the aroma of disinfectant and cherry perfume laced the air. "I went back in memory to Kellogg, Idaho, to whorehouses when I was a kid, and just being sort of appalled by the whole situation— not being able to perform because it was just a really crummy, bad experience, a bunch of old women with sagging breasts that were supposed to turn you on," Kienholz said.[12]

The 1962 opening of *Roxy's* at Ferus was a sensation. Collector Monte Factor remembered, "Kienholz stationed a Brink's guard at the door and wouldn't let anyone in without a white tie. Kienholz wore a tuxedo. Kenny Price dressed like a Texan in white coat and tails and had a limousine drive him. He came up La Cienega and told the driver to make a U-turn to stop right in front of the gallery. The driver said, 'I can't make it.' Kenny said, 'I'm paying for this fucking thing. You make a U-turn right here.' The driver made the U-turn and he sees the Brink's guard. And the driver says, 'Ah, shit, we're busted.' He thought the guard was a cop. Kenny gets out and tips him and sends him away and walks in, making an entrance. Inside, they were serving boilermakers. Everybody got drunk. Bob Irwin wore a white hat and coat."[13]

Roxy's established Kienholz as a mature artist of biting insight and wit. In one of the first reviews to be published in the newly launched magazine *Artforum*, painter Arthur Secunda opined that it was "thematically effective—not always formally satisfying but unreservedly tasteful." That was the last time that anyone would accuse Kienholz of being "tasteful."[14]

For another sculpture, Kienholz used a cut-out figure from a Bardahl oil sign to make *Walter Hopps, Hopps, Hopps*. The title referred to his friend's frenetic pace and old-school surname: Hopps III. Kienholz altered the suit jacket so that it could be opened to reveal miniature replicas of paintings for sale by Pollock, De Kooning, and Kline. Since Hopps was never on time, the watch on his wrist states

"LATE." The sculpture was purchased by Hopps's dedicated patron and friend, art collector Edwin Janss Jr., who had inherited a sizable fortune from his father, Dr. Edwin Janss, the developer of Westwood, Holmby Hills, and areas of the San Fernando Valley. A handsome, fun-loving renegade, Janss, with his wife and three children, raised cattle and bred thoroughbred horses on his ten-thousand-acre ranch in the Conejo Valley, acreage that he developed as the suburb of Thousand Oaks.

Janss had just begun collecting art in the early sixties when he flew to New York and bought paintings by Rothko, Pollock, and Sam Francis, which he hung on the walls of his ranch house. Shortly afterward, *Sports Illustrated* sent a reporter to interview him about plans for a resort to be built at Sun Valley, Idaho, on land the Janss Investment Corporation had purchased from Union Pacific. The reporter could scarcely help but notice the three large abstract paintings and asked Janss who he thought were the best painters in the world at that time. Thinking quickly, Janss replied, "Rothko, Pollock, and Francis." A few months later, there was a knock at the front door. Janss opened it to a stocky stranger who said, "I want to meet the man who thinks my painting is as good as Pollock's." Sam Francis and Janss became immediate friends.[15]

Janss went on to build a sizable art collection between 1962 and 1964. Hopps, whom he had met at Ferus, was his primary adviser. Janss made the sixty-mile commute to Los Angeles in his private plane, since there was no freeway to the west hills of the Valley. Both Hopps and Janss came from established families in Southern California, and both had attended Stanford—though Janss had graduated with a degree in medicine—but it was their interest in modern art that cemented their bond.

These attractive and irrepressible Californians must have made quite an impression in New York. With Hopps in tow, Janss bought major canvases by Rauschenberg, Johns, Warhol, and Ellsworth Kelly: paintings that "assured liquidity," according to one art dealer. Janss and Hopps flew to the Venice Biennale in 1964, the year that Rauschenberg's work broke down a long-standing distrust of American art to win the international prize for painting. Yet, despite his comfort with the collecting class and his ability to advise them, Hopps found it dif-

ficult to actually sell art. "Walter was a hapless salesman, unable to focus on that part of the business because his interest was in the objects, the art," observed Janss's daughter, Dagny Corcoran.[16] Monte Factor said, "He connected with objects the way most of us connect with people."[17]

Hopps would spend hours, even days, hanging out with Kienholz and other artists while Blum was all efficiency. "I can remember one time that somebody wanted to go to Chicago for something, and there were no reservations available," Kienholz recalled. "Irving said, 'Here.' He just took the phone and said, 'This is Colonel Blum. My serial number is blah-blah-blah-blah. And I want a reservation in the name of . . . and I want it for this flight. You arrange it and call me back in five minutes and confirm it.' He hung up. And somebody called back, you know. He'd invented the serial number and the whole thing. We all laughed and thought that was funny as hell."[18]

Throughout 1961, Hopps ensured the continued focus on West Coast artists at Ferus, making a sole exception for a show of pale still lifes by the Italian painter Giorgio Morandi. There were shows of hulking ceramic sculptures by John Mason, big paintings of postcards of the stone formation known as Eagle Rock by Llyn Foulkes, and gestural abstractions by John Altoon.

Blum was excited about some paintings he had seen in Altoon's studio. "A dozen paintings, roughly nine feet square that were Miroesque. . . . I was just trembling with pleasure."[19] Blum brought them to the gallery. The following day, Altoon came in and said, "Irving, what did you do with my paintings?" Blum said they were in storage. Altoon pulled a switchblade knife out of his pocket, aimed it at Blum's throat, and said, "I want to see those paintings."

Blum replied quickly, "John, absolutely no problem."

They went down the alley and opened the door to the storage. "As I stood there watching, he ribboned with his knife the dozen pictures I had back there," Blum recalled. "Ribboned beyond restoration. When he finished, he turned and left, didn't say a word."[20]

That was not the only time that Altoon nearly cost Blum his life. In 1961 Abstract Impressionist Hassel Smith, who lived in Sebastopol, California, was showing at Ferus and, thanks to Hopps, having a simultaneous show at the Pasadena Art Museum. Blum and Altoon

hitched a trailer onto Hopps's station wagon and drove to Sebastopol to pick up Smith's oil paintings. After a boozy dinner with the painter, Altoon was driving them back to Los Angeles when he fell asleep at the wheel. The trailer hit a concrete barrier and flipped the car over. Blum broke his hip, jaw, and shoulder and was confined to a hospital in the town of Los Banos.

The accident made the newspapers in Los Angeles mainly because Altoon was the husband of movie star Fay Spain, who immediately sent an ambulance north to recover the badly injured artist, though not his dealer. "John left me there to rot," Blum recalled with a sardonic laugh.[21] Fortunately, his uncle Albert Waldinger, a well-known diamond setter in Los Angeles, saw the article. Blum had been selling art to his daughter Pearl and her husband Merle Glick, a dentist who wound up treating many of the Los Angeles artists. Waldinger dispatched an ambulance to bring Blum down to Mount Sinai Hospital, now Cedars Sinai Medical Center. Blum spent the next six months recovering. Altoon left Ferus to show with the David Stuart Gallery.

The messy Beat ethos embraced by Altoon, which had been so instrumental in the founding of Ferus, faded rapidly after 1960 and the election of John F. Kennedy. It could be seen in fashion, film, art, and architecture. The very appearance of the city changed as some of the city's preeminent modernist architects used the latest developments in engineering and technology to forge curved and circular buildings that were termed futuristic. John Lautner completed the Malin residence, called the Chemosphere, a hexagonal, glass-sided residence mounted on a pole in the Hollywood Hills overlooking the Cahuenga Pass. The Los Angeles International Airport gained a circular glass restaurant suspended between a pair of linked arches, a collaborative effort by four of the city's top architects: William Pereira, Charles Luckman, Welton Becket, and Paul Williams. A serpentine clover leaf of smooth pavement opened to connect the Santa Monica and San Diego freeways.

Critic Jules Langsner had been thinking about such an aesthetic shift when he mounted Four Abstract Classicists in 1959 at the L.A. County Museum of History, Science, and Art. He coined the term "hard-edge" for painters John McLaughlin, Frederick Hammersley,

Billy Al Bengston,
Los Angeles, 1971

Photograph by Patricia
Faure, © The Estate of
Patricia Faure

Lorser Feitelson, and Karl Benjamin, who painted with a notable absence of emotional brushwork. Indebted variously to Piet Mondrian, Kazimir Malevich, and Zen Buddhism, the older hard-edge painters were not exactly a movement, but their uncluttered, geometric abstractions underscored the tectonic shift away from what the younger artists called "messy painting." As with so many things at Ferus, the shift began with Billy Al Bengston, whose dynamic personality and protean talent led the other artists to see him as their leader.

Bengston was born in 1934 in Dodge City, Kansas, where his father, a tailor, owned a dry-cleaning establishment, and passed on to his son an early interest in sartorial matters. In high school, Bengston wore such brightly colored clothes that he earned the nickname "Rainbow." His mother was too talented and too ambitious for Dodge City. A trained opera singer, she taught music in the local high school,

but every other year she took courses toward a master's degree at the University of Southern California. As a result, Bengston's primary education seesawed between Dodge City and Los Angeles until the tenth grade, when the family stayed in California for three consecutive years so that he could graduate from Manual Arts High School, a technical school with a fine-arts program that boasted as alumni Robert Motherwell, Philip Guston, and Jackson Pollock.

With blue eyes, sun-streaked brown hair, and a mustache, Bengston was equally gifted as a craftsman and an athlete. He received a gymnastics scholarship to USC but spent most of his time surfing. Dropped from the scholarship, he enrolled at L.A. City College, where he studied ceramics with Bernard Kester yet continued to spend so much time surfing that he wound up with a job as a beach attendant. He then transferred to California College of Arts and Crafts in Oakland where he furthered his study of ceramics for a year.

Bengston claimed that he took enough peyote to fool the draft board into giving him a 4-F classification. In 1956, he enrolled at the L.A. County Art Institute to study with Bay Area transplant Peter Voulkos, who had transformed the crafts orientation of ceramics by building massive fired-clay sculptures. Throwing out notions of utility, Voulkos and his followers highjacked craft materials and techniques in the service of their art.

Within six months, the school administration had threatened Bengston with expulsion for refusing to follow the curriculum. Voulkos interceded and the rebellious twenty-two-year-old settled down to master the difficult medium. "I decided I would be an artist. I think the only contribution I ever made was that I realized that ceramics was art," he said.[22]

Voulkos, in his midthirties, had modeled his hard-drinking, tough-guy behavior after the New York School abstract painters, and he modeled his art after theirs as well. Peter Plagens, author of *Sunshine Muse: Art on the West Coast, 1945–1970*, wrote, "In four years, Voulkos and his students managed the redoubtable feat of removing the craft of ceramics to the province of sculpture by overcoming a dependence on the potter's wheel, by slab-building, denting, cracking, and only partially glazing—in short, by creating a Southern California Abstract Expressionist ceramics."[23] Voulkos threw gestural rather than func-

Peter Voulkos
Photograph courtesy of Frank Lloyd Gallery, Santa Monica

tional works in clay, making art, not craft. He worked big and fast, qualities that were anathema to many in the craft-oriented ceramics community. With his student John Mason, Voulkos rented a studio in Highland Park and built one of the largest walk-in kilns in the country to pursue clay sculpture of architectural proportions. The stocky and quietly dedicated Mason would exhibit four times at Ferus, once covering the entire wall with his blue-glazed ceramic art. Collector and actor Sterling Holloway commissioned from him a pair of doors inset with rough ceramic squares resembling natural rock.

"I loved being with Voulkos," Bengston said. "I learned so much . . . like how to handle your actual physicality. The strength, the tenacity. Ceramics are wonderful in that you have to comply with the medium."[24]

Bengston was working as a beach attendant at Doheny State Beach when he befriended fellow surfer and aspiring artist Ken Price. Fine-boned and wiry, with an easy smile, Price was a natural on the

waves. Price had surfed almost daily for some fifteen years, more often during the two years that his family lived in a trailer on the beach while their house was being built on Chautauqua Boulevard in the Pacific Palisades. Price's father, an inventor, had come up with the Popsicle and other innovations for the Good Humor Ice Cream Company. His mother was a homemaker. "One of the great parts of growing up there was the opportunity to experience nature in a relaxed aimless kind of way, just walking down a stream or onto the beach or into the mountains, as long as I was home by dinner," he said.[25]

Price, born in 1935 in Los Angeles, was a year younger than Bengston, and his new friend inspired him with his commitment. "He was the only person I had met at the time who was serious about being an artist," Price said about Bengston.[26] "I was confused about a lot of things at that time, but not about being an artist. I knew that's what I had to be."[27]

While at University High in the Palisades, Price received a scholarship to attend Chouinard Art Institute for summer school, where he took a cartooning class with a teacher named, appropriately enough, Tee Hee. After working with clay in a class at Santa Monica College in 1953, he returned to Chouinard but found the ceramics department there to be "crafts-dogma hell, with lots of rules about 'form following function,' 'truth to materials,' 'life and lift,' and dripping teapot spouts. In those days clay as an art medium was dead and buried."[28] He found a similar atmosphere at USC, from which he graduated in 1956, but not without offending F. Carlton Ball, "another guy from craft hell."[29]

Price broke all the rules for his USC graduate presentation. "I had representational decor on everything, including plates with reclining nudes of Bengston and Voulkos."[30] They were on view in a glass case next to the art and architecture library. "There was a big stink about it. These were cartoons! I found some leaves to paste over the genital areas and the reaction was even worse."[31] Ball tried to evict Price from the education department, where he was getting a minor so that his parents would pay his tuition. "I was saved by the dean . . . who liked my work."[32]

Price enrolled in the graduate program at L.A. County Art Institute to study with Voulkos. "He worked better and faster than any-

thing we had expected. He worked in large scale with ease. He opened the whole thing up for us. . . . Voulkos is the man who liberated clay from the crafts hierarchy in America."³³

Bengston and Price spent entire days and nights at the "pot shop," unless they could surf. "If it was a hot day and there was enough money for gas, we were at the 'bu,' Malibu," Bengston said. "I was driving a 1937 Pontiac Phaeton with a blown clutch and no starter. I couldn't afford a battery so I parked on a hill. It didn't have a top. The upholstery was tuck and torn. But it was wheels."³⁴

Though Bengston was praised for his ceramics, he switched suddenly to painting. "Voulkos, who I beyond admired, was always trying to be Picasso and I figured if Picasso was a painter first, you might as well try and get into that field," Bengston said.³⁵ But he refused to follow the traditional methods of instructor Herbert Jepson, a painter of such repute that he had helmed his own school, Jepson Art Institute, from 1947 to 1953. "I didn't graduate," Bengston said. "I was finished. I was thrown out of every [art] school I ever went to."³⁶

The director of L.A. County Arts Institute, artist Millard Sheets, expected his students to work as his apprentices by applying tiny pieces of glass tile to the mosaic murals that he designed for the facades of Home Savings and Loan buildings. Price thought this was ludicrous and left the school. After spending six months in the army reserves, he transferred to the New York State College of Ceramics at Alfred University to develop low-fire brightly colored glazes. He graduated with a master's degree in 1958.

Voulkos's strong personality clashed with the director, and Sheets fired him shortly before an exhibition of his work opened at the Pasadena Art Museum in January 1959. Sheets looked rather foolish after his talented instructor moved back to the Bay Area and was promptly hired by the University of California–Berkeley and given a solo show at the Museum of Modern Art in 1960.

Bengston continued painting in a West Hollywood studio he shared with Robert Irwin and Dane Dixon, who happened to tend bar at Barney's Beanery. (Dixon later moved to New York to work for Willem de Kooning.) That year, Bengston and Irwin traveled around Great Britain, Denmark, Germany, Italy, and France for six months in an MGB that Irwin bought while there. Both had been to Europe

before and neither felt compelled to visit museums. "I only liked a couple things, Vermeer, Tintoretto portraits," Bengston said.[37] Irwin felt the same about art museums. "After a while my whole relationship to the history of art got cleared out to a matter of trusting my own eye. . . . I realized I was in the twentieth century, and I wasn't at all interested in historical forms," Irwin said.[38]

After returning from Europe, broke, Bengston paid ten dollars a month for a spare room in Walter and Shirley Hopps's West Hollywood apartment, where he completed his 1960 show of Valentine and Dracula motifs, renditions of hearts or irises located in the center of each composition. Disturbed by what he felt was a pomposity in abstract artist Lorser Feitelson's television lectures on Renaissance painting, Bengston decided to simplify his compositions by incorporating the main principle of ceramics. "European allegorical painting just doesn't do it for me at all, it's like commercial art," he said. "They're selling Jesus in the top left and Moses in the bottom right and who cares? . . . What I do know is that you center it, it's fine. So I started doing central image paintings. Anytime somebody says you can't do something is the time to do it. . . . You just have to do things with authority."[39]

According to Bengston, Hopps spent very little time in the apartment. "The bill collectors were always coming so he attached a rope to my balcony," Bengston recalled. "The bill collector would be in front trying to catch him and he would go out the back down the rope. He was great. One of his cronies went off somewhere and left him a macaw. He gave it to me and it ate all the woodwork off the room in the apartment."[40]

Bengston, who could live on thirty dollars a week, learned that he could make forty dollars for winning a motorcycle race. He drove his BSA Gold Star at record speeds around the track at Ascot Park, a snooty moniker hardly in keeping with its location at 178th Street and Vermont Avenue. "It was a nasty scene," Bengston said. "It was a half-mile track with a barrier around it that was as hard if not harder than concrete. There was no soft landing. Brakes were nonexistent. You just went to the corner and turned left, again and again. You'd run into each other. It was a nice aggressive thing. Coming from fields

that were subjective about the aesthetics, gymnastics or surfing . . . I wanted to do something where I knew what the result was. At the end of the day, if you won, you won."[41]

He combined his two passions in paintings of the BSA logo or of motorcycles in the center of orange backgrounds. The announcement of his November 1961 show featured an oval frame around a photograph of him jumping his motorcycle though the air. His own motorcycle was placed in the gallery. The prices of the paintings were low, yet almost nothing sold. Nonetheless, the art school rebel was hired shortly thereafter as a teacher at Chouinard.

The early sixties were peak years for Kustom Kars, the elaborately airbrushed and altered creations by Ed "Big Daddy" Roth, George Barris, and Kenny "Von Dutch" Howard that inspired Tom Wolfe to observe, "These customized cars are art objects, at least if you use the standards applied in a civilized society."[42]

Bengston had been working in a motorcycle shop and learned about customizing motorcycles and specifically Von Dutch's method of using an airbrush to spray clean or soft lines of intense lacquer colors. With enviable skill, Bengston took an airbrush to the tank of his own motorcycle. He then turned this technology to his art, abandoning the signature tool of expressionist painting, the paintbrush, to use a spray gun and compressor on Masonite. He was flying home from seeing Jasper Johns's work in the Venice Biennale with Irwin, who was talking philosophically about one thing after another, when he got the idea for his breakthrough series: chevron stripes. He would stack sergeant's stripes in the center of radiant fields of airbrushed enamel paint sprayed onto Masonite panels.

After Price returned to Los Angeles from New York, he reconnected with Bengston. He had learned to use an airbrush while in the service and he, too, started using it, spraying high-gloss enamel on egg-shaped ceramics with odd, erotic extrusions in unnaturally, brilliant colors. For his first show, at Ferus in October 1961, the gallery announcement featured a photograph of him surfing an open wave with his hands spread wide over his head. Price recalled, "That was my idea but everybody thought it was weird. . . . It was as if they

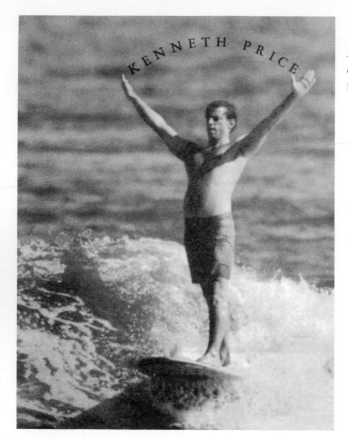

*Ken Price surfing
announcement*
Photograph by Pat Beer

thought maybe the work wasn't serious because the poster was kidding around."[43] The following year, he continued his study of ceramics in Japan. When he returned, he lived in the beach town of Ventura.

Bengston and Price, with their tough yet lovely shows, signaled a shift at Ferus—the beginning of comfort with an aesthetic that was informed by technological innovation as well as popular culture. Irving Blum marketed these artists as unapologetically free from the sober introspection associated with the Abstract Expressionists. They were having fun and Blum was promoting it with the same vigor of record promoters hawking the sounds of the Beach Boys. It didn't hurt that "Surfin' USA" could be heard streaming out of cars and transistor radios throughout the country.

Hopps brought the prominent New York dealer Martha Jackson

to Bengston's studio, and she immediately offered to show the chevrons. Thinking the New York reviews would be murderous, Bengston balked but Hopps pushed. The deal was sealed when Jackson offered Bengston $1,000 a week to finish the work for the show. "And that was an enormous amount of money then," he recalled.[44]

At his May 1, 1962, opening in New York, Bengston met Frank Stella and Andy Warhol, both of whom applauded the radiant, brightly colored ovals containing the symbolic stripes in the center. Warhol was doubly thrilled when actor Roddy McDowall made an appearance at the opening, prompted by a mutual friendship with Dennis Hopper. Sculptor John Chamberlain befriended Bengston and, shortly after, moved to a neighboring studio in Ocean Park where Bengston introduced him to the airbrush technique.

Craig Kauffman and his wife Vivian were moving back from Europe, and they stopped in New York. Kauffman saw the new spray-painted works of his old friend at the Martha Jackson Gallery. They looked so fresh, so free of any European influence, that Kauffman said to himself, "That is what I need to be doing."[45]

With his fine, sandy hair, chinos, and polo shirts, Kauffman looked more conservative than his friends, but even the competitive Bengston saw him as a great talent. Initially interested in architecture, he had shown his early Paul Klee–inspired paintings at the Felix Landau Gallery while just a freshman at the University of Southern California where he met future architect Frank Gehry. Encouraged by the response to the Felix Landau show, Kauffman transferred to UCLA, where he got a degree in fine arts in 1956. He found inspiration in the American Vanguard Art exhibition in Paris featuring work by Pollock and De Kooning that came to the L.A. County Museum of History, Science, and Art in Exposition Park. "I was bowled over by that show. At first I didn't like the stuff. I thought it was awful. Then I went back and the second day and third day."[46] Like Moses and Altoon, he moved to New York for a few months, where he befriended abstract painter Franz Kline. Also, like the others, he missed the West Coast and soon moved to San Francisco where Hopps's friend James Newman introduced him to Vivian Chinn, a slender young acting student of Chinese and British extraction with long black hair. They eventually married.

It was Kauffman's second marriage, and their 1960 wedding was emblematic of the dawning informality of the era. Newman, their best man, was supposed to drive them to Reno, but his car broke down twenty miles outside the city limits. The trio then hitchhiked into town to spend the night. The next morning, after a justice of the peace performed the ceremony, Newman announced that he had to get back to San Francisco right away. He decided to gamble their remaining cash to win enough money to buy plane tickets. He lost. They had to hitchhike to Sacramento where they had just enough money left to buy bus tickets back to San Francisco.

A few months after this rather inauspicious start, the Kauffmans moved to Europe where, over the course of two years, they lived in Paris, Copenhagen, and Ibiza, Spain, looking at art and developing relationships with other artists. Kauffman was the most cosmopolitan of the Ferus group yet when he saw Bengston's paintings in New York in 1962, he recognized the significance of shiny lacquer on a hard surface. He shared a studio with Ed Moses and Robert Irwin on Santa Monica Boulevard near Sawtelle Avenue and began drawings of voluptuous forms on the pages of a Frederick's of Hollywood catalog. "A lot of those early catalogs were terrific," he said. "They had blow-up bras and images of girls blowing up their boobs and giant padded butts."[47] He transferred those figures with other images to flat sheets of plastic.

Under Bengston's tutelage and inspired by Duchamp's *Large Glass*, Kauffman began spraying paint on glass and then on plastic panels. One morning he stopped in Jan's coffee shop on Beverly Boulevard to get a cup of coffee and noticed a sign shaped like molded plastic fruit and started wondering about how it was made. He drove over to a small industrial plant in the suburb of Paramount called Planet Plastics, where he learned about molds and vacuum-form machinery. In 1964, he amplified and simplified shapes into low-relief wall pieces he called "erotic thermometers." He sprayed the reverse side of the clear plastic with acrylic paint in the intense colors of Jell-O. Kauffman realized the significance of this discovery and took out an advertisement in a 1964 issue of *Art International* with a photograph of his first molded plastic wall relief to officially document his formal ingenuity. His name became associated with vacuum-formed plastic

as surely as Dan Flavin's was connected to the fluorescent tube. The following year, his work was shown at Ferus and, in 1965, at Pace Gallery in New York.

Bengston, Kauffman, and Moses, who had moved back to Los Angeles, befriended Robert Irwin, who was tall and lean, had short-cropped blond hair and blue eyes, and drove an Austin-Healey. Ruscha described him as a "Herculean Californian: sunshine, energy, surfing. He had a definite aura." His paintings of sailboats were being shown at the Felix Landau Gallery when his new friends from Ferus walked across the street to his opening. Kauffman took one look around and in his strange, squeaky voice, drawled, "You've got to be kidding!"[48]

With that, Irwin saw all the weaknesses of his work and decided then and there to change. He recognized that the younger artists from across the street were onto something, and his art evolved quickly and dramatically. "My friendship with them was crucial in the sense that there was nobody really around who was interested in what we did. . . . We had no proof but we believed that we were special, that we were doing it. We basically supported ourselves in that relationship and gave ourselves the kind of milieu that allows you to operate as a free-flowing person without doubting yourself."[49]

Irwin's family had moved to the working-class neighborhood of Leimert Park in Los Angeles during the Depression after his father lost his Colorado construction business. From the age of seven, Irwin made money by selling *Liberty* magazine and working in movie theaters, coffee shops, and as a lifeguard at Lake Arrowhead or Catalina Island. Like Bengston, he was athletic. He taught himself to dance the Lindy and earned more than $100 a week from dance contests held at the Jungle Club in Inglewood or the Dollhouse in the San Fernando Valley, making quite an impression when arriving in the '39 Ford that he had personally perfected with twenty coats of ruby-maroon paint applied to the dash. At Dorsey High School in the 1940s, Irwin succeeded at football and art classes but flunked his only two requirements: algebra and Latin. At nearby Hollywood Park, he learned to bet on horse races and within a few years, he supported himself as a handicapper.

In 1946, Irwin joined the army and was posted in Germany.

When he returned to Los Angeles the following year, he enrolled at L.A. County Art Institute a decade ahead of Bengston and Price. A naturally gifted draftsman, he had vague notions of becoming an artist, but he didn't feel he was learning much there. In 1950, during the Korean War, he was recalled into the army and served his time at Camp Roberts in central California. After his discharge, he enrolled at the Jepson Art Institute, where he studied with the charismatic Rico Lebrun, who worked in a popular Cubist-Surrealist style. After three months of lectures on philosophy and Marxism, Irwin left to attend Chouinard. "By the time I got out of art school, having gone to three places, I was still very naïve."[50]

Artists sharpen their skills on the whetstones of their colleagues. Irwin hit his stride when he started to compete with younger painters such as Kauffman and Bengston. At one point, Irwin and Kauffman shared a studio. Irwin recalled, "My painting was full of sound and fury. Craig had a little porcelain dish with a little red and blue. He wore a smock! He would make a mark and then go to the opposite side of the room and sit there. I thought, 'What's happening here?' I got the lesson. It's about paying attention."[51]

The Ferus artists' clubhouse was Barney's Beanery, several blocks north of the gallery on Holloway Drive. Similar to the Cedar Street Tavern near the artists' studios in New York, Barney's was inexpensive, worn down, and hospitable. Onetime boxing manager Barney Anthony opened the white and green clapboard structure in 1927 to serve motorists arriving on what was then Route 66. Barney's sister turned out chili burgers and onion soup in the tiny kitchen, but after Prohibition ended in 1933, the main business was drinking. It was a hangout for Errol Flynn, Clark Gable, and Bette Davis. When Barney opened the so-called Crown Room in 1960, it was rumored that Princess Margaret donated a portrait of herself to add to the decor.

After openings at Ferus or at lunch or virtually any other time that a quorum could be mustered, Kienholz, Irwin, Altoon, Moses, Kauffman, Price, and Bengston would sit in one or more booths and talk about cars or girls. Since no one was making much money selling art, almost everyone had a part-time job. If someone was down on his luck, Barney would extend a line of credit of up to twenty dollars. At times, artist-cum-bartender Dane Dixon would slip his

friends an extra drink. In this dimly lit joint, with a sign on the wall announcing "No Fagots [sic] Allowed" and a calendar that was many years out of date, these artists honed their individual ideas while supporting one another. There were ongoing antics.

Each artist took turns holding court. Kienholz told Ed Moses that he had bought a suit in a thrift store for two dollars and, with Dixon, gone into various Cadillac dealerships pretending to be a promising customer. "Ed would intimidate them into taking a car for a test drive. As soon as he got around the corner, Dane was waiting for him and they'd steal the rear tire, the mats—anything they could get—and then he'd take it back."[52]

"At Barney's, everyone would stand around and drink and tell lies," remembered Moses. "[They would] try to pick up on the girls that were there."[53] Moses went to Barney's on his first date with an attractive brunette from Virginia, an aspiring writer named Avilda Peters. When he brought her home, she said, "I want you to do me a favor. Never call me again."[54] A few months later, they were married and moved back to New York, then to San Francisco, and then to Spain with their little boy.

"We had good disagreements of ideas," Kienholz said, about the group at Barney's.[55] As Ferus gained popularity, other galleries opened on North La Cienega, which gave rise to Monday night art walks when all the galleries would stay open late and serve wine. On one such occasion, Ferus was between shows and therefore empty. Kienholz suggested to Blum that he put up a selection of work, but Blum was racing off to San Francisco and didn't have time. "We were sitting in Barney's, and we were about half-drunk," Kienholz recalled. "Craig Kauffman and I and maybe Allen Lynch and Dane sat there grumbling about, you know, 'Fuck Irving, goddamn him.' "[56] They went out to the parking lot and found a pile of weathered boards with nails sticking out of them and some old service station pumps. They gathered them together with whatever else was around and stacked them in the gallery. "We sat there, and all the people came by and said, 'Oh, my, isn't this interesting.' We just left it there, and when Irving came back, there was his gallery full of junk . . . and he was not too pleased."[57]

"We didn't talk the art out," Kienholz added. "If we sat around in

the Beanery, we talked about who was a good fuck and where we were going to get six dollars so we could buy gas for a car to go to the Valley and get drunk. . . . I don't know that I've ever talked to Bob Irwin about art in my life. I can remember sitting in his studio for half a day, down at the beach, watching him paint brushstrokes all in one direction so if you stood in one place, you saw the reflection of light on the actual stroke, and if you stood in another place, the whole surface was an entirely different color because you saw it differently."[58]

Art may not have been the primary discourse at Barney's, but the camaraderie helped the artists move decisively away from what Kauffman called "messy fifties painting." Young and reckless, having been to New York and Europe, they decided collectively and individually to break away from prevailing views and practices of mainstream art and criticism. They chose to live in Los Angeles instead of New York precisely because there was a dearth of critical discourse and gallery infrastructure. As a group, they reveled in being pugnacious and anti-intellectual. Unlike the Abstract Expressionist painters who had been their heroes, they took a stand for optimism, humor, and pleasure. Though most came from quite modest backgrounds, they refused to adopt the sorrowful introspection and angst of the New York School artists. As Irwin said of his own upbringing, "We didn't have nothing to do with all of that—no dark side, none of that struggle—everything was just a flow."[59]

This outlook got Irwin into an argument with an *Artforum* critic from New York about the value of the automobile as an aesthetic influence. The early 1960s was the apotheosis of reverence toward the automobile in Los Angeles; the new Corvette convertible had a role as memorable as any of the stars of the TV series *77 Sunset Strip*. Irwin took the critic out to the San Fernando Valley to introduce him to a kid who was working on a 1929 roadster. "Here was a fifteen-year-old kid who wouldn't know art from schmart, but you couldn't talk about a more real aesthetic activity than what he was doing. . . . The critic simply denied it."[60] Irwin tried to explain, but the critic refused to acknowledge the possibility that such activity could be considered a form of art. Finally, an angry Irwin pulled his car over.

"I just flat left him there by the road, man, and just drove off. Said, 'See you later, Max.' And that was basically the last conversation we two ever had."[61]

Curiosity about contemporary art escalated in the well-to-do neighborhoods of West Los Angeles. In response, Walter and Shirley Hopps teamed up with bespectacled young art historian Henry Hopkins to give slide lectures on modern art in private residences around Beverly Hills, most often in the home of Frederick and Marcia Weisman. Aspiring collectors Donald and Lynn Factor, Leonard and Betty Asher, Stanley and Betty Freeman, Stanley and Elyse Grinstein, Monte and Betty Factor, and others were sufficiently impressed by these talks to drop by Ferus on a regular basis and, eventually, to buy some of this challenging new art. Don Factor, film producer and heir to the Max Factor cosmetics fortune, even began to share his insights by writing reviews for *Artforum*.[62]

Shirley recalled, "I did much more teaching than Walter did. But his lectures were memorable. He was showing a Barnett Newman slide and Fred Weisman said, "You got me there, kid," and walked out of the room. This stuff was Latin to these people. They were interested but it was all uphill."[63]

The Weismans were primed to collect art. Marcia Weisman's brother, Norton Simon, had amassed a stunning collection of Impressionist and Postimpressionist art as well as Old Masters. Frederick Weisman was an executive at his brother-in-law's Hunt Foods before establishing Mid-Atlantic Toyota Distributors. Within a few years, the Weismans became great collectors of modern and contemporary art. In fact, their purchase of Newman's *Onement VI*, a blue vertical canvas with a central green stripe, was considered sufficiently impressive to warrant a full-page color reproduction in *Artforum* in 1962.

As these collectors expected a certain amount of courting and convincing, Blum's role in running the gallery expanded. "Walter was enormously sympathetic and enormously farseeing," Blum said. "He was completely intuitive about the significance of works of art—I've never heard the equal of it when he got wound up. . . . At the same time, he had these lapses. We'd be having a discussion, Walter would

get a little heated, he'd say he needed a cup of coffee, he'd walk out of the gallery, and I'd see him ten days later. This happened fairly frequently."[64]

Hopps was notorious for his disappearing act. His wife recalled, "Walter had no sense of time. He disappeared in town and I think he usually went to stay with an artist. Walter had the mentality of an artist. There is no more difficult life, nor are there people who have a harder time living within a regular social scheme. I think Walter had a lot of that inability and unwillingness to cope with the real world, and he found solace with artists. He's always had people who will look after him, no matter what. All of us have a certain amount of time we can do it, and then we can't do it anymore."[65]

Blum, the dutiful Jewish son, was driven; Hopps, the son of WASP privilege, was elusive. By 1962, Blum recognized that Hopps could not run an art gallery. "Walter had extraordinary insight into art. A major flaw . . . was that he could see every side of every given situation. So much so that he would freeze and be unable to go in any direction. You'd give him a letter to mail and he'd look at it and understand the ramifications of not mailing and, as often as not, you'd find it upstairs under his mattress, which was his way of solving that problem."[66]

Blum was not exaggerating. Kauffman said that Hopps had worked with him to produce a small catalog for his Ferus show. After days spent painstakingly printing and binding the edition, Kauffman addressed a hundred envelopes by hand and gave the packages to Hopps to mail. After such an effort, he was surprised that many of his intended recipients had not come to his opening. Months later, he found the entire box of catalogs, ready to be mailed, under Hopps's bed.[67]

"Happily . . . [Hopps] was offered a job as curator at the Pasadena Art Museum," said Blum. "I doubt that I could have gone on any further with him, and I took over the gallery then."[68] Hopps was working on the Duchamp retrospective for the Pasadena Art Museum when, in 1962, he was hired as curator at a salary of $6,000 a year. After a few months, director Thomas Leavitt, who had hired him, decamped to become director of the Santa Barbara Museum of Art. At thirty-one, Hopps was promoted to acting director and then director.

The youngest director of an art museum in the country, the square-jawed Hopps was nothing if not ambitious for the tiny institution when he told the *Los Angeles Times* about his plans for a new pre-Columbian art council and a coming survey of American portraiture from colonial to present times. When Hopps left Ferus, he gave his shares to Shirley so there would be no appearance of conflict of interest.

After Hopps's departure, Blum proceeded to run Ferus like a business so the artists would be paid for their efforts, but it was unrequited love. The artists never reciprocated with the blind affection they had always given to Hopps. More than most people, the artists sympathized with the irresponsible genius who was on their side no matter what. Few others had Hopps's devotion to art. For instance, in 1962 Kienholz completed an assemblage sculpture called *The Illegal Operation*, portraying the filthy conditions of a backroom abortion, a piece so disturbing that he was contemplating how to destroy it. Hearing of his intention, Hopps stole the piece from the gallery storeroom and transported it in the trunk of his Buick to an unknown location, where it remained for six months. When Kienholz confronted him, Hopps said, "You were going to destroy it anyway. What are you going to do? You going to put me in jail?"[69] Fifteen years later, Kienholz was grateful for the intervention. "If I ever made a piece of art, *The Illegal Operation* would be it. It contains the kind of fury that is felt."[70] By that time, it had been sold to ardent Kienholz collectors Monte and Betty Factor.

After the Factors bought a Spanish Colonial Revival home in Santa Monica that had belonged to drama critic Kenneth Tynan, the piece went on view in their living room with other works by Kienholz. (In 2008, the L.A. County Museum of Art purchased it from the Factor Collection for reportedly $1 million.) The Factors owned an eponymous men's clothing store in Beverly Hills designed by Alvin Lustig and regularly traded clothing to the artists in exchange for works of art. Monte Factor paid Ed Ruscha to design his logo. Factor said, "The artists gave us more than we could ever give them."[71]

Okies: Ed Ruscha, Mason Williams, Joe Goode, and Jerry McMillan

On a sweltering summer day in 1956, Ed Ruscha and his best friend, Mason Williams, waited impatiently to set out for Los Angeles. The two had grown up in the same Oklahoma City neighborhood, had attended the same classes, had double-dated to the high school prom, and had even collaborated on an episodic painted mural about the Oklahoma Land Run. Ruscha looked to be on the cusp of manhood, his face defined by high cheekbones, brown hair, and almond-shaped eyes. Williams, squarely built with dark hair, an upturned nose, and a dimpled chin, retained a boyish appearance. Both were blessed with charming Oklahoma accents, a honeyed meld of southern and western tones. Fittingly, they headed off to college together. Ruscha, nineteen, packed his black 1950 Ford with trunks of clothes, school supplies, and sandwiches made by his mother. The car tended to burn oil so Ruscha

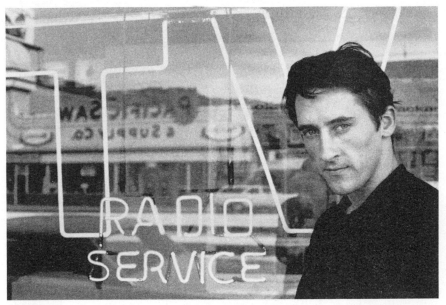

Ed Ruscha
Photograph by Dennis Hopper, © The Dennis Hopper Trust,
courtesy of The Dennis Hopper Trust

had a case on hand and, indeed, the car went through thirteen quarts making the 1,250-mile journey west along Route 66. For them, the fact that they were going to college paled in importance beside the fact that they were getting out of Oklahoma City.

Edward Joseph Ruscha IV was born in Omaha, Nebraska, in 1937 and was five years old when his parents moved to Oklahoma City. His father was transferred to Oklahoma to work as an auditor for the Hartford Insurance Company, and he remained for the next twenty-five years. A survivor of the Depression, Ruscha's father had a singular piece of advice for his son: "Always pay cash."[1] He had paid $7,000 cash for their 1920 brick house on Northwest Seventeenth Street in 1942.

Ruscha's father remained a devout Catholic despite having been excommunicated in 1922 after divorcing his first wife. For many years, Ruscha and his siblings were not told that they had a step-sister, the daughter of that first marriage. "It weighed heavily upon him," Ruscha recalled. Ruscha's repentant father attended mass daily, taking his eldest son with him on Sundays, despite the fact that he was

prohibited from taking communion or kneeling during the service. Ruscha's mother, also Catholic, attended church only on occasional Sundays or holidays, and instead of kneeling, she sat with her husband as a show of loyalty. While Ruscha studied catechism, he could not be an altar boy like his neighbor Joe Goode.

While his father traveled for business, Ruscha grew close to his mother, who was gifted with both a sense of humor and of propriety. Her two sons and daughter sent thank-you notes promptly and addressed their elders as "sir" or "ma'am." A dedicated reader and correspondent, she kept an open dictionary in the dining room and encouraged her children to look up word definitions.

According to Ruscha, his mother's literary sympathies extended to the creative efforts of Williams, who called her "a godsend."[2] Williams had spent his earliest years in Rule, Texas, where his family had lived a hardscrabble existence in a shotgun house with no indoor plumbing. "We were like a Walker Evans photograph," he said later.[3] Williams's father, a tile setter, made a better living after bringing the family to Oklahoma City, but young Williams spent most of his free time at Ruscha's house. "[My mother] hit it off with Mason, who was always spouting poetry and silly stuff," Ruscha said. "She encouraged him, almost like a second mother. He'd come over and play guitar, folk songs, or country and western."[4]

The Ruschas were the last on their street to get a television; such an indulgence was thought to be a bit "show-offy" so the family listened to radio drama, and Ruscha came to value not just the meanings but the sounds of words.

As teenagers, he and Williams discovered a store in town that carried 45 rpm records by rhythm and blues musicians, what Oklahomans called "race music." Ruscha's first purchase was the Clovers single "One Mint Julep" with "Lovey Dovey" on the B side. The slow, rocking rhythm and suggestive lyrics promised darkened rooms, close dancing, romance, and mystery. He bought recordings of Stan Kenton, Count Basie, and Billy Eckstine and missed few concerts at the Municipal Auditorium. In 1949, Spike Jones and the City Slickers found Ruscha hanging around the back of the auditorium trying to sneak in. They gave him some money and told him to go buy some eggs. Thrilled by this brush with celebrity, Ruscha did what he was

told. When he returned, they invited him backstage where he watched these grown men throw eggs at one another in front of a live audience. The wild array of instruments they played, the jokes, the nutty clothing—Ruscha knew he was witness to denizens of an exotic netherworld. "Music played such an important role in my development as a kid," he said. "Enough to visualize how big the world was."[5]

Ruscha became friends with Jerry McMillan and Joe Goode when all three joined a Classen High School fraternity that held events with a sorority. Dating was fine, but Ruscha was wary of marriage. "In those years people were trying to emulate their parents. Marrying and settling down was an issue to be approached. It all crashed when the book *On the Road* came out and we started reading beatnik poetry and took an about-face to that old order of thinking."[6]

Ruscha, McMillan, and Goode ruled in the art classes, whether drawing still lifes or designing record album covers. Ruscha found a book about Marcel Duchamp in the library, and art and absurdity became entwined in his thinking. He thought about the Dadaists as Goode and McMillan "were cutting up . . . making these stupid sculptures and lighting them on fire," Ruscha said. "It all linked with the idea of having madcap fun."[7]

By his own account, Ruscha was a mediocre student, receiving Cs in most classes, and occasionally Ds. "I got a B in history class and I was stunned," he said.[8] In art, however, he got all As. "I was aimless. I didn't know what I wanted to do until the eleventh grade."[9] Just before graduating from high school in 1956, he was awarded first prize in graphic design from the Oklahoma City Chamber of Commerce. At that point, he decided to go to art school.

To avoid being drafted for service in the Korean War, Ruscha joined the navy. After boot camp at the Great Lakes Recruit Training Command near Chicago, he had to commit to two weeks a year on a destroyer, but at least he would be able to attend art school and get out of Oklahoma City. "I knew I couldn't hack the Bible Belt. . . . And the East, that was just too old world for me," he said with a shrug.[10]

An earlier family vacation to Los Angeles had made a great impact. "The patterns of vegetation, the feeling of acceleration, the corner of Sunset and Vine"—all were potent memories. "Another attraction was the hot rods, the custom cars. I knew I wanted to go

to California. That was the only place."[11] Ruscha's father tried in vain to direct him toward a more dependable profession. "He thought [art] was too ivory tower," Ruscha said.[12] So they compromised: Ruscha would study commercial art in order to pursue a career in advertising.

Ruscha had not contacted any schools before making the trip to Los Angeles. He had heard about Art Center in Pasadena, which had a successful commercial art program. When he went there to apply and found that the classes were full, he heaved a sigh of relief. "They had a dress code!" he said indignantly. "No facial hair. No affectations of Bohemianism, no berets, no sandals, no short pants. You couldn't be a beatnik."[13] So, Ruscha enrolled at Chouinard Art Institute near Lafayette Park on the eastern end of Wilshire Boulevard where "you didn't have to have a professional appearance."[14]

Nonetheless, Chouinard was a professional commercial art school. Founded by artist Nelbert Murphy Chouinard in 1921 in a modest building on Eighth Street, the school was considered a serious environment for art, even though it was not accredited. "The attitude was that a diploma did not matter. You were judged by the product you came up with," Ruscha said.[15] Walt Disney had asked Chouinard to train artists in the skills required to animate the films he was making. At the time, he could not afford to pay her tuition. She believed in what he was doing and told him to pay her when he was able. Animators were produced, films were made, and Disney later paid her the overdue tuition for every student. (In 1970, Disney facilitated the merger of the school with the L.A. Conservatory of Music to become what is now California Institute of the Arts in the suburb of Valencia.)

Ruscha and Williams rented a room in a nearby boardinghouse on Sunset Place. The August smog was so intense that they went to a drugstore for a salve for their burning eyes. "We'd never experienced air pollution before," Ruscha recalled.[16]

Their Chouinard instructors Bengston, Altoon, and Irwin were committed to careers as practicing artists despite the dearth of professional opportunities. Bengston once had his students stretch paper around the classroom and draw and paint on it collectively. At the end of the day, he told them, "Tear it down and throw it away." Ruscha said, "It was the idea of, 'Just get in and do the work.'"[17]

Williams had enrolled at L.A. Community College with the idea

of majoring in accounting but spent most of his time in jazz clubs and concerts. Deciding to pursue a career in music, he returned to Oklahoma City and took a crash course in piano with a teacher who told him that he would never become a great musician. With the burden of greatness lifted, Williams decided to have fun. In 1958, he bought his first guitar, an old Stella, for thirteen dollars. He began playing and singing with groups in coffeehouses and clubs and eventually got his songs recorded. He remained in touch with Ruscha from a distance until 1961 when, having joined the naval reserves, he was called to serve on the USS *Paul Revere* with the U.S. Navy in San Diego. Sailor by day, folksinger by night, he performed at clubs in San Diego with weekend stints at the Troubadour on Santa Monica Boulevard.

After just a few classes, Ruscha abandoned his pursuit of commercial art, drawn by what he called the "bohemian" fine-arts department. Like his teachers, Ruscha was painting in a gestural abstract style until he saw the cover of a 1958 *ARTNews* featuring Jasper Johns's *Target with Four Faces*. He also saw a photograph of Robert Rauschenberg's 1955 combine *Odalisk*.

"That just sent me," Ruscha said. "I knew from then on that I was going to be a fine artist. It was a voice from nowhere; it was the voice I needed I guess; I needed to hear this and see this work. And it came to me, oddly enough, through the medium of reproduction, and so it was a printed page I was responding to, and not the work itself. But the kind of odd vocabulary they used inspired me—it was like music that you've never heard before, so mysterious and sweet, and I just dreamed about it at night. . . . These new voices I was hearing transplanted the temporary excitement I had from Abstract Expressionism, which was the only thing at the time. . . . The work of Johns and Rauschenberg marked a departure in the sense that their work was premeditated, and Abstract Expressionism was not. So I began to move toward things that had more of a premeditation . . . having a notion of the end and not the means to the end. . . . It's the end product that I'm after."[18]

Ruscha started incorporating words into his paintings, an effect not appreciated by the Chouinard professors. One teacher was notorious for expressing his disapproval by taking out a cigarette lighter

and setting fire to students' work. Ruscha was out of town when this happened to his collage so his indignant friends stormed the dean's office to protest the vandalism. When Ruscha heard about it, he thought he must be onto something if it so upset the faculty.

During the summer recess, Ruscha returned reluctantly to Oklahoma City. The trip home reinforced his decision to leave. "[I was] so glad that I had gotten away from the Bible Belt and all those people. Because there was just no room for poetry. . . . An artist would starve to death there."[19] His ceaseless praise of L.A. weather, women, and cars—not to mention art school—convinced Jerry McMillan to follow him west. The following year, they convinced Joe Goode.

Goode described his father as a "wannabe artist" who worked as a display manager at a department store.[20] He taught Goode to draw by walking with him into the woods one day and spending an entire afternoon making a precise rendering of a fallen log. After his parents divorced, Goode and his father sat in front of the television together doing line drawings of Jack Benny. Goode thought his father was trapped by family ties and vowed to avoid such responsibilities. As a teenager, Goode lived with his mother, who had remarried, but he did not get along with his stepfather. He dropped out of high school and earned pocket money by playing cards and shuffleboard in bars. His gloomy future was changed by the return of his two friends from Los Angeles. "By then, I knew I wanted to study art and I thought, 'If I leave here, no matter where I go, at least I won't embarrass my mother by what I am doing, if I want to gamble or whatever.' As . . . it started snowing, I thought, 'I'm going to California.' "[21]

Goode had never flown before. As his Los Angeles–bound plane banked over the ocean before landing at LAX, he looked down at the vast grid of lights and thought, "Jesus, how am I ever going to find anybody?"[22]

McMillan and Ruscha were taking classes at Chouinard, but Goode had come to the big city with only sixty-five dollars. Slightly built, with blue eyes and a quick wit, Goode was hired to run a printing machine at a shop on Beverly Boulevard. "Two weeks go by and I'm due to get a check," Goode recalled. "This guy said, 'All right, just have a seat there.' He brings a check and sits next to me and puts his hand on my leg and starts rubbing. Oh man, I freaked. I never

*Joe Goode, Jerry McMillan, Ed Ruscha, and Patrick Blackwell
in their shared studio, 1959*

Photograph by Joe Goode, courtesy of Joe Goode

knew anyone who was gay. . . . I was twenty-one but mentally much younger."[23]

It was a startling introduction to the city. Goode enrolled at Chouinard in January 1960 and settled in with Ruscha, McMillan, Patrick Blackwell, and Don Moore (also from Oklahoma City), in a rented house at 1818 North New Hampshire Avenue in Hollywood. (Wally

Batterton, another student, had moved out.) They took their meals at Norm's restaurant (later the subject of Ruscha paintings) and had one extra room that they shared as a studio. Goode said, "Jerry had a wall, I had a wall, Ed had a wall, and Pat Blackwell had a wall. We could be in there at the same time."[24]

Goode had his first revelation about art in Robert Irwin's class that fall. "He's a very engaging talker. So when you are subjected to him as an authority figure and he is telling you in a million different ways you can do anything you want, that was the biggest influence," Goode said.[25]

Despite his determination to avoid responsibilities, just one year into his studies, Goode married ceramics student Judy Winans. A few months later, they had a baby daughter. To support his family, Goode worked three part-time jobs while taking classes. Exhausted from the effort of going to school and supporting his family, Goode had to drop out six months later. He threw himself into making art for himself. "When I came home from work, these milk bottles would be sitting out on the steps. That is how I got the idea of the milk bottles with a plane in front of them and a plane in back of them. A way of seeing through something."[26] This homey inspiration led him to create large monochrome canvases each with the outline of a single milk bottle at the base. Instead of hanging them, Goode leaned them against a wall with actual glass milk bottles, also painted, on the floor in front of them. Within a year, this work propelled Goode into the surging realm of Pop art at a time when no one really knew what it meant to be Pop.

Ruscha completed his studies at Chouinard in 1960. Despite his dedication to his own art, he supported himself doing layout and graphics for an advertising agency, Carson-Roberts, housed in a glass and steel modern structure in West Hollywood. He designed the original Baskin-Robbins illustration of the single scoop, double scoop, and triple scoop.

In 1961, he left to join his mother, Dorothy, and brother, Paul, on a spring tour of Europe. His father had died of a stroke, and his enterprising mother bought a Citroen in Paris. The three of them drove

through Spain, Italy, Greece, Yugoslavia, Austria, Germany, England, Scotland, Ireland, and France. After his family returned to Oklahoma, Ruscha stayed in Paris for two months. Visiting museums, he came to the same conclusion held by many of his Los Angeles peers. "I found that I had no scholarly interest in art whatsoever." he said.[27] Not the art produced before the twentieth century, at any rate. He was bowled over by his actual encounter with Rauschenberg's "combines," however—radical combinations of found objects, images, and painting, on display at the Iris Clert Gallery. And, not surprisingly, he loved the Parisian lifestyle. While there, he transformed foreign words into small oil paintings and took photographs of street signs, harbingers of the art that he would pursue.

On his return, Ruscha stopped in New York City and went to the Leo Castelli Gallery. Ivan Karp, then working for Castelli, took Ruscha into the back room to show him a painting of a tennis shoe by Roy Lichtenstein. "It was completely aggravating and inspirational," Ruscha recalled, realizing that someone else saw popular culture as a valid antidote to Abstract Expressionism.[28] He did not want to stay in New York, however. "I was overwhelmed by the number of people in New York and the impersonality of the place," he recalled. "I feared being chewed up by the whole machine."[29]

Back in Los Angeles, Ruscha made a radical leap by applying his graphic arts skills to a series of large paintings with product names such as "Fisk" in white letters with a white tire on a turquoise ground. Another large canvas has the word "Spam" occupying the top while a rendering of the tinned meat in its actual size—*Actual Size* is the title of the painting—hurtles across the canvas like a rocket with yellow flames trailing behind it. Ruscha said, "The word 'Spam' is similar to the sound of a bomb. So you have this noisy thing at the top and then this projectile flying after the noise, arcing across the sky like a shooting star."[30]

Ruscha's paintings were included in the first Pop art exhibition held in the United States: The New Painting of Common Objects at the Pasadena Art Museum from September 25 to October 19, 1962, just two months after the Ferus show of Warhol's soup-can paintings. Organized by Hopps who, with Blum, had visited the studios of the

Pop artists in New York, it included three works each by eight artists: Warhol, Lichtenstein, and Jim Dine from New York, and Ruscha, Goode, Phillip Hefferton, Robert Dowd, and Wayne Thiebaud, all from Northern or Southern California. Hopps considered this group to be "post-Rauschenberg, post-Johns" in their use of everyday objects and, like many others, he was trying to comprehend the significance of this increasingly widespread development. Instead of a catalog, he asked the artists to contribute line drawings that were mimeographed and put in an envelope as a portfolio.[31]

Hopps asked Ruscha to create the exhibition poster. Thinking it should have the same Pop appearance as the art, Ruscha telephoned a commercial printer who usually ran off announcements for boxing matches. He dictated his copy with only one directive: "Make it loud!" The black and red type on a bright yellow background was the ideal off-the-shelf look. John Coplans was visiting from San Francisco and Hopps said, "Come on, help me hang it—we have no staff." Coplans recalled, "There we were, the director and the critic, hanging the show I was writing about days later."[32]

On the West Coast, at least, the show was a sensation. Ruscha's painting of a smashed box of Sun-Maid raisins rendered in the top half of a canvas with the word "Vicksburg," site of a Civil War battle, covered in a yellow wash of paint on the bottom, sold for fifty dollars to C. Bagley and Virginia Wright, art collectors from Seattle, where Wright had just funded the building of Space Needle for the 1962 World's Fair. Amazed by this early endorsement of his talent, Ruscha said, "I just couldn't believe that I actually got money through this thing."[33]

The show was featured in *Artforum*, a magazine conceived that year in San Francisco with a focus on West Coast art. Goode's painting *Happy Birthday*, a purple monochrome canvas poised behind a glass milk bottle covered in orange paint, was on the cover of the distinctive ten-and-one-half-inch square magazine, a format conceived by a graphic design student in San Francisco.

Coplans, an English painter of geometric abstractions who was then teaching at the San Francisco Art Institute, had started contributing reviews to various magazines. He was instrumental in founding *Artforum* with Oakland printer John Irwin. Reviewing the show, he

complimented Goode on making "two of the loneliest paintings imaginable . . . powerful, deeply moving and mysterious paintings," and declared that Ruscha had done no less than create a "totally new visual landscape."[34] He concluded his review with a chronology of influences that included Duchamp, Man Ray, Schwitters, Eduardo Paolozzi, and Richard Hamilton, adding that his colleague, English critic Lawrence Alloway, had coined the term "Pop art" in 1954. Like Hopps, Coplans saw the movement of Pop art as evolving out of interest in the printed word and everyday objects as seen in assemblage and Beat poetry. Influenced by the multitalented Los Angeles designer Alvin Lustig, who created graphic book jackets for New Directions, Knopf, and other publishers, Ruscha confidently pursued the appearance as well as the meaning and sound of words without images. His next sale was a large painting of one word from the title of a popular comic strip in curvaceous red letters on yellow above a panel of blue: *Annie.*

Ruscha traded *Annie* to Goode in exchange for one of his milk-bottle pictures. Shortly after, Blum asked Ruscha to join Ferus with the enticement that his client Betty Asher would buy *Annie*. Ruscha called Goode and pleaded, "Can I trade it back from you?"

"Sure," said Goode, adding later, "That is the way we worked. We didn't have any money so that always came first."[35] The following year, Asher rewarded him by buying a milk-bottle painting for $300 and persuading red-haired comic actor Sterling Holloway to buy one as well. Holloway became another important collector.

Ruscha made a small version of *Annie* for his intimate friend Ann Marshall, daughter of actor Herbert Marshall and best friend of Michelle Phillips, the gorgeous nymphet singer of the Mamas and the Papas. Along with Toni Basil, the dancer and choreographer who was dating Dean Stockwell, and Teri Garr, the dancer and actress who was dating Bengston, these adventurous and beautiful young women embodied the essence of California girls. They became regulars at Ferus and Barney's and feckless feminine models for photographs by Dennis Hopper.

Ruscha was stunned to be invited to join the elite Ferus artists who were, to him, "like a collection of altar boys with black eyes," he said. "There were other progressive galleries operating then, but

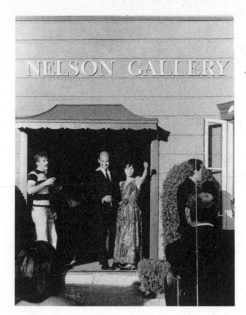

*Rolf and Doreen Nelson's wedding
party at his gallery, 1966*
Courtesy of Doreen Nelson

Ferus was the most progressive, and they had a much sparer approach
to showing art. If you wanted to put one tiny painting on a big wall
you're welcome to it. The artist is the boss."[36]

Goode, on the other hand, was not asked to join Ferus, despite
the critical acclaim for his work. "The great thing about Ed [Ruscha]
is that Ed has no enemies," Goode said. "Everybody could learn a
great deal from Ed."[37] Goode held no resentment toward his friend
but was bitter toward Blum, despite being invited to join a promising
new gallery: Rolf Nelson.

Nelson, who had worked for Martha Jackson in New York, came
west to run the short-lived Los Angeles branch of James Newman's
Dilexi Gallery. A Parsons-trained artist turned dealer, Nelson opened
his own gallery on 530 North La Cienega Boulevard a year later. As
Blum cast off artists, Nelson welcomed them, including Llyn Foulkes,
who performed music on a one-man band of his own invention and
painted landscapes based on postcards of his Eagle Rock neighbor-
hood, and George Herms, the assemblagist and filmmaker who had
adopted Berman's mantra "Art is Love is God."[38]

The Common Objects show turned out to be a big break for the
youngest artists, Ruscha, twenty-four, and Goode, twenty-five, who

had been introduced to Hopps by Henry Hopkins. Hopkins had defected from a family of Idaho agronomists to study art at the Art Institute of Chicago. He was drafted to serve in the Korean War in 1952. Mustered into the photography department and posted to Europe, he visited museums and became interested in art history. On the G.I. Bill, he enrolled at UCLA to get a master's degree in art history under the revered art historian and artist Frederick S. Wight.

As director of the university art gallery from 1953 to 1972, Wight had shown a number of modern artists, including Arthur Dove, Charles Sheeler, John Marin, Modigliani, Picasso, Matisse, Arp, and even Claes Oldenburg, bold choices in the conservative city. He also showed his own landscape paintings at the Esther Robles Gallery.

It was at UCLA that Hopkins had befriended fellow student Shirley Hopps and her husband Walter. James Demetrion, who became a curator at the Pasadena Art Museum, was a graduate student at that time. Together, they decided it was important to locate the next group of young artists to supplement the core group at Ferus.

Backed by a group of three young lawyers who wanted to start a gallery, in 1961 Hopkins opened Huysman, named after the Symbolist French novelist, at 740 North La Cienega Boulevard with a small group show called War Babies. The show and gallery gained instant notoriety for its controversial poster, a photograph staged and shot by Jerry McMillan, of four artists eating the food of their ethnic stereotype: Jewish Larry Bell with a bagel, Japanese American Ron Miyashiro with chopsticks, African American Ed Bereal with a slice of watermelon, and the Irish American Catholic Joe Goode with a mackerel. An American flag was draped over the table where they sat, and that detail alone caused such an uproar that it contributed to the demise of the gallery. "We were attacked from the left for using clichés. We were attacked from the right, including the John Birch Society, for desecrating the American flag," Hopkins said. "It was one of the first racially integrated exhibitions in Los Angeles, which we weren't thinking that much about, but it caused a wonderful furor."[39]

It also launched McMillan's career as a photographer who documented the L.A. art scene and took some of the most intimate portraits of Ruscha. In his own work, he was an innovator, playing with the

Ed Bereal, Larry Bell, Joe Goode, and Ron Miyashiro at Huysman Gallery,
Los Angeles, 1961

Photograph by Jerry McMillan, © Jerry McMillan, courtesy of Craig Krull Gallery, Santa
Monica

boundary between a two-dimensional image and a three-dimensional
object using photography processes.

Hopkins, still a student, thumbed his nose at the conservative
political and social forces still in power in Los Angeles. In *Artforum*,
he wrote a cogent rebuttal to a 1962 article, "Conformity in the Arts,"
written by Lester D. Longman, the art department chair at UCLA,
which decried the work of Rauschenberg, Yves Klein, Jean Tinguely,
and others as evidence of an age of "anxiety and despair, of existential
nausea and self pity."[40]

Hopkins wrote his dissertation on the modern art of Los Angeles,
a topic that did not exist according to his UCLA advisers, though
Wight granted permission. Such ambition caught the attention of
curator James Elliot at the L.A. County Museum of History, Science,
and Art in Exposition Park. With Elliot, Hopkins worked on the exhi-
bition *Fifty California Artists*, which included Irwin and Kienholz,

along with more established artists. The show traveled from UCLA's gallery to the Whitney Museum of American Art in New York and other museums around the country. The L.A. County Museum hired Hopkins as assistant curator, but his salary for the first year had to be paid by collector Marcia Weisman because the museum had not allocated funds for modern art.

Hopkins wrote the first published (and positive) review of Warhol's soup-can exhibition for *Artforum*. He was also the first to purchase a word painting by Ruscha: *Sweetwater*. It came to a tragic end when a student took it from Hopkins's office and painted over it. (Hopkins frequently told this story to the amusement of many but without much real forgiveness.)

Soaring from the attention that came with Common Objects, the following year Ruscha and Goode decided to hitchhike to New York. They rode with amphetamine-fueled truckers and, when no cars offered rides, they took a bus that was so crowded that Goode slept on the floor. Then they had an experience that could have been lifted from a cheesy porn film. A young woman stopped and, after a brief chat, asked if she should get her friend and show them the sights in the nearby small town. That sounded like a great idea. At her suggestion, they took off their clothes to go swimming in a pond while waiting for her return, which, rather predictably, she never did.

When they finally reached New York, Goode agreed with Ruscha that it would be impossible to make art there. "One of the great things about working [in Los Angeles] was that most artists didn't care about what was happening in New York," Goode said. "What Irwin stressed is what everybody out here believed. You can do what you want and this idea of having a theory tied around your work, you don't have to do that. That is what I really liked. It always looked stifled to me, New York art, because of the heavy reliance on European art."[41]

In New York, Larry Rivers took them to the Five Spot to hear Thelonious Monk. Warhol invited them to lunch, and Ruscha showed him his first book of black-and-white photographs, *Twentysix Gasoline Stations*: Standard stations, Texacos, and so forth, with no essay, in a five-by-seven-inch paperback. Warhol looked through the book with his deadpan serious expression. "Ooh, I love that there are no people in them."[42]

Not long after, Ruscha painted *Standard Station, Amarillo, Texas*, a long horizontal canvas roughly five feet tall and ten feet long in flatly commercial shades of red, black, and white. "I think they become more powerful without extraneous elements like people, cars, or anything beyond the story. . . . I wanted something that had some industrial strength to it."[43] Dennis and Brooke Hopper bought that painting, which made sense in that Hopper had taken an iconic photograph of two Standard signs at a gas station on the corner of Santa Monica Boulevard and Melrose Avenue as seen through the windshield of his car: *Double Standard*. In the 1960s, gas stations could be slightly exotic. Tom Wolfe described the Union 76 in Beverly Hills as a "Futurama Pagoda" designed by Jim Wong of Pereira and Associates: "What Wong has done here with electric light sculpture—as an artist—goes so far beyond what serious light sculptors like Billy Apple and Dan Flavin (and serious architects, for that matter) have yet attempted; it poses a serious question for art historians."[44]

Ruscha knew intuitively that there was something unsettlingly special about his small book of gas station photographs even if Philip Leider, the editor of *Artforum*, wrote that he found himself "irritated and annoyed" by it. Ruscha showed it to his sometime girlfriend Eve Babitz, who went on to write a series of scandalously funny memoirs beginning with *Eve's Hollywood*.

"We were driving down to have dinner at La Esperanza in the Plaza," she recalled. "We used to get enchiladas rancheras with sour cream, melted cheese, avocado. . . . So I look at this book and said, 'Why did you make this book?' He said, 'Somebody had to do it.'"[45]

Ruscha became a regular at the unruly but warm Babitz household in Hollywood, where her violinist and musicologist father, Saul Babitz, and artist mother entertained the Igor Stravinskys and other Europeans visiting or relocating to the city. Ruscha became friends with the entire family. "He would come over to our house all the time. And for Thanksgiving. My mother would make these huge meals. Ed's thing was 'May Babitz sure is good to her boys.' He was my boyfriend for a long time."[46]

Babitz's portrait was included in a Ruscha project for the 1970 Design Quarterly called *Five 1965 Girlfriends*. Another girlfriend was the slim and stylish Danna Knego. Ruscha had met her at Hanna-

Barbera studio, where she worked as an artist inking the line drawings of animators.

Meanwhile, Goode's marriage had crumbled under the strain of poverty and creative ambition. After divorcing his wife Judy in 1964, Goode dated Eve's sister, Mirandi, who introduced him to the music of the Beatles. Both daughters were regulars at the clubs proliferating on the Sunset Strip. Goode remembered going with Mirandi to hear Donovan perform and seeing John Lennon hop on the stage for an impromptu jam.

Knego, a slender twenty-one-year-old with high cheek bones and clearly set brown eyes, was living at home with her mother. Her father, who had left the family when she was eight, had been an actor, and a close friend of Robert Mitchum. Knego and Ruscha shared a passion for the stories and remnants of old Hollywood and the historic city. "We'd drive around L.A and look at different things and feel the nostalgia even then for the old buildings," she said.[47]

Many such buildings could be found in Echo Park on the east side of the city where stucco bungalows nestled on the hills that rose around a large pond with blooming lotus plants. In 1964, Ruscha had moved to a small house on Vestel Avenue. He preferred to live near his circle of Oklahoma friends on the east side of town rather than follow the rest of the Ferus artists as they moved to Venice Beach.

Bell, Box, and Venice

I rving Blum honed his relationship with Leo Castelli in order to exhibit New York–based artists Frank Stella, Ellsworth Kelly, and others who were celebrated for their clean geometric abstractions. In many ways, the work was not unlike that being done by Karl Benjamin, Lorser Feitelson, John McLaughlin, Frederick Hammersley, Helen Lundeberg, and June Harwood, an older and more established group of Los Angeles artists supported critically by Harwood's husband Jules Langsner. But Blum wanted to expand his New York network, and he added no more Los Angeles artists to the gallery apart from Larry Bell.

Bell was born in Chicago in 1939 but raised after 1945 in the sprawling L.A. suburb of the San Fernando Valley. His father sold insurance. His mother helped but was creative and eventually went back to school to study art. Bell was an attractive, wisecracking kid

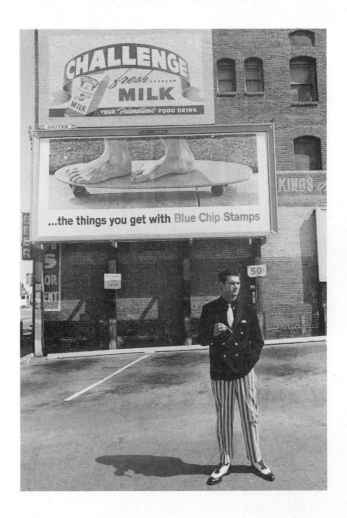

and a mediocre student at Birmingham High School in Van Nuys. "I was a flake of a student," he said.[1] Yet, his ability to draw cartoons got him a PTA scholarship to attend Chouinard during summer school. He enrolled full-time in 1958 with the vague notion of becoming an animator. He rented a room four blocks away from the school in a bright pink boardinghouse, the Shalimar, which once belonged to Charlie Chaplin.

Bell was partially deaf, though the condition was not diagnosed correctly until he was forty-six. He felt overwhelmed by the pressure at Chouinard and dropped all of his classes, apart from a watercolor course at night with Robert Irwin, who encouraged his splashy efforts.

"He was the first person to take a real interest in what I was doing," Bell recalled later.[2]

Irwin was renowned for his Socratic method. "My ideal of teaching has been to argue with people on behalf of the idea they are responsible for their own activities," Irwin asserted. "Because once you learn how to make your own assignments instead of relying on someone else, then you have learned the only thing you really need to get out of school, that is, you've learned how to learn. You've become your own teacher."[3]

Inspired by Irwin, Bell returned to Chouinard in 1959 and began making odd geometric paintings with two opposing corners removed from a square or rectangle. Herb Jepson, who had joined the Chouinard faculty, taught drawing. In the class, Bell did not draw the figure as assigned but repeatedly drew squares and rectangles. When asked about this, Bell innocently explained that he was transcribing the metaphysical aspect of the assignment. Jepson suggested Bell visit the school's "aesthetic advisor."

Bell dutifully showed up for several sessions with this advisor to explain his art, which had grown more abstract and sophisticated. Bell was perfectly pleased with this arrangement until his roommate let on that the advisor was a psychologist employed by Walt Disney, adding, "the school hired him to weed out the weirdos." Bell said, "I had thought that for once I was making decisions about my work and where I was going and this guy had just set me up because he thought I was some kind of nut. I went back to the school, took out all my stuff, and I never went back."[4]

Bell used his tuition money to rent a studio and got a job at a framing shop in the Valley. He attached leftover pieces of mirror to his paintings of geometric shapes to add the element of reflection to the illusion of dimension. Over the next two years, he transformed those geometric paintings into "constructions," boxes made of mirror or glass that dovetailed perfectly with the glossy work being made by Kauffman and Bengston. "I realized I'd been making illustrations of volumes when what I really wanted to do was make the volumes themselves," he said later. "At that point, I became a sculptor."[5]

In 1962 he discovered a small manufacturer who had the equipment to coat a clear glass surface with a prismatic mist that lent his

boxes a transcendent glow. Bell recalled, "I found this guy who did this vacuum coating process. I remember when I looked at the piece I just couldn't believe it. It was the most fantastic thing I'd ever seen in my life. Bengston was a little bit jealous."[6]

Irwin introduced him to Hopps and Blum. Bell so wanted to be part of the Ferus scene that he decided to play upon their sympathies to get his first show: "I actually thought I was going to get drafted into Vietnam in 1961. I went to see Walter Hopps and said 'Walter, I think I'm going to have to go into the army. I'd like to have a show.' He and Irving came down and looked at my stuff and said OK. I did a show the following year. As it turned out, I did get drafted, but I was rejected. When I came back from the induction place down on Olive and Olympic, I went banging on Bengston's door. He opened the door and starting laughing. 'Man, I knew they weren't going to take you!' "[7]

After Bell's grand opening at Ferus on March 27, 1962, the gang adjourned to Barney's. "I was twenty-two. I walked in and Barney said 'Congratulations, I'm buying you a drink. What do you want?' "[8] Bell was stunned by the gesture. "That guy was so tight his asshole squeaked when he walked."[9] They closed down the bar that night at two in the morning as Barney called out, " 'Last call, last call for al–ca–hol.' "[10]

Later that year, just before Christmas, Bell received an unexpected check for $2,000 from the Copley Foundation that not only provided validation but also enabled Bell to produce larger boxes of coated glass.

Copley also brought Marcel Duchamp to visit Price, Irwin, and Bell. No one bothered to tell Bell, so when he heard the knock at the front door, he assumed it was a building inspector. (It was illegal to live in working studio spaces in those days.) After the persistent pounding continued, he peered through the window and saw three men in suits. He recognized Copley, who introduced Duchamp and Richard Hamilton. Bell often did not hear parts of conversations, and on that occasion he did not realize that his visitor was the great Duchamp. He chatted away in a relaxed and irreverent manner until he overheard Copley say something to "Marcel." From that moment on, Bell was

intimidated; he could barely utter a word. The trio left, but not before Duchamp, who once said, "I don't believe in art, I believe in artists," invited him to visit when in New York.[11] A year later, in 1964, Bell accepted the offer.

"Teeny took me into the parlor and brought in a tray with tea and cookies. She closed the door and there I was with the great man all by myself. There were Picabias, Magrittes, and a Brancusi wooden blonde Negress up on the armoire. It was a heavy moment. When I asked what he was doing, he said, 'I'm working on a show of early work.' I said, 'Really, how early?' He said, 'Oh, I was four or six.'"[12]

It was at the Duchamp opening at the Pasadena Art Museum that Bell met his future wife, Gloria Neilsen, who was twelve years younger than her sister Shirley Hopps and just as pretty. The two blondes went to Western Costume in Hollywood and rented laced bodices and short skirts in red, white, and blue to attend the black-tie event. "They both looked so cute, and Gloria in particular just knocked me out," Bell recalled.[13] Bell and Neilsen were married three years later in a Las Vegas drive-through chapel.

Unlike Ruscha, who did not integrate his social life with that of the older Ferus artists, Bell made a point of ingratiating himself with Bengston, Kauffman, and Altoon. He said, "I come from a lower-middle-class family in the San Fernando Valley. I didn't know shit about anything. I lived vicariously off these sophisticated young men."[14]

Bell followed the migration of Bengston, Price, Altoon, and Irwin to the beach. Initially, some lived in Ocean Park but most moved to the less expensive environs of Venice. Bell rented three thousand square feet of studio space for seventy-five dollars a month on Marine Street, two blocks from the ocean, in what had once been, in the early decades of the twentieth century, a resort with colonnades and canals built in simulation of Venice, Italy. By the 1960s, the beach was lined with oil derricks and the neighborhood had grown dangerous and dirty, "where the debris meets the sea." Yet it was a magnet for struggling artists and poets. The Beats had taken over the Venice West coffee house for marijuana-stoked poetry readings. The Ferus crew continued to drive into town to drink at Barney's, but they had breakfast together at a café on Pacific and Windward. Asked what

profound topics of discussion might have engaged them, Bell replied with practiced nonchalance: "Pussy."[15]

Altoon lived next door to Bell, and Irwin was one block to the south, not far from Bengston and Price. New York transplant John Chamberlain shared a nearby space with Neil Williams. Other younger artists experimenting with the properties of pure light, Doug Wheeler, James Turrell, and DeWain Valentine, soon moved into the same neighborhood. "The reason was it was cheap," Bell recalled.[16] (In 1966, Bell bought a nearby building at 74 Market Street for $6,000 and the bank balked at giving him a loan, protesting that it wasn't worth $6,000.) "Every commercial storefront was empty and had been for a couple of years."[17]

The artists' proximity to one another accelerated their growing interest in the properties of light, the nature of perception, and how those factors might be utilized in their art. It was easy to overlook their run-down environs when the sky shifted daily from the soft, gray dawn to a perfect clear blue to a vibrant tangerine and pink sunset. The magical light flooded into their studios, accompanied them on their strolls along the beach, and led them to reflect upon the best ways to capture the experience.

This obsession with light was a historic preoccupation in Los Angeles and the principal reason that the movie studios had moved there from the gloomy East Coast. Directors valued the smooth, golden quality of early morning light as the most flattering for their leading ladies. As it had for the Impressionists in the south of France, sunlight inspired a new crop of plein air painters in the 1920s known as the Eucalyptus School, who captured the whitecaps on the Pacific Ocean and fields of poppies near the Pasadena arroyo. Later, Modernist architects such as the Viennese Richard Neutra devised houses with entire walls of glass to take advantage of the light and the steady climate.

These artists were not stuck in the European past; they sought out new materials that would best serve contemporary explorations. Glass, plastic, and acrylic replaced canvas and paint. Precious little time was spent discussing their art, though they took note of one another's discoveries. Irwin, Kauffman, Bell, and Bengston especially

were light-years and a continent away from their chatty predecessors at the Cedar Tavern in New York.

Bell grew closest to the caustic Bengston. "You could hang with this group if you were serious about what you did. You had to take a lot of shit and be ready to dish it right back. But it was all based on a profound love and sense of humor. Nobody thought there was any money in doing this stuff."[18]

Bell was rarely seen without an outlandish hat, tie, or shoes. Walter Hopps used to call Bell "luxury" because Bell and Bengston would haunt cheap thrift stores and buy a whole suit for a dollar. Often the "luxe" clothes were handmade, such as silk ties from Sulka with seven folds. Bengston made belts with stitched-in nicknames for each of the Ferus artists. Bell was "Luxe" while newcomer Ruscha got the insulting name of "Waterboy." Later, when Ruscha was showing throughout Europe and New York, Ed Moses teased Bengston: "Who is the waterboy, now?"[19]

Bell's work sold but, like the other artists, he did not make much money at first. According to Blum, "The gallery was very much like a club. We shared whatever money we had. . . . I mean me and the artists . . . would see each other several times a week and share meals and scratch to get by."[20] The gallery was consistently helped along by Shirley Hopps's paycheck from the University of California–Riverside, where she was assistant professor of art history. Walter's salary as director of the Pasadena Art Museum was modest.

Collector Betty Asher and her physician husband Leonard helped to support the gallery and were the first to buy one of Bell's mirrored boxes. They lived in a Spanish-style house in Brentwood, where they often had Blum and the artists for dinner and held charity poker games, letting the poorest artist win. Their son, Michael Asher, became an artist whose Minimalist work was in the spirit of Kauffman and Irwin. Today he is better known as a Conceptual artist and is an influential teacher at the California Institute of the Arts.

For Bell, perception held sway over conception. His glass boxes were originally decorated with spray-painted patterns. Then, as he gained confidence, he simplified his creations. "I finally realized that it was the sensuality of the surface quality which was what I was working with, and what I was able to do with the coating process

was to keep the same surface quality but enhance the way light was either reflected or transmitted."[21] As Bell's breakthrough came at a time when Donald Judd was producing his early boxes of metal and wood, it appeared to critics that a uniquely Southern California Minimalism was being also born.

Bell quickly became the gallery's rising star. Blum explained, "Arnold Glimcher came and said, 'This guy's a genius.' Because he was the youngest, it didn't sit well with the others."[22] Glimcher needed ten boxes for a 1964 show at Pace, his New York gallery. Blum asked Bell how long it would take him to make twenty of the boxes—ten for Glimcher and ten for himself—and what it would cost. Bell reported that it would take six months and cost $20,000. Glimcher sent a $10,000 check to Blum, who in turn secured a $10,000 loan from his backer Sayde Moss. With $20,000 in hand, an excited Bell went to work.

Bell confided news of this astonishing windfall to Bengston, who immediately stormed into Ferus. "Irving," he said, "I want $20,000."[23] Blum explained that it was not possible. There was no waiting list for Bengston's paintings, no impending show in New York. An indignant Bengston threatened to quit the gallery and, in a fury, attempted to convince others to leave as well, but his friends were unmoved. After that, Bengston left Ferus and was no longer the ringleader.

Bell was confused and troubled by his friend's reaction. He was even more upset by the fact that Bengston had confronted Robert Irwin and the two had wound up in a brawl that concluded their testy friendship. "You either had to play the game Billy's way or not play," Irwin said. "At one point I grabbed him and threw him up against a wall and told him to get the fuck out of my life."[24] When Bell tried to patch things up, Irwin told him not to bother. The artists, who once had had lighthearted fun at Barney's together, were each now on a more urgent course.

Bell made friends with Donald Judd and other rising artists in New York. In 1965 his reflective glass boxes sold briskly at Pace. "I made more money when I was twenty-five than my dad made in his whole life. I was totally unprepared," Bell would later say. Success came at a cost. "It gave me a nervous breakdown by the time I was thirty and turned me into an alcoholic."[25] He grew rich while his Los

Angeles friends remained broke. "I felt really guilty about it. A lot of the money I made I just pissed away, just because I didn't feel that I should have it."[26]

Meanwhile, Glimcher took on Irwin and Kauffman. "They were giving us money and my first show back there, gee whiz, they paid for a first-class airline ticket," Kauffman said. "I didn't know how to deal with all that."[27] Glimcher rented a loft for Bell to pursue his glass sculpture in New York. Kauffman rented one on Seventeenth Street in Manhattan that he shared with John McCracken, who also showed with Pace. McCracken, Kauffman, and Ruscha were selected for the Cinquième Biennale de Paris at the Musée d'Art Moderne de la Ville de Paris in 1967. The same year, Kauffman, McCracken, Bell, and Ron Davis were shown with Judd and Flavin in A New Aesthetic at the Washington Gallery of Modern Art. In her catalog essay, critic Barbara Rose claimed their work "portends a brilliant world of color, light, and direct experience."[28]

After Bengston's diva departure from Ferus, he broke his back in a motorcycle accident, which left him paralyzed for four days. He had remained friends with the soft-hearted Bell and, unable to live on his own, slept on Bell's couch for four months, utterly alienating Bell's new wife. "He was awful, cranky," Bell recalled. "His mother knitted me a beautiful afghan, which I still have, for taking care of him."[29]

Disciplined in his physical habits, Bengston rehabilitated himself by putting on his motorcycle leathers and boots and running up and down the stairs to his studio thirty times a day. He'd then ride his bike for four hours. A few months later, he began an even less conventional form of physical therapy by going out dancing at the different clubs on the Strip. "I was sort of a dance hall slut at the time. I'd work out in the day and go dancing at night. At that time, the Whisky, Gazzaris, Ciro's were dance clubs. Primarily rock 'n' roll, Ike and Tina Turner, the Temptations, stuff you could really wing with," he later said.[30]

Bengston was on hand for one of the legendary performances of Otis Redding, who stomped the stage so hard that the whole club filled with dust rising from the floor. In 1966, Whisky a Go Go owner Elmer Valentine had Redding and his ten-piece Memphis band for four nights of performances that were remembered as legendary

Ann Marshall in front of Billy Al Bengston painting at actor Sterling Holloway's house in 1965

Photograph courtesy of Billy Al Bengston

after the twenty-six-year-old Redding died the following year in a plane crash. Ry Cooder played in the opening act, Rising Suns, and recalled that it was a "super hot show, nothing like anyone had seen in Los Angeles."[31]

One night, Bengston went to Ciro's to hear the Byrds, who were friends with Mary Lynch Kienholz and involved with the Ferus scene. Bengston hung out with Teri Garr, Ann Marshall, and Toni Basil. Though romantically involved with Garr, he was such close friends with all of them that he eventually combined their initials to name his daughter: Blue Tica—standing for Teri, Toni, Isherwood, Cliff, Ann, and Altoon. "They were tremendously energetic those girls, they were real trouble," he recalled.[32] Garr and Basil were professional dancers working in beach-party movies and television shows such as *The Sonny and Cher Comedy Hour*, but they were happy to meet him several nights a week to continue dancing into the early morning hours.

They were not strangers to the art world. Through Hopper, years

earlier, Garr had been drafted to read Michael McClure's *The Beard* in the loft above the carousel on the Santa Monica Pier. Bengston already knew Hopper, Dean Stockwell, and Peter Fonda but then grew friendly with Jack Nicholson through Garr and Basil, who took acting classes with him. Nicholson wrote the slim script *The Trip* for Roger Corman. Largely a montage of psychedelic special effects, the movie starred Fonda as a director of TV commercials—bad karma from the POV of the sixties—who is given acid by his friends Hopper and Bruce Dern. Nicholson also wrote a part for Garr in his next psychedelic movie *Head*, a vehicle for the Monkeys. Nicholson remained in touch with the Ferus artists through Ann Marshall, who became his girl Friday in the late sixties after her friend Michelle Phillips had left him. (Nicholson rarely collected contemporary art, preferring Picasso or the erotica of Tamara de Lempicka. However, one Christmas, he bought a large suite of watercolors from Bengston to send to friends as presents.)

Bengston, who titled his radiant enamel paintings after Hollywood personalities—Humphrey, Zachary, Busby—went on to date Diane Varsi of *Peyton Place* and Bobbi Shaw, who had a role in *Beach Blanket Bingo*. Bengston introduced Shaw's roommate Babs Lunine to John Altoon, who was divorced by Fay Spain in 1962. Lunine's upper-middle-class East Coast background was more boarding school than bohemian, though she majored in art history at the University of Miami before moving to Los Angeles in 1964. She was seventeen years younger than Altoon and was so wholesome and blonde that both Bengston and Altoon referred to her affectionately as "Fluffy." She married Altoon in 1965.

Bengston, too, settled down. His girlfriend, Penny Little, was registrar of the Pasadena Art Museum. After leaving Ferus, Bengston represented himself, showing and selling out of his studio as well as loaning work for gallery and museum exhibitions. Little helped him organize a system for keeping track of his work. (He had had such difficulties getting work returned that he asked the Whitney Museum of American Art to pay him for loaning his work to their prestigious biennial exhibition. The museum refused.)

Handsome and charismatic, Bengston had little difficulty selling his own work for sizable sums. The work was strongly backed by critics

such as John Coplans, who wrote, "It would not be too much to say that by the early sixties Bengston had probably extended the notion of a complex synthetic order of color far in advance of anyone else working at the time."[33] After he had finished a group of what he termed "Dentos"—sheets of thin metal that he had beaten with a ball-peen hammer and then sprayed with lapidary-colored patterns of lacquer—he agreed to a show in 1970 with Riko Mizuno, who had split from a partnership with Eugenia Butler to open her own gallery at 669 North La Cienega Boulevard. Bengston insisted that the show be lit only by candles on stands that he had built so that flickering illumination would cast changing shadows over the glistening, irregular surfaces of the Dentos. Unfortunately, the paintings could barely be seen at all. "That went over like a turd in a punch bowl," he said.[34] It was his only show there. "I always felt that I was the best," he later said, with a dry laugh. "I think everyone would agree with me that I had a very inflated opinion of myself. . . . I burned a lot of bridges and was very, very stupid."[35]

Glamour Gains Ground

In the early 1960s, Larry Bell worked part-time at the Unicorn coffeehouse on Sunset Boulevard, walking distance from Barney's. The Kingston Trio and Judy Henske performed regularly at the Unicorn, but the acoustic scene was about to give way to electric rock. It was at the coffeehouse that a well-to-do young man with a tenor voice, David Crosby, met producer Jim Dickson, who put him together with Jim (later Roger) McGuinn, Gene Clark, Michael Clarke, and Chris Hillman, an electric folk-pop group conceived of as the "American Beatles" but known, by 1964, as the Byrds. Dickson was friends with Dennis Hopper, also a regular at the Unicorn. "That is where I first heard 'Howl' read by Ginsberg. And Freddy Engelberg was playing guitar," Hopper recalled.[1] Engelberg also acted in *The Beat Generation* with Fay Spain, Altoon's first wife, before releasing two albums of his own music.

Occasionally, Bell played his own twelve-string guitar at the Unicorn and hung out with the musicians. Since he watched the door, he would slip in friends for free, including the Grinsteins. Hopps had brought them to Bell's studio with the warning, "Listen, this is going to look really weird to you but you have to believe it's art."[2] The Grinsteins embraced the artist and the era. Elyse declared, "We were straight Westsiders but we were changed by the sixties."[3] Though raised on jazz and swing, they had no problem moving on to rock and roll when Johnny Winter played the Whisky a Go Go.

At Bell's suggestion, they dropped by the Unicorn one night to watch comedian Lenny Bruce, his sharp features softened from alcohol and drugs. He was friendly with Altoon, who lived near the club. Hopper, a staunch supporter of Bruce's incendiary monologues, was there that night. He was infuriated when authorities intervened. "They dragged him off the fucking stage," Bell recalled.[4]

Bruce was determined to use obscenity in his stand-up act, and the police in various cities were just as determined to stop him. Sherman Block, who later became L.A. County sheriff, arrested Bruce on the charge of violating California's obscenity law at a 1962 performance at the Troubadour on Santa Monica Boulevard in West Hollywood. Less than two weeks later Bruce faced charges in Chicago following a show at the Gate of Horn. Later in 1962 he was arrested again in Los Angeles for a performance at the Unicorn. "Here I am, living up to my public image," wrote a defiant Bruce. "A true professional never disappoints his public."[5] Bruce's many influential friends included magazine publisher and freedom of speech champion Hugh Hefner, who serialized Bruce's *How to Talk Dirty and Influence People* in *Playboy*. Bruce's greatest supporter was twenty-five-year-old record producer Phil Spector, whose "wall of sound" was perfected in Los Angeles with the Ronettes' "Be My Baby."

Spector had moved to Los Angeles from New York in 1963 because he had "tired of the condescension of East Coast session men, and now welcomed the chance to work with the younger, hipper musicians of Hollywood."[6] There were more independent labels recording folk, pop, and rock music in Los Angeles than anywhere else in the country. Spector saw his opportunity and broke the rules of recording by "pushing volume levels way into the red, packing the studio with

musicians and instruments, devoting hours to each song."[7] He scorned conservatives fighting Bruce's scathing free-form monologues about religion and race in America. (After Bruce was found dead of a heroin overdose in 1966, Spector bought the paparazzi photographs of his bloated body to outmaneuver the media. Spector himself went to jail in 2009 for the murder of actress and House of Blues hostess Lana Clarkson.)

Hopper identified with Bruce's expressed feeling of persecution. Like Bruce, he had a reputation for escalating drug use. After eighty-five takes of one scene in the 1958 film *From Hell to Texas*, director Henry Hathaway spread the word that he was difficult. By the early 1960s, Hopper was not getting as many offers to act and, inspired by Kienholz, started to make collages and assemblages. The opening of his show at the Primus Stuart Gallery brought out friends Paul Newman and Joanne Woodward. It was as a photographer, however, that Hopper's true talent emerged.

Before marrying Hopper in 1961 at Jane Fonda's New York apartment, his fiancée Brooke had bought him a 35 mm Nikon camera for his birthday. She recalled, "It turned out that he was as natural a photographer as he was an actor, constantly taking pictures of everything and everyone he came into contact with that intrigued him."[8]

After Hopper lost his paintings in the 1961 Bel Air fire, he dedicated himself to photography. "The artists wanted to be photographed," he recalls, "while the actors were used to it and I, for one, felt like it was often intrusive."[9] He spent his considerable free time hanging around Ferus and taking photographs of the artists. "Light" artist Irwin with a lightbulb in his mouth, luxe Bell wearing striped trousers and two-tone spectator shoes, cool Ruscha posed in front of a shop with a neon sign. In 1963, Hopper's photographs were reproduced in *Artforum* with the bravura endorsement: "Welcome brave new images!"

Hopper was hitchhiking on Sunset Boulevard one day when William Claxton, driving his Ford convertible, stopped to pick him up. They had not met previously but synched quickly over their mutual love of photography and jazz. When they reached Hopper's house at the top of steep Kings Road, Hopper invited Claxton in and Claxton spent the afternoon photographing the rebellious actor. Both were

Dennis Hopper, Double Standard, *1961*
Photograph by Dennis Hopper, © The Dennis Hopper Trust,
courtesy of The Dennis Hopper Trust

fans of Charlie Parker, whom Claxton had photographed countless times at the Tiffany Club. "The Bird" fascinated Claxton with his tough demeanor and angelic face. Hopper, too, hung around jazz clubs, including the Renaissance opened by Benny Shapiro.

Once, after Thelonious Monk had played the Renaissance, Shapiro asked Hopper to take Monk to the airport. "I went to pick him up and he was in this Victorian house in Watts," Hopper said. "I went three hours early because he loved to miss planes and just get high at the airport and watch people. He was in bed and high and had pills all over the floor."[10] Referring to William Parker, the hard-nosed chief of the LAPD, Monk took a long, stoned look at Hopper and asked, "Dennis, how could a man with the name of Parker be down on jazz?"

"So anyway," Hopper continued, "we missed the airplane."[11]

Claxton's acclaimed pictures of jazz musicians earned him a position as art director and photographer for Pacific Jazz Records. A Pasadena native, Claxton had attended UCLA with Hopps and was a

regular at Ferus, where he befriended many of the jazz-loving artists, especially John Altoon. On more than one occasion, Altoon would borrow money from Claxton and, to secure the debt, give him a painting. A few days later, Altoon would sneak into Claxton's studio and retrieve the painting without ever telling him. Claxton solved the problem by commissioning Altoon and Irwin to create album covers of their abstract paintings.

The tall, fair Claxton married short, slight Peggy Moffitt in 1961. A Los Angeles native who initially considered a career in acting, Moffitt became one of the top models of the era with her black eye-liner, pale makeup, and glossy dark hair—the absolute opposite of the California girl popularized by television and pop music. Thanks to her association with the radical young Los Angeles fashion designer Rudi Gernreich, she became a recognizable icon of the sixties.

Moffitt and Blum, both extroverts, bonded over their love of the theatrical gesture. One day, she rounded up leggy model Léon Bing and a few other girls. With Blum and Claxton, they all went to the marina for a special photo shoot. Claxton mounted adhesive letters spelling "FERUS GALLERY" on the stern of a cabin cruiser borrowed from his brother. Moffitt and her girls were outfitted in Gernreich bathing suits on loan from the Beverly Hills boutique Jax, where Moffitt had worked as a teenager. Moffitt was furious when "one of the models destroyed one of the bathing suits with a cigarette butt, which I had to pay for."[12] Claxton took a glamorous shot of the pretty girls clustered around Blum, who was wearing his customary blue blazer and assuming an attitude of prosperity. When the photo went out as a gallery announcement, few recipients knew anything about the impoverished Blum. He said, "You have to look like you are doing well and I think we pulled it off."[13] Shirley Hopps recalled that it was all smoke and mirrors. "It was not glamorous. No matter how it looked, Irving was living on about one hundred dollars a month. He had no money but he was a great showman, all facade."[14]

Blum, who had aspired to be an actor, could not restrain such indulgence in fantasy. When he spied a Silver Cloud Rolls-Royce parked on La Cienega, he called Seymour Rosen, a photographer who had taken pictures of the Watts Towers and of various artists, and asked him to hurry over to the gallery. When Rosen arrived,

Ferus Gallery yacht with Irving Blum and Peggy Moffitt on the right
Photography by William Claxton, courtesy of Demont Photo Management, LLC

Blum hustled him across the street and assumed the pose of the putative Rolls owner. "I need to send a photo to my mother in Phoenix to show her I am doing all right," he said with one of his hearty laughs.[15] Clearly, Ferus had moved on from its chaotic Beat origins.

Thanks to Moffitt, Gernreich invited Ferus artists to parties at his house behind a Moroccan wall on Laurel Canyon where he lived with Oreste Pucciani, chairman of the UCLA French department and authority on Jean-Paul Sartre. The house featured Gernreich-designed floors of burnished leather squares, with furniture by Marcel Breuer and Le Corbusier and art by Ruscha, Bell, and Rauschenberg. "Rudi loved to have artists around," Bell said. "He had great parties with fancy people. We'd clown around and he was happy to have an entourage of crazy people as well as fashion people."[16] It was at one such party that Craig Kauffman met fashion-model-turned-photographer Patricia Faure, who took pictures of the Ferus artists in a number of antic poses.

Gernreich was the first fashion designer since Christian Dior to become a household name, thanks to the debut of his topless bathing suit as well as unisex clothing. Born in Vienna in 1922, he and

his mother came to Los Angeles with other Jewish refugees in 1938. His father had committed suicide in 1930. He attended L.A. City College and initially hoped to be a dancer, studying with choreographer Lester Horton, who was considered the West Coast Martha Graham. While dancing, he worked part-time designing fabrics and then clothes for various small firms in New York, ultimately returning to Los Angeles feeling discouraged by the French couturiers' monopoly on taste.

His bra-free jersey swimsuits, knit tube dresses, mini-dresses, and other clothes were carried by Jax, Jack Hanson's cutting-edge Beverly Hills boutique. Hanson, retired shortstop for the Los Angeles Angels, had designed the fitted and tapered Jax slacks, with the zipper up the back instead of on the side, favored by Jackie Kennedy and the period's curvy movie stars Marilyn Monroe and Elizabeth Taylor. On any given afternoon, he could be found driving around Beverly Hills High School in his 1934 white Rolls-Royce and inviting the cutest girls to work in his store. His wife Sally Hanson became his chief designer, and as profits soared, they opened a "brutally private" nightspot for their exclusive clientele in Beverly Hills called the Daisy.[17] Hairstylists Vidal Sassoon and Gene Shacove, whose lively love life inspired the movie *Shampoo,* socialized at the Daisy with their celebrity clientele: fashion models, actresses and actors, socialites, movie moguls, and international jet setters.

Hanson and Gernreich eventually parted company. Not everyone could accept his increasingly controversial designs. After Gernreich received the Coty American Fashion Critics' Award in June 1963, Norman Norell, known for his sequined gowns, returned his own Coty award in protest. The following year, Gernreich launched his topless bathing suit. Gernreich said, "Baring these breasts seemed logical in a period of freer attitudes, freer minds, the emancipation of women."[18] With Moffitt modeling, Claxton took photographs that emphasized the modern, graphic quality of the swimsuit. Gernreich initially did not intend to produce the suit but Diana Vreeland at *Vogue* convinced him otherwise.

Gernreich headquarters at 8460 Santa Monica Boulevard was a khaki-colored square stucco building with twelve-foot panel doors with his name in chrome letters. Three walls and the floor of the showroom were white, one wall was khaki burlap. The room was fur-

nished with black leather Breuer chairs and sofa. Artist Don Bachardy, the partner of author Christopher Isherwood, created sketches for Gernreich's dresses.

In 1965, Moffitt went to New York where, in the studio of photographer Richard Avedon, she met Vidal Sassoon, who had revolutionized hairstyling in London. When Sassoon came to Los Angeles a few months later, Moffitt introduced him to Gernreich. Sassoon created architectural haircuts that perfectly complemented Gernreich's graphic, structured fashions. A mutual admiration society was born, and that was the beginning of the end for teased, bouffant hair.[19]

The Dawn of Dwan

A round the time that Blum took the helm of Ferus, new contemporary art galleries were popping up all along La Cienega. Everett Ellin's gallery showed work by Stella, Johns, and Oldenburg—who created an elaborate plaster cake for Ellin's wedding—before Ellin was recruited by art dealer Frank Lloyd in 1963 to be the first director of twentieth-century art for Marlborough Galleries in New York.

Art dealer Rolf Nelson, who would marry Frank Gehry's sister, Doreen Goldberg, in 1966, added Philip Hefferton and Ed Bereal to his roster. David Stuart showed Dennis Hopper and Tony Berlant as well as pre-Columbian art. Esther Robles handled established Modernists Stanton Macdonald-Wright, Karl Benjamin, and Claire Falkenstein. Ceeje Gallery, a joint effort by Cecil Hedrick and Jerry Jerome, showed expressive figurative art by Charles Garabedian and Les

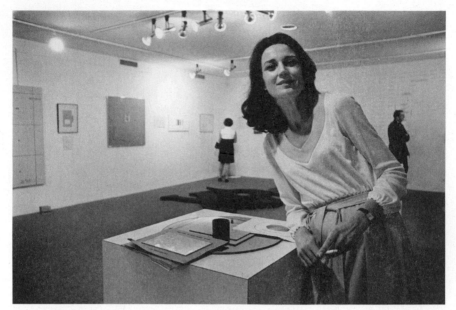

Virginia Dwan, 1969
Photograph by Roger Prigent, courtesy of Dwan Gallery Archives

Biller. Paul Kantor handled De Kooning and top Abstract Expression-
ists. The Viennese Felix Landau, who had been Pete Seeger's man-
ager in the late 1940s, was considered the archdeacon and showed
European moderns Egon Schiele and Francis Bacon as well as Califor-
nians John McLaughlin, Peter Voulkos, and Tony DeLap.

The most serious alternative to Ferus, however, stood several miles
west of La Cienega in Westwood: Dwan Gallery. Operating during
the same years as Ferus and offering a parallel universe of abstract
and Pop artists from New York and Europe, Dwan imported fresh
stimulus to the city. Blum said, "It was the gallery that was the most
competition."[1]

From the outset, Virginia Dwan had a singular advantage: She was
heir to a portion of the 3M fortune. A native of Minneapolis, she first
learned about modern art at the esteemed Walker Art Center. To avoid
the bitter Minnesota winters, her parents rented houses in Los Ange-
les between 1939 and 1945. After her older sister, June, married and
moved to Los Angeles, Dwan followed her west and enrolled in the
art department at UCLA. Abstract painter Ed Moses was a student

then, and he was the first to bring the pretty, slender brunette to Ferus to meet the other artists.

Dwan was an artist by temperament but felt she did not have the requisite personal drive. She left school to marry social psychiatrist Paul Fischer and soon had a daughter, Candace. (Candace Dwan is now a photography dealer in New York.) While her husband worked, Dwan visited local galleries and one day asked modern art dealer Frank Perls about opening a gallery of her own. "Well, tell me how much money you would like to lose?" he quipped.[2] Noticing her crestfallen expression, Perls hired her to sit at the front desk in his gallery on Saturdays. She was there for exhibitions of work by Jean Dubuffet, Pablo Picasso, and the popular UCLA teacher William Brice, the son of vaudevillian Fanny Brice and convicted swindler Nicky Arnstein.

Intelligent and restless in her housewife role, Dwan divorced her first husband and later married Vadim Kondratief, a French medical student at UCLA, who also became a psychiatrist. He encouraged her to open a gallery in 1959 and helped her find the storefront space in a Spanish-style building on Broxton Avenue. "I had no experience," she said. "I was totally naive."[3]

The couple lived in a Malibu Colony shake-shingle beach house that had once belonged to movie star Warner Baxter. There were two guesthouses, one of which was converted into a studio where visiting artists could work. Dwan also kept a second house on Malibu Road where artists could stay. Though she entertained collectors and a few Hollywood types such as the Hoppers, Dean Stockwell, Tony Curtis, and screenwriter George Axelrod, she preferred the company of artists. Dwan said, "I found early on that artists don't just paint or make sculpture; they're also fascinating thinkers and have a different connection with the world and what's happening than the average person."[4]

The first two years, Dwan exhibited a range of abstract painters, including Matsumi Kanemitsu and Friedel Dzubas, while traveling to New York often to meet other artists. Larry Rivers agreed to a show at Dwan in February 1961. She also connected with Franz Kline and Philip Guston and convinced them to show with her that April. Being an outsider, she didn't realize that the two artists were not on speaking terms. "It was kind of nice. In my innocence, I was able to bring

people together occasionally for a common cause—in this case, their joint show."[5]

Dwan spent part of each summer at a house in the south of France with her husband. On one trip to Paris, she grew familiar with the French Pop Nouveaux Réalistes and decided to show five of them: Arman, Martial Raysse, Jean Tinguely, Niki de Saint Phalle, and Yves Klein.

Dwan had seen Klein's monochrome canvases, all painted identically in his own concoction of International Klein Blue, in the windows of the Iris Clert Gallery in Paris. Klein's Los Angeles debut on May 29, 1961, included the blue monochromes and large canvases covered in natural sponges and painted blue, hot pink, or gold. During the opening, Klein showed a film of his infamous Paris performance dragging nude women covered in blue paint, "living brushes," across a roll of white paper while tuxedoed musicians played his 1949 composition *Monotone Symphony*, a single note held for twenty minutes followed by twenty minutes of silence. (John Cage, then living in Los Angeles, had not yet written his version, *4'33"*)

"It caused a furor in L.A.," Dwan recalled. "L.A. artists were jealous and bitter over the attention to Klein. There was anger."[6] John Baldessari remembered, "Klein came out and gave a talk in the gallery. The artists hated him and someone, I think it was John Altoon, starting saying 'Bullshit, bullshit, bullshit. Louder and louder.'"[7] Altoon marched out in a huff. Baldessari was intrigued. "It made an impression on me because it just defied everything I knew about art. Blue monochrome paintings, all the same size. I said, 'This can't be art.' It snapped something."[8]

Dwan was mesmerized. Collectors Melvin and Pauline Hirsch gave a party for Klein in their modern architectural home and had a cake made with IKB-colored frosting. "Yves loved it," Dwan recalled.[9] He was, however, the last to arrive at his party after spending the day with Kienholz and Dwan shark hunting on her boat.

Klein and his wife Rotraut Uecker stayed in one of the guesthouses of Dwan's Malibu home. Dwan remembered "staying up late discussing life and death and whether the soul goes on."[10] Klein, a mystic temperament who had spent time in Japan pursuing a black belt in judo and Zen, loved California. He was less pleased with New

York after Leo Castelli failed to sell any of his paintings. While staying at the Chelsea Hotel, he wrote a manifesto about the "mutual incomprehension" provoked by his exhibition.

He had a much more pleasant experience with Los Angeles collectors Michael and Dorothy Blankfort. Michael was a successful novelist and screenwriter while Dorothy was a literary agent. They had bought work by De Kooning, Bengston, and Kienholz, but it was a great leap when they contacted Klein asking if they could buy an "immaterial."

Calling the purchase an "adventure of unreason," Blankfort explained, "This 'work of art' was exactly what the word meant; in short, it didn't exist except as an experience which had no material substance."[11] Klein told him to buy 160 grams of gold in sixteen small ingots and meet him near the Pont Neuf in Paris. On the morning of February 2, 1962, the Blankforts, Dwan, and others gathered for the event, which Dwan remembered as "a really beautiful moment."[12] Klein examined the gold, then looked at Michael and said in a low voice, "Now, throw the gold pieces in the river."[13] Michael hesitated and then watched, astonished, as his own hand tossed the gold away, glittering before splashing into the water. "I felt a wave of exaltation . . . a sensation of being outside my body, not completely myself; a paradox of taking in more than I gave out," he wrote later.[14] Klein handed Michael a bill of sale but instead of keeping it, he fumbled in his pocket for a match. Klein had one ready and lit the corner of the paper, which quickly turned to ash. Michael Blankfort was a proprietor of an experience, the owner of *The Zone of Immaterial Pictorial Sensitivity*, as Klein titled the incident.

The Blankforts were feeling quite pure until they discovered that the entire performance had been documented by Klein's photographer, pictures that now constitute unique evidence of this work of art. At first, the Blankforts were disturbed to have the intimacy of the act sullied but as those photographs became a part of Klein's touring retrospective, Michael admitted, "Vanity came to the surface to appease me."[15] It was destined to be more memorable than expected. Four months later, on June 6, 1962, Klein died of a heart attack at the age of thirty-four.

Another unique art adventure began for the Blankforts two years before, in 1960, when Ed Kienholz asked Michael if he thought he

would "make it" as an artist. When Michael responded in the affirmative, Kienholz proposed one of his dubious deals. He asked Blankfort to confirm his faith by buying a work that he would not be able to look at for a decade. The deal was for a down payment with the balance paid at the end of that term. "If you open it during that time," Kienholz added, "you pay it all and I keep the piece." Blankfort agreed and kept the wrapped box in storage until he opened the piece as scheduled on April Fool's Day, 1970. By then, Kienholz's career was firmly established, and he offered to buy the piece back. Blankfort refused and the artist removed the wrapping to reveal the gaping, hollow neck of a preserved deer still covered with its soft brown fur, surrounded by a coil of ochre-colored rubber hose in a painted wooden box. It was terrifying and Michael thought the horrors of war had inspired the title, *The American Way II*. Dorothy asked the meaning of the title: "It's obvious," said Kienholz. "The way you bought it is the American way. On the installment plan."[16]

Dwan held half a dozen shows by abstract painters, including Ad Reinhardt, before her 1962 coup: the first West Coast showing of Robert Rauschenberg's "combines," a word coined by Johns for what he described as "painting playing the game of sculpture."

Tinguely and Saint Phalle were showing with Everett Ellin while Blum was presenting Kienholz's *Roxy's*. To promote this trifecta of assemblagists, the three dealers discussed renting a billboard on the Sunset Strip and asking the artists to collaborate in making an ongoing, changing public art piece. Since all were working with found materials and had become friends, it seemed a very Pop idea, though it was abandoned after a cost analysis.

Ellin sponsored a performance by Saint Phalle, then Tinguely's girlfriend and later his wife, that garnered plenty of attention. Kienholz, Bengston, Price, Ruscha, Goode, and Hopkins were among the 150 in the audience on March 8, 1962, in the parking lot behind Club Renaissance on the Sunset Strip. Niki de Saint Phalle, pretty and petite, sporting a Joan of Arc hairstyle, had spent days constructing a twenty-foot-tall fortress out of ladders, dummies, and bicycle wheels. Dressed in a fitted white jumpsuit with Kienholz and Tinguely supplying cartridges for her rifle, Saint Phalle shot balloons filled with

paint and beer that exploded over the surface of a canvas to create an "action" painting. Her exhilarated audience then filed over to Ellin's La Cienega gallery to see Tinguely's hopping, waving, jittering machine sculptures.

The Rauschenberg show at Dwan included *First Landing Jump*, a canvas topped with a rusted license plate, an enamel light reflector, a black tarpaulin, and a street barrier that impaled a tire resting on the floor in front of the work, evidence of Rauschenberg's view of the world as one gigantic painting. For the next year and a half, Dwan tried to sell the daring piece to dubious Los Angeles collectors for $5,800. Finally, she had to ship it back to Leo Castelli who immediately sold it to architect Philip Johnson, who later gave it to the Museum of Modern Art. Castelli was patient, however, and continued to work with Dwan on future exhibitions. "Leo was a revolutionary at the time in his attitudes about consigning exhibitions," she recalled.[17] Dwan said that Castelli lent art on favorable terms hoping to develop a West Coast clientele that would buy from him in New York—a strategy that ultimately paid off.

For his part, Castelli was thrilled to have access to Dwan and Blum. He ran into Lorser Feitelson at the Guggenheim and told him, "Oh, Los Angeles is wonderful. We've got to have more collaboration," adding that he was exhibiting his artists there.

Feitelson asked, "Does that mean that you are exhibiting Californians in your place here?"

"Oh, no," he said. "They are not ready for that yet."[18]

Dwan's private income reduced the pressure to sell, and she enjoyed showing work "which was so far in the avant-garde that by definition anyone logical would have to say, 'It can't sell yet, maybe later on,'" she recalled. "I really enjoyed the challenge of putting out there into the world things which were rather stunning and surprising and to me very challenging and exciting, and then just sort of seeing what happened.[19]

"We were all trying to convince the world that Los Angeles was a viable art world in itself," she added.[20] "Irving would come and visit and discuss what was happening in the so-called art world in Los Angeles because really the collectors were not that open to the things that I was showing. We sort of gave each other strength and com-

miserated with each other and joked with each other about the whole thing."[21]

"I remember Irving coming into the gallery and saying, 'I've just come back from New York and I was telling them what a great art market we have out here.' The gallery was empty, nothing was happening. But at that time, Irving was taking shows on consignment from Leo and Sidney Janis, and so was I. So we couldn't very well indicate that nothing was happening in L.A. because they would question why they would want to send anything out there. So it was a pact between us that I've always enjoyed. It was a myth that became real."[22]

Dwan gave artists stipends and formal contracts and then sold the work. This gave her first choice of the finished work, and she took one-half of the sale price. She sold to the key Los Angeles collectors, but unlike Blum, Dwan did not relish courting them. "My relationships were always with the artists I was showing more than the collectors," she said. "I remember having a party for Merce Cunningham and John Cage and the dance troupe at my house in Malibu and I didn't invite any collectors. Just David Tudor, Sven Lukens, and myself."[23]

Though her inheritance gave her the freedom to make provocative choices in the works she chose for her gallery, Dwan had to recognize that her wealth was finite. "We were not wealthy," she said.[24] "There were five different people that started 3M so all of them are inheritors as well. I am just one person who has an inheritance and it is not enormous." Referring to Michael Heizer's gigantic Earthwork piece *Double Negative*, she said, "It cost thirty thousand dollars [$136,000 in today's currency]. It is written up as though I put billions into it. I find that painful because the emphasis is on money rather than having an eye."[25] She was not discouraged, however. "More and more I was, I suppose, on a spiritual high with this gallery. I felt that what I was showing was not only for my good, but for everyone else's and that it was a gift to the world."[26]

In May 1962, Dwan opened a larger gallery at 10846 Lindbrook Drive designed by a student of Frank Lloyd Wright and modeled after Wright's V. C. Morris Gift shop in San Francisco. A broad arch separated the interior from the street "to give a sense of setting aside one's other rush-rush attitudes."[27] Twice as large as the previous gallery, the main room was fifty by fifty feet. "There is the beginning of a sense of

almost sacredness—that the viewer in coming in to look at art should in my mind feel that this was to be approached with a different part of himself than the rest of his day-to-day living."[28]

Dwan met Arman through Klein and gave the French artist the inaugural show at her new gallery. Kienholz took Arman shopping to find old violins and cellos to break up and encase in clear plastic boxes. "Kienholz had the largest pick-up truck. He knew his way around everywhere. . . . He was ambassador from Los Angeles to these European artists in particular," Dwan said.[29]

Dwan also hired John Weber, who had worked for Martha Jackson in New York and had organized a 1961 proto-Pop show called Environments, Situations, Spaces featuring Jim Dine, Allan Kaprow, Claes Oldenburg, and Robert Whitman. His first task as director was to help critic Gerald Nordland with his American Pop-themed show My Country Tis of Thee at the gallery from November 18 to December 15, 1962, around the time of Hopps's Common Objects show.[30] Kienholz joined the Dwan Gallery in 1963.

Never able to understand why anyone wouldn't enjoy hunting as he did, Kienholz insisted on driving Dwan, Weber, and Martial Raysse around the dirt roads of the Malibu hills in search of coyotes or cougars, but all they found was a flock of crows. As a joke, Dwan later sent an old jaguar skin to Arman's wife with a note that it had been bagged during a hunting excursion in the wilds of Malibu.

After Ellin closed, Dwan showed Jean Tinguely in May 1963, and the artist constructed work for the show after arriving in town. Kienholz took him to a large hardware store near MacArthur Park. Coming from postwar Paris, Tinguely was enthralled by the variety of machine parts available, especially motors. "It's the motor that counts," he said.[31] He bought motors that were too large for his sculptures but Dwan gave him carte blanche because he loved them. He was "hugging them to him with great fondness," she said.[32] The motors had to be bolted to the floor to keep the sculptures from vibrating around the gallery.

Kienholz's next scavenger hunt took him to the downtown district with Saint Phalle, where she found the balloons, paint, glitter, and plastic toys for the work for her January 1964 show. In addition,

plastic sacks full of paint were attached to a twenty-foot-long canvas and shot open during her performance in Malibu. Metropolitan Museum of Art curator Henry Geldzahler attended and later wrote about it for *Vogue*. Jane Fonda and French actress Micheline Presle, who had just appeared with Paul Newman in *The Prize*, attended as well. The leftover canvas stood outside at the end of Dwan's pool until it faded into extinction. Chained to the corner was a small cannon that Tinguely had created to lob shots into the ocean.

"It was a playful period," Dwan recalled. It wasn't that people weren't taking the art seriously but there was an openness to enjoyment and having fun in the process.[33] Dwan's sense of the playful led her to organize a progressive dinner for Tinguely. The artist built a working fountain at the home of each participating collector, and a bus carried champagne-sipping guests from house to house. Later, Tinguely and Saint Phalle cruised down to Mexico with Dwan and Kondratief on their boat. The trip went badly; Dwan had to face the fact that her marriage was coming to an end. "Things were miserable," she said.[34]

Kienholz was also having trouble at home. He and his wife Mary divorced in 1964 and began an ugly custody battle over their two children, Noah, four, and Jenny, three. "He was a miserable bastard," Mary said later.[35] She moved out of the Nash Drive house and went to work for Virginia Dwan's sister-in-law, Eugenie Kondratief Thompson, who started Cart and Crate, the first Los Angeles company to transport art professionally, a service that dealers and collectors needed increasingly.

The divorce was savage, and Kienholz channeled all of his grief and anger into his art, which exploded in scale and detail and brought him greater recognition. Dwan sold a large installation to the Moderna Museet in Stockholm. "I never considered anything unsalable," Dwan said.[36]

Claes and Patty Oldenburg rented a pink cement block furnished duplex on Linnie Canal in Venice early in 1963. Claes also rented a nearby studio and they began preparing for shows at Dwan and at Sidney Janis Gallery in New York. Claes designed and Patty sewed the canvas and vinyl soft sculptures that were quickly establishing his reputation as one of the new breed of Pop artists.

Claes Oldenburg installation at Dwan Gallery, 1963
Photograph courtesy of Dwan Gallery Archives

Patty Mucha, as she has been known since her 1970 divorce from Oldenburg, recalled their year in Los Angeles. "Claes began to embellish his art now with fluffy acrylic fake furs (leopard-patterned or polka-dotted), cowhide, or zebra-striped vinyl. In L.A., he found new and exciting fabrics that I would construct into a multitude of soft sculptures."[37]

Oldenburg, born in Sweden, was inspired by the city's Pop architecture. "After all, its cartoons came to life in the fast food joints that Angelinos stopped at for chili dogs or other comestibles," Mucha wrote in her memoir *Clean Slate*.[38] The Dwan show in October reflected such affection and included some fuzzy *Soft Good Humor Bars*. "The zaniness of that little sculpture, created out of totally unrealistic materials—impossibly colored in green tiger and orange leopard 'flavors'—touched a lot of funny bones," she added.[39]

Oldenburg explained, "I wanted to feel the West and I came back with these enormous simple big forms. A different type of thing—it didn't look right at all in New York."[40]

The show was popular but there were no sales, according to Dwan, apart from the soft old-fashioned telephone sculpture that she

bought for her house in Malibu. "I wasn't concerned about whether it was going to sell or not. I was more interested just simply in showing it. I enjoyed the whole experience of what they were doing—the iconoclasm of it."[41]

Dwan did underwrite the costs of Oldenburg's Happening *Autobodys*, a West Coast variant of the impromptu performances with his own sculptural props and costumes that he had put on in New York. Allan Kaprow coined the term "Happening" in 1957 for live action events with minimal theatrical guidelines that had contributed to the evolution of the Pop art style of Oldenburg, George Segal and Jim Dine. "We just used everything in the world, you know," Oldenburg said.[42]

The nearly four million cars cruising around greater metropolitan Los Angeles inspired *Autobodys* on December 9–10, 1963, in the parking lot behind the American Institute of Aeronautics and Astronautics at 7600 Beverly Boulevard. Aided by Ed Kienholz, Dennis Hopper, younger artists Lloyd and Nancy Hamrol, and Judy Gerowitz (later Judy Chicago), Oldenburg auditioned cars and trucks and selected only black and white models. Arranged in a circle around the perimeter of

the parking lot, their headlights at night illuminated a staging area where women on roller skates, men on motorcycles, and even a cement truck moved along in an unchoreographed ballet.[43] Whistles were blown, sirens sounded; noises of the urban environment provided the only soundtrack. The audience included most of the art community, including Pasadena Art Museum curator James Demetrion with artist James Turrell, who had been his student at Pomona College.

The script consisted of five poems written by Oldenburg with specific directions: "Lloyd drives in from NE / Maneuvers / Stops center facing south / Sits." As people looked on, milk was spilled from glass bottles, a white concrete mixer whirled, car radios blared music, people walked around the scene, and cars were moved about. Hamrol recalled the excitement: "I loved it, but the whole idea of temporary events just didn't jibe with what I had learned Art was supposed to be about."[44]

Despite the high spirits surrounding the event, no one could completely shake off the sense of tragedy that accompanied the assassination of President John F. Kennedy on November 22, 1963. Hopper photographed the funeral as it aired on television, the first time such a tragedy could be seen in millions of homes. Dwan watched the shocking coverage with Ad Reinhardt, whose opening had been scheduled for November 24. Dwan admired the sardonic Reinhardt so much that she had chosen the ceiling height of her new gallery to complement his vertically oriented paintings. When they arrived, however, she learned he had switched to a sixty-inch square format. The penumbral canvases with barely visible crosses appeared to be a memorial.

In 1964, Dwan began divorce proceedings against Kondratief. He eventually married art dealer Riko Mizuno, who partnered with Eugenia Butler to open Gallery 669 on North La Cienega.[45] Though Dwan continued her progressive agenda by showing James Rosenquist, Lucas Samaras, and others—her personal collection was considered worth showing at the UCLA art gallery that year—she started spending much more time in New York, where she opened a gallery on Fifty-seventh Street on November 11, 1965.

Her Manhattan debut was indebted to a Los Angeles icon: Kienholz's installation of *The Beanery*. The artist had re-created a three-dimensional facsimile of his favorite watering hole but added biting

Ed Kienholz, The Beanery, *1965*

Collection of the Stedelijk Museum, Amsterdam,
Photograph courtesy of Stedelijk Museum, Amsterdam

elements of insight and satire. When *The Beanery* opened in New York, it was covered by *Life*, *Time*, and *Newsweek*. Outside the simulated front door, a news rack offered the *L.A. Herald Examiner* with the headline: "Children Kill Children in Viet Nam Riots." (Having dodged the draft successfully for many years, Kienholz became one of the sixties' most trenchant if unpredictable observers of social and political hypocrisy.) The ramshackle interior of the bar was constructed out of the actual bar stools, counter, and other junk Barney discarded when he remodeled his old place. Plaster casts of Dwan, Barney, and other figures sat at the bar or stood by the jukebox, their faces replaced with clocks all set at the same time: ten minutes after ten. The premiere viewing was held in the parking lot of the original Beanery from October 23 to 25, 1965. Barney himself walked through the life-size re-creation bemused though pleased to see himself at the bar and his sister Fern in the kitchen. Dwan sold the piece to stockbroker Burt Kleiner for $25,000. Kienholz got $12,500, which he called "a hellish amount of money for then," and he bought a house on Magnolia Drive in the Hollywood hills. Two years later, the piece was bought by the Stedelijk Museum in Amsterdam.[46]

When Duchamp was asked his opinion of Kienholz, he laughed and said, "Marvelously vulgar artist. Marvelously vulgar artist. I like that work." Hopps told Kienholz of this great compliment. "Well, that's nice," Kienholz said. "I like his work too."[47]

John Weber kept Dwan's Los Angeles gallery open until 1969, but the energy went to her New York operation where she discovered and supported emerging Minimalist and Earthworks artists: Sol LeWitt, Robert Smithson, and Dan Flavin among them. With her artist Mark di Suvero, she became an original backer of Park Place, the cooperative gallery on West Broadway run by Paula Cooper.

In 1969, Dwan's Westwood space was taken over by Vancouver dealer Douglas Chrismas, who opened Ace. He restructured the interior as a white cube with white floors, walls, and ceilings without moldings or architectural details of any kind. The environment was perfect for LeWitt, Carl Andre, and the other Minimalists he would exhibit, carrying on Dwan's legacy, as well as for a new wave of Los Angeles artists working in light and plastic: Doug Wheeler, DeWain Valentine, and Ron Cooper.

A Bit of British Brilliance:
David Hockney

B y 1964, at least seven Pop art exhibitions had been shown at museums around the United States. Into this welcoming atmosphere came David Hockney, a taciturn Englishman with a northern accent and shockingly artificial blond hair, who was swept up in the frenzy by his paintings of the manicured green lawns and sparkling blue swimming pools of Los Angeles.

The city seemed like another planet to the artist born in the mining town of Bradford, England, in 1937, into what he called a "radical working-class family." His mother was a strict Methodist who did not smoke or drink. His father, a conscientious objector during World War I, had enough creative urge to paint sunsets on the doors of their home. Young Hockney was fascinated by this and by age eleven had decided to be an artist. At the Bradford Grammar School on scholarship, he was interested only in the art classes. When told that he

couldn't take art while concentrating on the more advanced courses of study, such as the classics and languages, he opted to get poor grades so he would be put in the general studies course where art was still offered. He contributed drawings to the school magazine, drew posters, and, at age sixteen in 1953, convinced his parents to enroll him at the School of Art in Bradford. That summer, he earned money for his studies by pitching hay.

Though he attempted the more pragmatic commercial art course, within a month he had switched to a major in painting for the national diploma in design. For four years, he concentrated on drawing and painting, mostly from life. "I loved it all and I used to spend twelve hours a day in the art school," he said later.[1] He submitted a portrait of his father to a group show in Leeds and it sold for £10, a considerable amount in 1954. He called his father to ask if it was all right to sell it. "Ooh, yes. . . . You can do another," he said.[2]

Following his father's example, he spent two years as a conscientious objector in the national service from 1957 to 1959, which he spent working in hospitals in Bradford and Hastings. He completed no paintings during that time but had done a lot of thinking before enrolling as a postgraduate student at London's Royal College of Art. His classmates included Ron Kitaj, Allen Jones, Derek Boshier, and Peter Phillips.

The abstract paintings of Alan Davie helped him realize that there were alternatives to the realism he had been practicing in school. American Abstract Expressionism had been shown at the Tate Gallery in 1956, and he saw the 1959 Jackson Pollock retrospective and 1961 Mark Rothko exhibition at the Whitechapel Gallery. But it was Picasso who made the biggest impact. After eight visits to the retrospective at the Tate, he realized, "Style is something you can use, and you can be like a magpie, just taking what you want."[3]

Though he excelled at figurative painting, it was seen as antimodern. He began adding words—scraps of poetry or graffiti—to his pictures. Though thousands of miles apart, Ruscha was showing his first word paintings in the Common Objects show as Hockney was making brushy paintings of Typhoo tea boxes, his mother's preferred brand. He constructed one canvas to simulate a three-dimensional box just as Ruscha had painted the illusion of a flattened

box of raisins. The two artists did not know of each other or even draw from the same source material, but both wanted to find a way around the dominance of abstract painting. Both would rise to prominence on their ability to look beyond and even elevate the clichés of the Los Angeles landscape in their art. (Reyner Banham, another British resident of Los Angeles, was able to perform the same feat in his writing.)

Hockney was among the first generation of English artists to reject Abstract Expressionism. His work was included in the Young Contemporaries Exhibition of 1961, organized by Lawrence Alloway. Larry Rivers had visited and influenced many of the students. Richard Hamilton, who was teaching in the Royal College of Art's school of interior design, had constructed proto-Pop collages in the 1950s and was supportive of Hockney and Kitaj. (Allen Jones was kicked out after the first year for failing to follow the traditional course of study.) Hockney recalled, "There was subject matter, and the idea of painting things from ordinary life, and that was when everything was called 'pop art.'"[4]

Word spread about these rebellious young artists, and soon the stodgy Royal College of Art was transformed by attention from the press. Visitors regularly stopped by Hockney's studio and bought paintings. The topic of homosexual love, in *The Fourth Love Painting*, 1961, was slightly coded in the number "69" and the poetry of W. H. Auden. It was considered cheeky, but he was eager to tell others about himself through his paintings. "The moment you decide you have to face what you're like, you get so excited, it's something off your back," he said.[5] *Doll Boy*, a painting of a figure, was loosely based on pop singer Cliff Richard. Hockney had photos of him pinned up in his studio as the other students had pinups of starlets.

The summer of 1961, with the £100 of prize money for his print based on a Cavafy poem, he went to New York City. "I must admit I'd begun to be interested in America from a sexual point of view."[6] He was in search of the matinee idol boys with beautiful bodies featured in American magazines. He dyed his hair platinum blond and went to the few gay bars that were opening in Manhattan. He met Oldenburg, Warhol, and Hopper. That Christmas, Hockney visited the Uffizi in Florence but was unmoved by the seduction of its great Renaissance

Portrait of David Hockney by Don Bachardy
Photograph courtesy of Don Bachardy

paintings. "In 1961, the modern world interested me far more, and America specifically," he explained.[7]

Despite the fact that he barely passed his courses in art history, he earned a gold medal from the Royal College of Art in 1962. The following year, British art dealer John Kasmin opened a gallery and gave Hockney a contract for £600 a year to paint. He had his first solo show at the age of twenty-six.

His experiences in New York led him to execute twenty-four etchings on the theme of lost innocence called *A Rake's Progress*, after William Hogarth's work. In 1963, the Royal College of Art published the series as a book, and the etchings were purchased for £5,000 by Paul Cornwall-Jones to be published as an edition of fifty, each set to be sold for £250. "I didn't dare tell people the price because it was so outrageous, I was ashamed of it."[8] The income allowed him to move to Los Angeles in 1963.

Los Angeles lived up to his expectations. "I think my notions were quite accurate in the sense that L.A. is a city where you can go and find whatever in a sense you want." Months before he arrived in

the city, Hockney painted *Domestic Scene, Los Angeles*, showing a man wearing an apron and scrubbing the back of another man in the shower. It was based on photographs in the Los Angeles body-building magazine *Physique Pictorial*.

John Rechy's startling, homoerotic novel *City of Night* inspired Hockney to paint *Building, Pershing Square, Los Angeles* based on Rechy's description of the downtown area: "Remember Pershing Square and the apathetic palm trees." He had never driven a car and, in all innocence, bought a bicycle to ride downtown from his quarters in Santa Monica, a short straight distance on the map that turned out to be sixteen miles. The next day, a friend volunteered driving lessons and in just one week, he had got his license and bought a Ford Falcon for $1,000. He managed to get on the Santa Monica Freeway but, not knowing how to get off, wound up driving all the way to Las Vegas, where he won some money at a casino and then drove home the same night. The next day, he drove to Venice, where he rented an apartment with a view of the ocean. This was the easy, affordable America that had captured his imagination back in London. "I thought, it's just how I imagined it would be."[9]

In the winter of 1964, Kasmin came to Los Angeles to see Hockney and took him around to visit a few art collectors. "I'd never seen houses like that," Hockney recalled. "And the way they liked to show them off! They were mostly women—the husbands were out earning the money. They would show you the pictures, the garden, the house."[10] His feelings were made clear in *California Art Collector*, his painting of a woman in her garden where a sculpture by the English artist William Turnbull competed for attention with the swimming pool.

In a seedy area downtown, he tracked down the *Physique Pictorial* offices and met the owner, who paid young toughs just out of jail to be photographed in the buff. "I was quite thrilled by the place," Hockney recalled. "I bought a lot of still photographs from him."[11] These inspired yet more paintings of men taking showers. Hockney was obsessed by American showers. "They all seemed to me to have elements of luxury: pink fluffy carpets to step out on, close to the bedrooms (very un-English that!).[12]

"A lot of sex is fantasy," Hockney said. "The only time I was pro-miscuous was when I first went to live in Los Angeles. I've never

been promiscuous since. But I used to go to the bars in Los Angeles and pick up somebody. Half the time they didn't turn you on, or you didn't turn them on, or something like that. And the way people in Los Angeles went on about numbers! If you actually have some good sex with somebody, you can always go back for a bit more, that's the truth. I know a lot of people in Los Angeles who simply live for sex in that they want somebody new all the time, which means that it's a full-time job actually finding them; you can't do any other work, even in Los Angeles where it's easy. . . . It doesn't dominate my life, sex, at all. . . . At times I'm very indifferent to it."[13]

After showers and cars, Hockney embraced yet another innovation. He switched from slow-drying oil paint to a quick-drying acrylic invented in the 1950s. The water-based Liquitex changed the appearance of Hockney's painting by facilitating smooth surfaces and intensifying colors. He also bought a new Polaroid instant camera, which, he said, "coincided with an interest in making pictures that were depicting a place and people in . . . California."[14] These instant snapshots, with a shallow depth of field and artificial color, contributed to the flattened perspective of his pictures of boxy buildings with carpets of green lawn or turquoise pools.

Once he had settled in, Hockney decided to visit the galleries and meet other artists during the Monday night art walk. Daunted by the "Fagots Stay Out" [sic] sign at Barney's, Hockney felt the macho atmosphere of the Ferus group was not welcoming. He met art dealer Nicholas Wilder, who had just moved to the city from San Francisco. His closest friends became English author Christopher Isherwood and artist Don Bachardy, who invited him regularly to their home overlooking the Pacific Ocean in Santa Monica Canyon. After spending the summer teaching at the University of Iowa, Hockney drove through the southwest with designer Ossie Clark, visiting from London. They got back to Los Angeles just in time to see the Beatles perform at the Hollywood Bowl. In late 1964, Hockney attended the opening of his exhibition at the Alan Gallery in New York, where his paintings sold out at $1,000 apiece. After this exciting year, he found himself back in cold, gray London painting pictures of swimming pools as though revisiting Los Angeles.

Six months later, after teaching at the University of Colorado, Boulder, in 1965 he moved back to Los Angeles and shared a small house with his art school friend Patrick Proctor. During his short time back, Hockney concentrated on a series of lithographs, *A Hollywood Collection,* for the just-launched publisher Gemini GEL. His renderings of palm trees and other city icons were surrounded by his elaborately depicted frames.

Hockney's restless creativity led him to Beirut to do drawings for a set of etchings relating to the poems of C. P. Cavafy and then to London to design sets for the Alfred Jarry play *Ubu Roi* at the Royal Court Theatre. In the summer of 1966, Hockney moved back to Los Angeles and stayed for four months in the Larrabee Street apartment of Nicholas Wilder, who had opened his eponymous gallery on North La Cienega Boulevard. Hockney recalled, "I liked Nick because he, like me, was a slob, untidy some people said, but I would tell them our excuse was a higher sense of order, and I mean that."[15]

Meaning that Wilder was devoted to his artists and showed both Hockney and Bachardy. "Everything was a lot more bohemian than it is now. I admired Nick's intelligent eye. I don't think he ever made much money, and possibly never expected to," Hockney added. "He was a very sensitive person, and the time I am talking about, his gallery was the centre of L.A. to me."[16]

Teaching at UCLA, Hockney anticipated a class full of lithe surfer boys, but there was only one: a full-lipped, shaggy-haired teenager named Peter Schlesinger. Together, they moved into a run-down house on Pico Boulevard near Crenshaw. Instead of installing a telephone, they made do with the corner pay phone. Hockney painted during the day, while Schlesinger attended school. It was the first time that Hockney had lived with a lover. Their neighbor was the geometric abstract painter Ron Davis, who also showed at Nicholas Wilder's gallery. Hockney and Davis played chess together. Hockney relished the memory: "I think the very first game of chess we played he won, and he said, 'That's what comes of playing with geometric artists.' The second game I won, and I said, 'That's what comes of playing with figurative artists who know what to do with a queen.'"[17]

Schlesinger was only nineteen so they couldn't go to the bars. It was a quiet and productive time during which Hockney produced some of his greatest paintings. "It was certainly the happiest year I spent in California, and it was the worst place we lived in," he reflected later.[18]

Hockney painted a number of large canvases that barely fit into the room he used as a studio. The first was a portrait of the elegant blond art collector Betty Freeman, who had seen his first show at the Kasmin Gallery in London and bought the one remaining drawing for $150. When Hockney moved to Los Angeles, actor and writer Jack Larson took Freeman to meet him at the run-down house. "David asked if he could paint my pool," she remembered. "He came over and took little Polaroids. Then Felix Landau called and asked if I wanted to see the finished painting."[19] The first two times that he offered it to her, she refused. It was about to be shipped to a New York dealer when Freeman finally bought it. In the painting, she wears a floor-length pink caftan (that she kept for the rest of her life) and stands near her zebra-striped chaise and a mounted antelope head on the wall, a trophy of her engineer husband Stanley Freeman, who was a big-game hunter. After seeing it, she informed Hockney, "There is only one thing you can call this painting: *Beverly Hills Housewife.* So he did."[20]

The twelve-foot-long double canvas hung in her dining area facing the glass doors opening to the patio. It joined an art collection that included sculptures by Oldenburg and Flavin, and paintings by Francis, Lichtenstein, and Warhol. The Freemans underwrote musical performances at the Pasadena Art Museum and at the L.A. County Museum of Art (LACMA), and their traditional brick house on Hillcrest Drive in Beverly Hills was later the scene of concerts by advanced contemporary composers Philip Glass, John Adams, and Harry Partch.

These encounters with collectors, so unlike anything that he had experienced in England, felt liberating to Hockney. "In Los Angeles, I actually started to paint the city round me, as I'd never . . . done in London. To me, moving into more naturalism was a freedom. . . . A lot of painters can't do that—their concept is completely different. It's too narrow; a lot of them, like Frank Stella, who told me so, can't draw at all."[21] This pursuit of "naturalism" led Hockney to concentrate

intently on the effects of light and shadow that embellish even the humblest views around Los Angeles.

After six months in Europe, Hockney and Schlesinger moved back to Santa Monica in 1968 and rented a small penthouse facing the ocean. Hockney rented a room in a wooden bungalow across the street where he embarked on his large double portrait of Isherwood and Bachardy. He took many Polaroids of them seated in their living room before a coffee table arranged with two stacks of large books, a bowl of fruit, and a rather suggestive dried corn cob. Bachardy went to London for two months before the portrait was finished while Isherwood visited Hockney's studio frequently to pose in person, so the rendering of the author is more detailed. Isherwood was distraught and spent a great deal of time worrying that he had become too possessive of his young lover. In the painting, he is turned toward Bachardy while Bachardy faces straight ahead. Isherwood's concern and affection for Bachardy is palpable. Hockney was facing similar difficulties with Schlesinger, who was restless and ready to move on.

Hearing of Hockney's portraits, collector Marcia Weisman asked him to paint her husband, Frederick. Since attending Walter Hopps and Henry Hopkins's art-collecting classes in their living room just a few years before, the Weismans had become discerning and voracious collectors of Kline, Rothko, Johns, and many of the Los Angeles artists. Hockney didn't accept commissioned portraits but offered to paint them together. *American Collectors* portrayed them standing in the garden at the rear of their modern glass and white stucco home. Frederick is formally attired in a gray suit and tie and facing Marcia, who is wearing a pink caftan. On an aggregate concrete patio, they are separated by modern sculptures by Turnbull and Henry Moore. The totem pole standing to one side is incongruous, as Hockney knew, and he used it to capture Marcia's outspoken nature and its effect on her husband, who often was so tense from her constant criticism that he clenched his fists. "There's a totem pole in the picture that looks rather like Marcia. It really had a similar look: the face, the mouth and things. I couldn't resist putting that in," he said. "So it's a slightly different kind of portrait in that the objects around the figures are part of them. I left the drip on Fred Weisman's hand

because it seemed to make his stance more intense, as though he were squeezing so hard that his paint was coming off."[22]

Two years later, Weisman was dining with a business associate in the Polo Lounge of the Beverly Hills Hotel. Frank Sinatra was hosting a dinner party for Dean Martin at a nearby table. Weisman complained that Sinatra's party was making too much noise and making anti-Semitic remarks. Sinatra said, "Listen, buddy, you're out of line." Sinatra started arguing with Weisman. Accounts differ about what happened next. Marcia, who was not there, said that her husband was hit with a blackjack by Sinatra's bodyguard. An eyewitness claimed that Sinatra threw one of the telephones kept in the Polo lounge booths at Weisman's head. Weisman was taken to Mount Sinai Hospital with a fractured skull and remained in a coma for months.[23] The LAPD wanted to make an arrest but Marcia received anonymous threatening phone calls warning her not to press charges. As they had three children, she decided not to pursue the case officially, but she spoke freely of the incident in order to spread the word of Sinatra's behavior.

While in a coma, Frederick had no recollection of family or friends until Marcia brought a small Pollock drawing into his room. The swirling patterns triggered his memory, and soon he was lecturing his doctors on the meaning and pleasure of contemporary art. This extraordinary occurrence prompted Frederick, who was a hospital board member, to suggest hanging contemporary art throughout the new hospital building then being built on Beverly Boulevard. Other board members said, "Well, that's fine. But we haven't the money for it. How do we do it?" Frederick replied, "I know how you'll do it. I'll give you Marcia."[24] Frederick provided the seed money and Marcia got busy selecting works from their collection and soliciting gifts and funds from friends. When the hospital opened, the stark white corridors were brightened by framed examples of original contemporary art, including prints by Hockney.

Initially, Hockney spent only five years in Los Angeles, returning periodically to England, yet it was the place where his unique sensibilities coalesced. Apart from Ruscha, no other artist was so completely identified with the city. The quintessential elements of Los Angeles—swimming pools, lawns with sprinklers, squat stucco build-

ings, and skinny palm trees—became the imagery associated most popularly with his work. The freedom of opportunity there allowed Hockney to pursue his convictions as a painter without worrying about history or critics. As English art critic Richard Dorment later put it, "The day he stepped off the plane in Los Angeles, everything changed. In a moment I would seriously compare to Vincent Van Gogh's arrival at Arles, it is as though the heat, light and colour of California entered Hockney's bloodstream. Overnight, a talented British artist became a major international star."[25] Captivated by the particular beauty of Los Angeles, Hockney bought a house off of Mulholland Drive and made it his primary residence in 1978.

He said, "In London, I think I was put off by the ghost of [Walter] Sickert, and I couldn't see it properly. In Los Angeles, there were no ghosts; there were no paintings of Los Angeles. People then didn't even know what it looked like. And when I was there, they were still finishing some of the big freeways. I remember seeing, within the first week, a ramp of freeway going into the air, and I suddenly thought: 'My God, this place needs its Piranesi; Los Angeles could have a Piranesi, so here I am!' "[26]

Hockney may have been tantalized by what he saw as a permissive lifestyle, but homosexuality was far from accepted in Southern California. The Friendship, the ship-shaped bar with porthole windows in Santa Monica Canyon, was packed nightly but many of Dorothy's friends were content to remain closeted. The Mattachine Society, created in Los Angeles in 1950 in the home of Communist activist Harry Hay, focused on assimilation and respectability for homosexuals. (Soon after, several women in San Francisco formed the Daughters of Bilitis, or DOB, for lesbians with similar goals.) Rudi Gernreich was a founding Mattachine member but never admitted his homosexuality publicly. His life partner of thirty-one years, Oreste Pucciani, recalled that not only was it still illegal, but Gernreich had joked, "It's bad for business."[27] (The Gernreich and Pucciani estates provided a trust for litigation and education in the area of gay and lesbian rights.) A small uprising of gays against police harassment took place in Los Angeles in 1959; an automobile parade was organized to fight exclusion of homosexuals from the military in 1966,

*Don Bachardy and
Christopher Isherwood in
front of the double portrait
of them painted by David
Hockney*
Photograph courtesy of Don
Bachardy

but it was not until the Stonewall riot of 1969 in Greenwich Village that the gay rights movement gained real momentum.

Isherwood's sexual inclinations could be gleaned from his books, especially *Goodbye to Berlin*, about his experiences during the Weimar Republic. It was later transformed into the musical and film *Cabaret*. Having rejected the upper-class upbringing of his parents by dropping out of Cambridge University, he moved to Los Angeles in 1939 with W. H. Auden, where he achieved his greatest success as a novelist and screenwriter. With friends Aldous Huxley, Gerald Heard, and Bertrand Russell, all prominent authors, he fell under the sway of Swami Prabhavananda. All wrote numerous articles about Vedanta but Isherwood wrote books on the subject, worked as the managing editor of the official publication of the Vedanta Society of Southern California, and later served on its editorial board with Huxley and Heard.

Isherwood was forty-eight when he met the sixteen-year-old Don Bachardy on Valentine's Day, 1953. He had been infatuated with Bachardy's older brother, Ted, but after Ted suffered a nervous breakdown, Isherwood was placed in the position of consoling Don. Their relationship continued until Isherwood's death in 1986.

Isherwood took his young partner as his date to all of the Hollywood parties, a brazen gesture for the times. Bachardy recalled the wonder of being warmly welcomed as "the only queer couple" in the

home of producer David O. Selznick and his actress wife Jennifer Jones, while confronting veiled hostility from actors Joseph Cotten and Henry Fonda.

Bachardy had been drawing portraits of movie stars from photographs kept in a scrapbook since childhood, probably inspired by weekly movie matinees with his mother. Raised in the suburb of Atwater, California, he was stunned to be dropped into the world of actual celebrities on one of his first dates. "I remember being in a restaurant in Hollywood called Naples with Chris. It was close to Columbia [Pictures] where they were making *From Here to Eternity*. After we'd been there a few minutes, the door opened and I saw Montgomery Clift come in. I said, 'Chris, Montgomery Clift just came in.' He turned around and we both watched Montgomery Clift come straight up to the table and say, 'Hi Chris!' I was absolutely awestruck. Chris introduced us and we talked for a few minutes and it was my first meeting with a movie star. Of course, I was thrilled to pieces."[28]

By 1956, it was clear that Bachardy had the makings of a talented portraitist—he later shared models with Hockney—and Isherwood underwrote his education at Chouinard Art Institute. (In 1962, when he had an exhibition at the gallery of character actor Rex Evans, a critic wrote that Bachardy managed to "freeze personalities like Stravinsky and Dorothy Parker in off-guard moments in such a manner as to arouse uncommon interest.")[29]

Bachardy was classmates with Ruscha, Goode, and Bell. "I was very shy and kept a low profile," he recalled. "They were artists of their time doing abstract pictures. Ed Ruscha was already doing words. And here I was doing nothing but pictures of people. I couldn't have felt more old-fashioned but it was all I wanted to do. Billy Al was my first artist sitter because I had a commission from *Harper's Bazaar* to do about fifteen 'in' people of Los Angeles, including Nancy Reagan, Betsy Bloomingdale, and Fred Astaire. Billy Al Bengston was the only artist on the list. Of course, I knew his work and had seen him at parties. I didn't know any artists yet.[30]

"I was scared," he continued. "I had already heard of his reputation for being very outspoken. I thought he might make quick work of me. But he sat very still, which is very uncharacteristic of him. It was a big moment for me. And we did a trade. A bona fide established

artist and little Donny did a trade! Artist to artist. That was very excit-
ing for me, and through him I met all the others. Ed Ruscha eventu-
ally had me do sittings with all the members of his family. His mother,
his sister, his brother, his wife, his son, and he sat for me many
times. That is how I got so many Ruschas."[31]

Bengston, the most macho of all the Ferus artists, became Bachar-
dy's friend and mentor. "It was very touchy then because in the six-
ties, these were all straight artists," Bachardy recalled. "Homophobia
was the flavor of the month for years on end. It was a quite touchy
situation getting to know Billy. I remember after that first sitting with
him for *Harper's Bazaar*, he was invited to dinner to meet Chris. Just
the three of us. We cooked dinner for him and that was our kind of
audition. If he passed us, we had a chance. But just as an indepen-
dent fag, I would never have gotten into the Venice art scene. I real-
ized from the beginning, I was only on approval. It was a concession.
Others were not encouraged to apply. It was largely because I was
guaranteed by Chris, who was charming, witty, modest, unpreten-
tious. Of course, if he made up his mind to charm whoever, he
always succeeded. Billy liked him immediately, and so did all the oth-
ers. Otherwise, I probably would never have gotten into the art world
here."[32]

Though they rarely frequented gay bars, Isherwood and Bachardy
went with Hockney and his friend Patrick Proctor to one on Melrose
in 1965. "They were three years younger than I but I was the only
one to get carded," says Bachardy. "That was my last great triumph."[33]
Hockney was amazed by the nightlife at bars that stayed open until
the wee hours—as opposed to the early-closing London pubs—but it
was still risky. As Bachardy recalled, "You could still find yourself in
a raid and arrested as well."[34]

Isherwood and Bachardy preferred hosting small dinners at their
home where artists found themselves in cozy conversation with movie
stars and writers. The flirtatious Bengston became great friends with
Jamie Lee Curtis, Teri Garr, and *Gigi* star Leslie Caron, who was mar-
ried to producer Michael Laughlin. Director and producer Tony Rich-
ardson, Vanessa Redgrave, Roddy McDowall, and Vivien Leigh were
regulars who mixed easily with art dealer Nicholas Wilder, the Ruschas,
and Joe Goode, who was living with *Beaches* screenwriter and

director Mary Agnes Donoghue. Other guests included Igor Stravinsky, authors Joan Didion and John Gregory Dunne, and visiting poets Stephen Spender and W. H. Auden—the Isherwood-Bachardy dining room became a center for bringing together the usually segregated artists of the city. Hockney was invited whenever he was in town.

Wilder Times with Bruce Nauman and *Artforum*

N icholas Wilder's conservative family in Rochester, New York, expected him to prepare for a career in law when he enrolled at Amherst College. A part-time job as a slide projectionist in art history classes derailed that ambition. Then he met Marcel Duchamp, who had come to lecture, and though he was only a guard at the college's Mead Art Museum, Wilder gave the artist a tour of the collection. In graduate school at Stanford, he studied art history while selling art at the Lanyon Gallery in Palo Alto. After selling some forty-five works by abstract painter Tom Holland in one year, he abandoned the academic life. He sold work by young artists Robert Graham, Ron Davis, and John McCracken, all then working in Northern California. By 1965, the twenty-eight-year-old Wilder knew it was time to open his own gallery, and he felt Los Angeles was his future.

To help launch the gallery, Barnett Newman gave him a painting to sell and two years to pay him for it. (*Tundra* was sold to Robert Rowan.) Ruscha designed his stationery. With $10,000 in shares sold to five backers—including his Stanford friend and publishing heir Charles Cowles, who also backed *Artforum*, and the father of another Stanford friend, Katherine Bishop, who became his business partner—he renovated the gallery space at 814 North La Cienega Boulevard next to the respected bookseller Jake Zeitlin. Within a year, he had bought back all of the shares from his backers.

As Bishop put it, "He loved Southern California as perhaps only an East Coast person could . . . an alternative to the expectations of [Eastern] educated 'good taste.' . . . Los Angeles epitomized the transgressive beauty Nick most enjoyed. . . . He was a gay man who hated associations of the *Queer Eye* sort, preferring steaks, scotch, Pink's chilidogs and ignoring his wardrobe and furniture completely."[1]

Wilder opened his gallery on April Fool's Day, 1965, shortly after the sensational opening of the new L.A. County Museum of Art. Trim, with thin brown hair, Wilder wore white suits and large horn-rimmed glasses. He was nothing like the flamboyant bleached-blond Hockney, with his propensity for wearing unmatched but brightly colored socks, but like Hockney, Wilder became liberated living in Los Angeles. Hockney lived at his house briefly in 1966, though not as a lover, and Wilder and the young men congregating around his swimming pool became a small but important genre within the immense Hockney oeuvre.

In spring 1966, Wilder showed the artist who came to be known as his greatest discovery: Bruce Nauman. At the apartment of artist Tony DeLap, Wilder saw his first Nauman. "It was like a rancid piece of toothpaste on the wall. About forty-six inches wide, a kind of khaki-colored thing that was cast plastic that dropped forty inches down the wall."[2] He couldn't get it out of his mind and decided to visit the artist.

By then, the Rolf Nelson Gallery was closing, so Joe Goode joined Wilder. Wilder invited Goode to drive north to meet the unknown Nauman. Goode recalled the saga: "Nauman was very shy. He didn't talk much but he was very bright and very nice. So we pick up these slimy, fiberglass things that were taken off molds to hang on the wall.

I was mesmerized. We put them in the back of the station wagon. We both were so excited to see what they looked like on a white wall that we hung that fucking show at three o'clock in the morning."[3]

Nauman, twenty-five, was still a student in the new fine-arts graduate program at the University of California–Davis near Sacramento. His teachers William Wiley and Wayne Thiebaud were far more progressive that those Nauman had had as an undergraduate at the University of Wisconsin, where abstract painting was barely tolerated. Raised in a middle-class family in the Midwest, Nauman had an aptitude for math and music that would percolate through his art after he abandoned painting to make abstract sculptures that incorporated nontraditional materials and processes. Even before Nauman had graduated and moved to San Francisco, Wilder showed his cast body parts of raw fiberglass and pieces of rubber that lay on the floor or hung at angles on the walls.

Wilder tried to convince collectors with his basic premise of collecting contemporary art: "That nineteenth-century notion of connoisseurship doesn't rule. There's no exam to be passed. You're on your own. The first thing you have to do is be comfortable with the fact that you're not on firm ground. That's a delightful situation."[4] Few got it until the following year when Fidel Danieli published an eight-page article in *Artforum* beginning: "A first encounter with the work of Bruce Nauman is extremely disconcerting."[5] By that time, Nauman was ready for his first show at Castelli in New York, where he and his wife Judy Govan had moved.

A year later, in 1969, they moved to Los Angeles and paid seventy-five dollars a month to live in part of Hopps's craftsman-style house in Pasadena. (Artist Richard Jackson and his girlfriend Christine Langras lived in the other half.) This enviable rental was passed from artist to artist for decades. Goode had lived there a few years before. Nauman's modest lifestyle was offset by the fact that he drove a classic Ferrari purchased for him by Paris dealer Ileana Sonnabend, Castelli's ex-wife, who owed him a significant sum for European sales. Like Ruscha, Nauman discovered snazzy cowboy shirts and boots at Nudie's, San Fernando Valley tailor to Roy Rogers and other singing cowboys. Nauman, who had become successful quickly, was friendly

with other Los Angeles artists but not one to hang out at the Barney's scene.[6]

In addition, Wilder discovered John McCracken as a student at California College of Arts and Crafts in Oakland. Influenced by the Zen Buddhist–inspired paintings of John McLaughlin, which mostly contained just two or three bands of very specific colors, McCracken covered a simple plank of plywood with some thirty coats of polyester resin, each coat sanded to a glossy, translucent sheen. Initially, he used other geometric shapes, but once he discovered the plank, which leaned against the wall like a surfboard, it became his principal unorthodox support for pure color. Wilder showed his work in Los Angeles in 1967, after it had been included in the Primary Structures show in New York.

Wilder thought Joe Goode was a "great artist" and eventually owned thirty-seven of his works. Sales were never very strong so Goode supported himself by betting on the horses at Santa Anita and Hollywood Park, often sitting with his mentor Robert Irwin, who made more money at the track than from sales of his art. Irwin taught Goode the complex mathematics of the handicap but there was a drawback. "You become addicted to it," Goode admitted. "I couldn't do it half-assed. So on my bio, in 1963 and 1964, there were no shows because I was at the race track the whole year."[7] When Wilder showed the New York artist Walter De Maria, Goode took him to the track as well, and pretty soon he, too, was avidly dedicated to the sport of kings.

When Wilder came to see his work in 1965, Goode was building sculptures of staircases that led to blank walls but didn't have the funds to complete them quickly. Wilder said, "What if I helped you financially and you can have a show in six months?"[8] Priced from $400 to $700, a couple sold, including one to Charles Cowles.

In addition to Hockney, Nauman, Goode, and McCracken, Wilder showed Hockney's former neighbor Ron Davis, who used resin to make dodecahedron-shaped abstract paintings. Robert Graham made Plexiglas containers bearing small nude figures of women or men, sometimes both having sex. Otherwise, Wilder drew from New York, bringing in the color-field painters supported by critic

Clement Greenberg—Kenneth Noland, Jules Olitski, and Helen Frankenthaler—and included in Greenberg's 1964 Post-Painterly Abstraction show. He also showed Flavin, Newman, Agnes Martin, Cy Twombly, and Richard Tuttle. Mary Lynch Kienholz came to work for him in 1969 and after that, he took on many more Los Angeles artists who had been with Ferus. In short, Wilder's taste was catholic. He showed seventy-one artists in one decade. Many showed with him only once, and he got a reputation for not being able to pay his artists, but he was revered for extravagant openings that always featured a fully stocked bar. Plus, he took out full-page ads every month in *Artforum*, which he had been instrumental in founding when working in San Francisco.

Shortly before relocating to offices above the Ferus Gallery, *Artforum* dedicated their summer 1964 issue to "The Los Angeles Scene Today." Articles about collectors, architecture, artists, and museums provided context for the new L.A. County Museum of Art scheduled to open the following year. In one article, editor Philip Leider coined the phrase "The Cool School" to describe artists from the Ferus and Rolf Nelson galleries: Irwin, Price, Bell, Bengston, Ruscha, Goode, and Foulkes. "Taken as a group, the Los Angeles avant-garde may be producing the most interesting and significant art being produced in America today."[9]

In the same issue, John Coplans eviscerated Post-Painterly Abstraction, the exhibition organized by Clement Greenberg, who was waning in power but still an influential New York critic. Held at what he must have thought of as a provincial outpost, the L.A. County Museum of History, Science, and Art, Greenberg attempted to define what might follow the Abstract Expressionism that he had promoted so intensely. Irwin, then doing paintings of two thin lines on feathered backgrounds of soft earth tones, was invited to add work to the show but refused after reading Greenberg's catalog essay. "I was correct in the sense that what he was trying to do I had no sympathy for, it was not what I was doing, and it was not my involvement," Irwin recalled. "I was naïve in the sense that I didn't know who he was. I just wrote him a letter and told him how dumb I thought his ideas were."[10]

Coplans, born in England but raised in South Africa, was mature

from his military experience as a young fighter pilot during World War II. A self-taught painter of geometric abstractions, he was inspired by the 1959 New American Painting show in London to move to San Francisco. He was hired at UC Berkeley two years later as a visiting assistant professor. He befriended Peter Voulkos, who was teaching in the architectural design department, as well as Hopps after hearing him lecture at the San Francisco Art Institute. Influenced by the pluralistic views of English critic Lawrence Alloway and far removed from the intimidating force of Greenberg's personality and reputation, Coplans questioned that critic's belief system because it allowed only certain methods of making art and rejected artists as talented as Rauschenberg and Warhol. "Greenberg, in rejecting the notion that contemporary art is clearly distinguished by the co-existence of a number of perfectly valid, credible and widely diverse styles, asserts that there is only one correct logical style at any one given time. . . . In short, what is not in the right style cannot be art, and what is in the right style must be art."[11]

Here was a magazine willing to take a stand against one of New York's most powerful critics and willing to defend the art of Los Angeles! *ARTNews* magazine's Thomas Hess and Harold Rosenberg had reigned for a decade as the promoters of Abstract Expressionism; their magazine covered a diverse range of exhibitions but rarely acknowledged the existence of artists in Los Angeles—or Europe for that matter. The art magazines of that time were focused on New York.

Artforum came about in recognition of this fact. A salesman for a San Francisco printing company, John Irwin, had come to the Bolles Gallery in Palo Alto to solicit business. Philip Leider, who was working there at the time, suggested, "Look, if you really want to make money as a printer, publish a West Coast art magazine. That's what we really need."[12] Leider, a graduate of Brooklyn College with an interest in literature and music, had moved with his wife Gladys to San Francisco to follow its thriving poetry scene. He did not know much about art but felt he could be an editor.

Shortly after, Leider left his job at the gallery and Irwin hired him at eighty dollars a week to edit the fledgling magazine. Their combined inexperience contributed to a chaotic launch. Irwin hired a

"kid just out of art school" who designed the distinctive ten-by-ten-inch-square format based on the News Gothic font. Early issues were not dated by month because they were not sufficiently organized or funded to predict such details. However, the magazine covered galleries and museums from Portland to Tucson, and within two years, advertising revenues had soared. It attracted well-heeled backers in San Francisco, including Elizabeth Heller and Charles Cowles, but it was not profitable enough to pay writers. Nonetheless, the magazine attracted talented contributors such as Coplans and James Monte, a painter who had worked at Bolles Gallery and eventually became a curator at the L.A. County Museum of Art and later at the Whitney Museum of American Art.

As the Los Angeles scene gained strength, it was decided to move the magazine south. Publisher Cowles, Leider, and Coplans came with it. Since the writers were not paid, Coplans accepted the post of gallery director at UC Irvine, a new campus forty miles south of Los Angeles. As a teacher, he invited Barbara Rose, also a contributor to *Artforum*, and her husband Frank Stella to be visiting professors. Stella refused to sign the loyalty oath required in post-McCarthy-era California and wasn't allowed to teach, even if he lectured gratis. This story did little to improve the backwater reputation of California once it made the rounds in New York. While in Los Angeles, Stella showed at Ferus and made prints at Gemini GEL, including a series dedicated to Blum.

Compared to San Francisco, the scene for contemporary art in Los Angeles was thriving, and Leider was excited at first. He said, "It was people like Shirley [Hopps] who were able to secure me, and make me certain that I wasn't being a fool. I was very buoyed by the fact that this was an art historian who did her doctorate on triptychs, and she had no doubt about the quality of Roy Lichtenstein." Shirley and Irving, he said, "educated me."[13]

Ruscha was hired as production designer, using the pseudonym "Eddie Russia," and in September 1964, placed a full-page ad for his show: a black-and-white portrait of a lovely blonde, with hair swept up and chandelier earrings, pulling a credit card from her cleavage with the artist's name and the words "Ferus Gallery." In keeping with

Billy Al Bengston, *O.K. Coral*, [sic], 1961
Photograph courtesy of Billy Al Bengston

Craig Kauffman,
Erotic Thermometer, 1964
Photograph courtesy of Frank Lloyd
Gallery, Santa Monica

Larry Bell, *Cube*, 1966
Collection of the Los Angeles
County Museum of Art,
Gift of the Frederick R.
Weisman Company
Digital Image © 2009
Museum Associates/
LACMA/Art Resource, NY

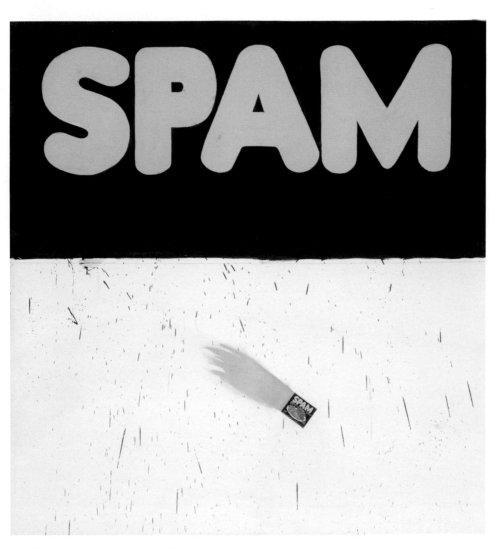

Ed Ruscha, *Actual Size*, 1962

Collection of the Los Angeles County Museum of Art,
Anonymous gift through the Contemporary Art Council
Digital Image © 2009 Museum Associates/LACMA/Art Resource, NY

Joe Goode, *Happy Birthday*, 1962

Collection of the San Francisco Museum of Modern Art

Judy Chicago, *Carhood*, 1964

Collection of Moderna Museet, Sweden
Photograph © Donald Woodman

David Hockney, *Portrait of Nicholas Wilder*, 1966
Courtesy of David Hockney

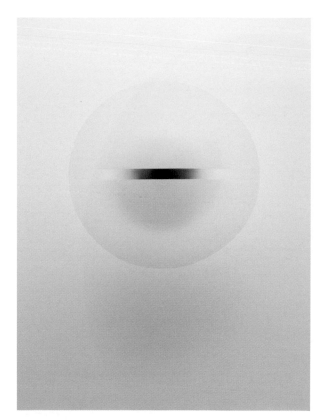

Robert Irwin, *Untitled*,
1969
Collection of Museum of
Contemporary Art San
Diego
Photograph by Philipp
Scholz Rittermann
@2010 Robert Irwin/Artists
Rights Society (ARS),
New York

Doug Wheeler *RM 669*, 1969
Collection of The Museum of Contemporary Art, Los Angeles

DeWain Valentine, *Circle,* 1970
Courtesy of DeWain Valentine

Ferus motorcycle and surfing announcements, Ruscha was willing to poke fun at the whole notion of marketing art.

Collector Don Factor and Henry Hopkins contributed articles along with Jane Livingston, who became a curator at L.A. County Museum of Art, and Peter Plagens, a painter who had recently graduated from USC and who had a talent for writing about the complicated issues of the time with a vernacular flair. Plagens recalled his application process. He walked into the office and said, "I want to review for this magazine."[14] Ron Davis's wife Susan was at the front desk. Plagens's first article was published in February 1966, and he went on to write features on Larry Bell, Ed Moses, and Michael Asher and, in 1974, the first book on West Coast art, *Sunshine Muse: Contemporary Art on the West Coast.*

The Ascendency of Irwin's Atmospherics

M arking its relocation to Los Angeles, *Artforum* devoted considerable coverage to the U.S. segment of the eighth São Paulo Art Biennal in 1965. The United States Information Agency had invited Hopps to be curator and he selected Irwin, Bell, and Bengston to share the glory with Judd, Stella, and Larry Poons. The principal artist, however, was the venerable abstract painter Barnett Newman, known for his wall-sized canvases bearing vertical columns of subdued colors. One wag called it six tugs moving a large liner into port.

Newman went to São Paulo six times to oversee his installation. None of the Los Angeles artists made the trip though art collector Ed Janss's daughter, Dagny, then eighteen, accompanied Hopps as, she said, "a sort of dogs body," to São Paulo. "I think my father negotiated with Walter to get me the job, but what was he thinking?" she added.

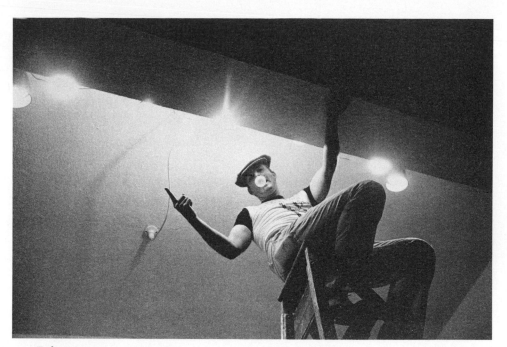

Robert Irwin
Photograph by Dennis Hopper, © The Dennis Hopper Trust,
courtesy of The Dennis Hopper Trust

"I think I was to act as interpreter because I could speak a little Por-
tuguese because I'd taken courses in school. Barnett Newman came
to install his paintings and his *Broken Obelisk* sculpture—my job was
to pour lemon juice and Coca-Cola on it so it could rust. I was there
about six weeks to be an assistant. Walter was taking black beauties
all the time. He had to physically install the show and he was out
every night with all the artists at every night club. There was an error
in the catalog so I had to glue the correction over the paragraph in all
of the catalogs. There were discos at night. Then we would take Mil-
town, the tranquilizer, to go to sleep. It was not regarded as wrong."[1]

Irwin's paintings were the most minimal of his career at that point.
He was intuitively paring away extraneous elements. Beginning with
paintings of the straight line, since it had "the least possible literate
meaning," Irwin had progressively reduced the marks on his paint-
ings until by 1964, there were only two lines running horizontally
across the painted canvas. Along the way, he was taken hostage by

his own curiosity and an increasing refinement of perception. What he called "dots" were paintings made between 1964 and 1966 on slightly convex white canvases almost seven feet square and covered with tiny spots of green and red paint. The dots seemed to vibrate against one another, creating what Hopps once described as "a field of color energy."[2]

The slightly curved surfaces of the canvases were barely noticeable, but it took Irwin months to build the special struts that supported their gently swelled forms and then cover each back with a veneer of wood. Irwin's exposure to Zen Buddhist pottery led him to believe that each piece had to be thoroughly finished. "I spent days, weeks, months finishing things no one is ever going to see. But it had much more to do with the fact that I couldn't leave them unfinished. I just had this conviction that in the sense of tactile awareness, if all those things were consistent, that then the sum total would be greater."[3]

Stella took one look at them and asked, "Why do you go to so much trouble in finishing your paintings, for example, in making the edges on your frames so perfectly straight?" Irwin answered, "Why don't you? How can you not?" Stella was making hexagonal paintings, but the edges of the canvases were often uneven and unfinished in appearance. Stella shrugged. "It's not important," he said. Irwin was stunned.[4]

Irwin's time-consuming efforts resulted in paintings with no imagery; just a blush of pale color that might not be noticed at all by a casual observer. Certainly such minimal art was not familiar to Brazilian audiences, who were, anyway, hostile toward the United States for political reasons. (There were suspicions, later confirmed, of U.S. involvement in the 1964 ouster of Brazilian president João Goulart.)[5] They vented their collective frustration on Irwin's dot paintings. "People attacked them, they cut them with knives, they threw things at them, they spit on them," Irwin said.[6]

When the paintings were returned, Blum and Hopps were afraid to tell Irwin about what had happened. It had taken three years for him to complete ten paintings, so losing two was a significant loss. Yet, when Blum finally worked up the nerve, Irwin was not even upset. He said, "I was really struck by the fact that I had absolutely no

emotion about it at all. . . . From that point on I knew I would no longer be operating or living in that kind of time frame."[7]

Brazil was not the only place where the "dot" paintings irritated viewers. When The Responsive Eye, an exhibition organized by the Museum of Modern Art, opened at the Pasadena Art Museum, Irwin's dots flanked a few Ad Reinhardts. At the reception, Irwin found himself confronted by a museum patron demanding that he not make this kind of art anymore. "She just insisted that the whole thing was absolutely un-Christian, anti-American. . . . I didn't react at first."[8] Irwin tried to avoid the attack by drifting away from her, but she continued the harangue, shouting after him. Finally, he turned around, raised his middle finger, and yelled, "Fuck you, lady!" The woman fainted.[9]

"That's a big difference between a West Coast artist and a European," said Irwin. "A European artist really believes in himself as part of that historical tradition, that archive. They see themselves in that way, with a certain amount of importance and self-esteem and so forth. . . . When I was growing up as an artist there simply wasn't any stream for you to orient yourself toward. Obviously you think what you do is important, or you wouldn't be pursuing it with the kind of intensity you do. But the minute I start thinking about making gestures about my historical role, I mean, I can't do that. I have to start laughing, because there's a certain humor in that."[10]

During the years that Irwin devoted to being in his studio, painting one tiny dot next to another, he retreated from the evenings at Barney's. His isolation took its toll on his marriage. In 1958, he had married the sister of one of his sister's friends, a Swedish American woman named Nancy Oberg. They divorced in 1959 but remarried in 1961. As he progressively pursued his quest, however, he was less available for the relationship. Irwin and Oberg divorced for the second time in 1966 and spent their last evening together dividing their few possessions—the toaster, the table, the car—in an all-night game of gin. Irwin was just beginning his voyage into the realm of phenomenology, and he would have to travel solo.

Set the Night on Fire

The Watts Riots forever changed the world's irresistible dreamy view of Los Angeles. Instead of celebrity and weather reports, television sets were tuned to its black citizens being dragged and beaten by uniformed white policemen while buildings went up in flames to chants of "Burn, baby, burn!" For a searing, smoggy week, from August 11 to 17, 1965, Los Angeles was stripped of her customary disinterest in political engagement. Coincidentally, the artist who had spent most of his life constructing the ceramic-encrusted towers in Watts, "Simon" Rodia, had died that summer in San Francisco, having given his spectacular creations to his neighbor and then leaving with no forwarding address.

The riots resulted in $40 million of damage to property in the Watts area, but the towers were untouched. They had become home to an art center founded by African American assemblage artist Noah

Purifoy with teacher Sue Welsh and musician Judson Powell. (Purifoy, a Chouinard graduate, scavenged the detritus of the riot with others to make assemblage sculptures that went on tour the following year as 66 Signs of Neon.)

Though sparked by the arrest of a black drunk driver, Marquette Frye, by white LAPD officer Lee Minikus, who insisted on impounding the car rather than letting the driver's brother take it home, the racial and class tension that fueled the riot had been accumulating for years. In the 1940s and '50s, the area around southeast and central Los Angeles had been home to a thriving community of African Americans, with jazz clubs, hotels, restaurants, and churches. Unemployment and poverty rose dramatically as white veterans returned from World War II and were given any available jobs. After two decades, addiction and alcoholism had contributed to the general neglect. Residents of Watts, like blacks all across the country, had been listening to Martin Luther King Jr. and reading about the marches in Selma, Alabama, and the rise of the civil rights movement. The previous year, Proposition 14, backed by the California Real Estate Association, repealed the state's Rumford Fair Housing Act, which had prohibited discrimination by landlords who refused to rent to blacks, Latinos, and others. This further inflamed the sense of injustice felt by the community.

Furthermore, L.A. police chief William Parker was perceived as biased against blacks, a feeling not lessened by his characterization of the rioters as monkeys in a zoo. His justification of the use of extreme force, along with the deployment of National Guard troops, was met with anger and exasperation.

Opinion throughout the city was polarized, but artists were on the side of the black community. Dennis Hopper powered his Corvair convertible, with the top down, through the flames and smoke to take photographs. Rudi Gernreich staged a fashion shoot with his models posing in front of the Watts Towers to draw attention to their surreal beauty. Ed Bereal, the African American artist included in the 1961 War Babies show, had just returned to Los Angeles after three years in San Francisco. Dwan had put him on retainer for a show at her gallery. All that changed when he opened his door on August 14, 1965, at nine in the morning and found himself surrounded by nine

National Guardsmen with guns. He was not harmed, but he was scared. Speculating on what might have happened if any of them had pulled the trigger, Bereal wrote, "My current series of sculptures is suddenly questionable. If I could put all the articles written about my work between me and that bullet . . . none of it would have stopped that bullet!"[1] A traumatized Bereal stopped making sculptures in order to pursue performance art and drama to better express his increasingly politicized outlook.

Up until the midsixties, the contemporary art scene in Los Angeles, as elsewhere, was largely the realm of white men. A handful of African American artists struggled to find places to show apart from the Watts Towers summer arts festival. In 1967, Alonzo and Dale Davis opened Brockman Gallery for African American artists, and two years later, Suzanne Jackson opened Gallery 32 in her apartment in the Granada Building near MacArthur Park. David Hammons, Betye Saar, Melvin Edwards, and John Outterbridge were among those who started to get attention.

Female artists were being taken more seriously, but not at Ferus, where the previous year's group show was unapologetically titled Studs. The gallery was, as Price put it, "the all kings stable."[2] Bengston and others jeered at aspiring female artists but, in truth, other galleries were not much better.

Shirley Hopps said, "I think a lot of that role-playing and machoness and complimenting each other came from the fact that what they were doing was so far-out, not working from the past, just working from themselves and avoiding confrontation with nothingness. There was competitiveness but mostly loneliness and fear."[3]

Nonetheless, it was a square-jawed woman of twenty-seven named Vija Celmins who addressed the riots most directly in her black-and-white painting *Time Magazine Cover*, which reproduced the magazine's headline and photographs of fire, an overturned car, and black men running in the street. A war refugee from Latvia whose family had immigrated to the United States in 1948, Celmins understood fighting in the streets quite a bit more than the average student at UCLA, where she had just graduated with a master's degree. She had been raised in Indiana where, unable to speak English at first, she had taken refuge in her extraordinary drawing

Vija Celmins, Time
Magazine Cover, *1965*
Collection of Hauser and Wirth

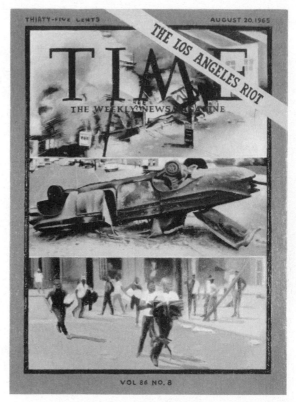

skills. After graduating from the John Herron Art Institute in India-napolis, she had earned a grant to enroll at UCLA in 1962, the same year that Hopps organized the first Pop art exhibition. Her precise drawings and paintings of utilitarian objects, such as toasters and fans in tones of gray, black, and white, got her roped into the beginning Pop art movement, though her concerns were considerably more mordant. She copied photographs from books to make detailed draw-ings and paintings of World War II–era airplanes, zeppelins, and war disasters, both revisiting her past and eliciting admiration from even the most hardened of her male colleagues, who were her neighbors in Venice. She broke through the barrier against women to show with the David Stuart Gallery in 1966.

The politicization of students and young people around the world was gaining velocity. Protests against the Vietnam War were taking place around the country. That April, fifteen thousand students marched

on Washington, D.C. The Artists Protest Committee was formed by painters Irving Petlin and Arnold Mesches, both then living in Los Angeles. Petlin, a visiting artist at UCLA, completed a vast canvas called *The Burning of Los Angeles*; his figurative and abstract paintings were shown in 1966 at the Rolf Nelson Gallery. A few years earlier, he had lived in Paris during the Algerian War of Independence and observed the repression of demonstrations in France. He saw similar government crackdowns against the Vietnam War protests. Though he initially believed Los Angeles artists to be apolitical, he decided to try and mobilize them. Petlin, who had shared an apartment in Paris with Kauffman, said to Mesches, "Let's do an experiment. Let's call Craig Kauffman, who was the most non-political person I could think of in Los Angeles, and let's call Ed Kienholz, and see how they feel about some form of coordinated political activism."[4] To his surprise, Kauffman answered, "Yeah, I would be interested in joining that." Stunned, he then called Kienholz, who said, "You guys are letting our troops down." Petlin thought, "It's impossible to predict what's going to happen here. . . . Let's call a meeting and see."[5]

The meeting at Dwan Gallery attracted Hopps, Coplans, Leider, and dozens of willing artists. The group decided to protest the RAND Corporation, perceived to be a liberal think tank but one that was advocating protected zones for Vietnamese civilians to allow greater free fire in other areas of the country. The group contrived a debate with RAND officials that attracted an overflow crowd of eight hundred to the Warner Theater. After this action was ignored by the press, Petlin called antiwar activist and sculptor Mark di Suvero to build a "Peace Tower" on a rented vacant lot on the corner of Sunset and North La Cienega boulevards.

Di Suvero had been in a wheelchair since 1960 after he was crushed brutally in an elevator accident. He had determinedly pursued rehabilitation and just as determinedly pursued sculpture on a massive scale. He designed a sixty-foot-tall pile of polyhedrons, a yellow and purple armature that was erected with the help of Melvin Edwards, Lloyd Hamrol, and Judy Gerowitz, as well as a few of Ken Kesey's Merry Pranksters. Inspired by the spindly height of Watts Towers, it was di Suvero's first sculpture of architectural scale and it transformed his subsequent work. His huge sculptures made of tim-

bers were being shown at Dwan Gallery, though he did not feel accepted by the Los Angeles artists who were perfecting pristine surfaces. "They used to put me down saying, 'Oh, you're A/E, meaning Abstract Expressionist," he said later. "They didn't believe in this grungy work I was doing."[6]

The tower supported 418 individual paintings of protest, each measuring two feet square, that were donated by artists from all over the world: Rauschenberg, Stella, Reinhardt, Lichtenstein, and others from New York, as well as countless Los Angeles artists. After three months, the works of art were auctioned and the proceeds were used to subsidize continued protests against the war.

A chain-link fence was erected around the tower to keep out vandals and bore a sign declaring "Artists Protest Vietnam War." Petlin and other artists were attacked by conservatives and outraged members of the military. African American supporters from Watts volunteered to stand guard. When Petlin had to defend himself and the tower with nothing more than the broken end of a lightbulb, Stella sent him a check for $1,000 with a note saying, "Anybody who puts their life on the line defending a work of art of mine, I'm going to send a thousand bucks to."[7]

Di Suvero, despite his disability, was harassed and beaten by police. To get rid of the tower, city officials claimed it was structurally unsound. To prove them wrong, the artists suspended a Buick from the armature. When there was no buckling or leaning, city officials had to relent. (The city's Department of Building and Safety was defeated previously by Watts Towers when, in 1959, they proposed to demolish it as unsafe. Supporters demanded a stress test and found that a crane applying ten thousand pounds of pressure could not budge any part of Rodia's creation. The Watts Towers remained.)

The Peace Tower grabbed attention from the press, but the *Los Angeles Times* and other papers and television stations were editorially conservative, and nearly all of the coverage was negative. On February 26, 1966, the day of a massive protest at the tower, Petlin received a telegram of support from Jean-Paul Sartre, Simone de Beauvoir, André Breton, Michel Leiris, André Masson, Matta, and other artists and intellectuals. Ironically, the Los Angeles war protest took place four years before an equivalent action in the theoretically more

politicized art community in New York, where the Art Workers Coalition was formed in 1969.

Adding to the hyperventilated atmosphere of the city, a couple of weeks earlier, on the symbolic date of Lincoln's birthday, 1966, author Ken Kesey's friend Ken Babbs had organized an "acid test" to bring love and tolerance to the Merry Pranksters' African American brothers and sisters in Watts. To bring LSD-fueled enlightenment to the multitudes, the Pranksters rented a vacant Youth Opportunity Center warehouse in Compton. They projected films of their travel adventures on Further, Kesey's bus, while the Grateful Dead played fitfully. Two plastic trash barrels filled with Kool-Aid were brought out: one labeled for "children," the other for "adults." No one bothered to explain that "adults" meant Kool-Aid heavily laced with LSD. Prankster Lee Quarnstrom wrote later, "Owsley [Stanley] had a couple of glass ampules with pure LSD in them and he poured it into the Kool-Aid. We did some quick mathematics and figured that one Dixie cup full of Kool-Aid equaled fifty micrograms of acid. The standard dose, if you wanted to get high, was 300 mics. So we told everyone that six cups would equal a standard trip. After a couple of cups, when I was as high as I had ever been, somebody recomputed and realized that each cup held 300 micrograms. I remember hearing that and realized that I had just gulped down 2,000 micrograms. The rest of the evening was as weird as you might expect."[8]

The event had been promoted on the alternative FM radio station KPFK and in the *L.A. Free Press*, and some two hundred people wound up having their perceptions altered, whether they liked it or not, from 10 p.m. until 6 a.m. In the early morning, the working neighbors of Watts woke up and dropped by to check out the crazy party where people with painted faces and outlandish costumes still had bloodshot, dilated eyes, but they did not grasp the truth of what had gone down that night. Police were on hand but no one was arrested. The tests were held five months before LSD was declared illegal.

For years, Beverly Hills psychiatrists had used LSD to treat the various neuroses of Cary Grant, Esther Williams, and other celebrities. But Timothy Leary and Ken Kesey had linked the drug to their code of "Tune in, turn on, drop out." Taking LSD was no longer an intimate though antiseptic process conducted with a blindfold in a doctor's

office. *Life* magazine gathered Prankster faithfuls and their bus in a Los Angeles studio where they were photographed for a big magazine article. Word of the acid tests spread fast, and in no time, LSD was too popular for its own good.

It soon became clear that the unhip population of California, which is to say the majority, was fearful of acid tests and peacenik hippies sweeping visibly down the coast from San Francisco to Los Angeles. In November 1966, conservative Republican Ronald Reagan was elected the thirty-third governor of California, ending the relatively benign eight-year rule of Democrat Edmund G. "Pat' Brown.

Little more than a week later, and a year after the Watts Riots, a smaller, whiter riot took place on the Strip at a purple and gold club called Pandora's Box owned by KRLA deejay Jimmy O'Neil. So many young rock fans were clogging the sidewalks outside the club and blocking traffic along the two-mile stretch of Sunset Boulevard that a 1939 curfew ordinance was used to establish a 10 p.m. curfew for minors. On November 12, 1966, flyers were circulated inviting a demonstration against the curfew, and rock stations announced a rally at Pandora's Box. One thousand people turned out, including Jack Nicholson and Peter Fonda, though they were not among the many who were arrested. Sonny and Cher performed at Pandora's Box, then Sonny wrote and immediately released a 45 rpm single "We Have as Much Right to Be Here as Anyone." The L.A. County Board of Supervisors responded by rescinding the youth permits of a dozen of the Strip's clubs so they would be off-limits to anybody under twenty-one. Within weeks, American International Pictures produced a film for the drive-in crowd, *Riot on Sunset Strip*. The official anthem came from Stephen Stills, who wrote "For What It's Worth," which was released two months later by his band, Buffalo Springfield.

> *Young people speaking their minds,*
> *Getting so much resistance from behind.*
> *I think it's time we stop, hey, what's that sound?*
> *Everybody look what's going down.*

Chicago Comes to Los Angeles

C alifornia's conservative politicians could not slow the radical shift in consciousness that had taken place since the collapse of Kennedy's Camelot. One artist who embraced this change was Judy Cohen, who was born to activist Jewish parents in Chicago in 1939. Her youthful desire to become an artist could only be described as a drive. As an undergraduate at UCLA, she was a classmate of Vija Celmins, and even her teachers were daunted by her apparent ambition.

An irrepressible personality, round-figured with mounds of springy brown hair, Cohen was still in the UCLA art department when she married aspiring songwriter Jerry Gerowitz in 1961. The couple moved to a house in Topanga Canyon where, just two years later, driving the treacherous curving road there, his car went over a steep embankment and he was killed. Devastated, she allowed herself a period of

mourning before returning to her studies at UCLA with greater resolve. She rented an apartment in a building in Santa Monica owned and designed by architect Frank Gehry, whose brother-in-law Rolf Nelson would show her work in his new gallery at 669 North La Cienega Boulevard.

The first paintings completed after her husband's death were biomorphic abstractions based on her own anatomy that disturbed her mostly male professors. "I had no idea it would be provocative because I was not thinking about how others might respond but rather about my own pain and grief and how to express that," she said later.[1] Still unsure of her direction, she retreated from these personal themes to complete a group of rectilinear painted sculptures. Relying on amphetamines, she worked eighteen hours a day to get ready for her master of fine arts show in 1964. She was rewarded for her efforts when Irwin looked around carefully before saying to her, "It's a damn fine show."[2]

She hung out with the Ferus boys, as well as with Rolf Nelson's boys, at Barney's, where she wore work boots and smoked cigars to fit in with her male colleagues. "They spent most of their time talking about cars, motorcycles, women, and their 'joints.' . . . They made a lot of cracks about my being a woman and repeatedly stated that women couldn't be artists. I was determined to convince them . . . that I was serious."[3]

By 1965, John Coplans was finding greater success as an art critic and curator than as an artist. At forty-three, twice divorced, he began dating Gerowitz, then twenty-four. Both Jewish, they also shared social and political interests. He tended to be combative, and so did she. Though he bought her art materials and took her to dinner, he remarked, "You know, Judy, you have to decide whether you're going to be a woman or an artist."[4] Their relationship soon ended but they remained friends. Four years later, Coplans organized a show of her work at the Pasadena Art Museum. And when she went to New York, he set up a meeting with the powerful critic Harold Rosenberg, who, though married, tried to seduce her. She returned to Los Angeles after the meeting, thinking "the new world really is the West Coast."[5]

Influenced by Leider's *Artforum* article "The Cool School," praising the efforts of Bengston, Bell, and Kauffman, Gerowitz decided to

attend an auto-body school to learn to spray paint on metal. The only woman among 250 men in the class, she enjoyed a fling with the African American instructor, who drove a lavender convertible. She applied her new painting skills specifically in her 1964 work *Car Hood*. She described it: "The vaginal form, penetrated by a phallic arrow, was mounted on the 'masculine' hood of a car, a very clear symbol of my state of mind at this time."[6] She kept striving to gain acceptance into the inner circle of Ferus bad boys. One night at Barney's, she got drunk enough to thank Bengston for influencing her work. Far from flattered, he dismissed her as a "flash in the pan."[7]

By that time, her earlier friendship with sculptor Lloyd Hamrol, who had divorced his wife Nancy, had taken a romantic turn and in 1965, the couple rented a five-thousand-square-foot loft on Raymond Avenue in Pasadena for seventy-five dollars, which they shared with Llyn Foulkes. They had found similar loft space for di Suvero. (Ruscha had briefly rented a three-thousand-square-foot studio in Pasadena but felt his work was overwhelmed by the enormity and moved his studio to an apartment on Western Avenue in East Hollywood that he kept for twenty years.)

Around that time, Gerowitz met Stanley and Elyse Grinstein at a party. Elyse said that until she met Judy, she wore a girdle and carried a handbag to match her shoes. The Grinsteins became her patrons, and one of their first gestures was to send a set of white porcelain dishes to the young couple's loft.

At her first solo show in January 1966 at Nelson's gallery, she wore a backless tuxedo of her own design. *Rainbow Pickett*, named after Wilson Pickett, consisted of six trapezoids of different lengths and pastel colors leaned against a wall at an angle in decreasing size. They were not airbrushed but made of painted canvas stretched over plywood forms. Her unpleasant encounter with Bengston had had an impact.

"I'm finished with the kind of surface & craft preoccupation of the Ferus boys," she wrote. "It's a dead end that leads to preciousness, & they're really fucked up by it."[8] These sculptures evolved during the earliest years of Minimalism but, as her biographer Gail Levin wrote, "Her developing feminist ideas were expressed indirectly in her choices of soft, feminine colors."[9] Kynaston McShine selected *Rain-*

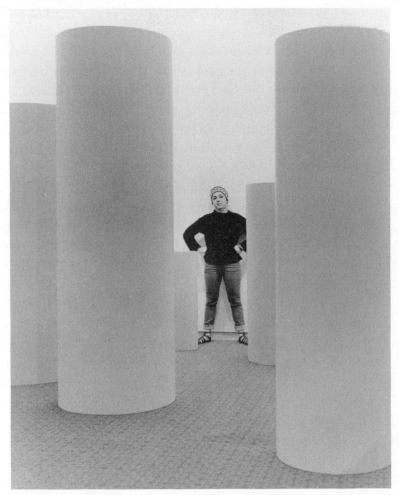

Judy Chicago with her sculpture 10 Part Cylinders, *1966*
Photograph courtesy of Through the Flower Archives

bow Pickett for the breakthrough Primary Structures show at the Jewish Museum in New York that opened on April 26, 1966. Developed with Lucy Lippard, then at the Museum of Modern Art, the landmark show also included work by Bell and John McCracken, along with Andre, Smithson, Robert Morris, and Walter De Maria.

Due to Gerowitz's flat Midwestern accent, in 1966 Rolf Nelson started calling her Judy Chicago, and soon she started listing herself that way in the phone book. Nelson had moved to a larger gallery

and in his empty room, Chicago and Hamrol erected plastic inflatable walls and filled the space with three hundred pounds of chicken feathers. Amusing and somehow in tune with the times, it garnered the publicity that she was increasingly adept at attracting. This was especially important after Nelson was forced to close his gallery at the end of 1966 due to mounting financial losses. His 736 North La Cienega Boulevard gallery had featured shows of Herms, Foulkes, and Hamrol. Nelson even convinced Georgia O'Keeffe to lend her monumental masterpiece *Sky Above Clouds IV* with a price tag of $75,000, but no one in Los Angeles, not even the new museum, bought it. Later, it went to the Art Institute of Chicago. Meanwhile, Eugenia Butler and Riko Mizuno had taken over his previous space and named it Gallery 669 for the address. They showed watercolors by the author Henry Miller, who later titled a book of his work *Paint As You Like and Die Happy.*

A number of artists were interested in moving out of the confines of their studios and into the industrial environment. Chicago, Hamrol, Oliver Andrews, Eric Orr, DeWain Valentine, and others formed a cooperative called Aesthetic Research Center in 1966. All wanted to be involved in new technological discoveries.[10] Around Christmas 1967, Hamrol and Orr helped Chicago manifest *Dry Ice Environment* at Century City, with thirty-seven tons of dry ice donated by the Union Carbide Company producing thick mist when stacked into low walls and ziggurats. They were inspired by Allan Kaprow, who had conceived the Happening in New York ten years before as a combination of his interests in the work of John Cage, Zen Buddhism, absurdist theater, and poetry, and to break down the barrier between art and life.

Kaprow's first survey exhibition had been held in September 1967 at PAM with a Happening called *Fluids.* For three days, volunteers stacked blocks of ice in rectangular arrangements some thirty feet long, ten feet wide, and eight feet high throughout the city. In the sweltering heat, the sculptures quickly attained the fluidity promised in the title but lived on in the many photographs of the event taken by Dennis Hopper.

Chicago was slowly coming to the realization that her experience as a woman was not legible in her work, yet she didn't want to be

labeled a "woman artist," either. In 1968, she refused to be included in California Women in the Arts, an exhibition organized by Josine Ianco-Starrels, director of the Lytton Center, saying, "I won't show in any group defined as women, Jewish or California."[11]

Chicago and Hamrol married in 1969. The following year, with some reservations, she accepted a teaching position at Fresno State College, two hundred miles north of Los Angeles. Far from urban influence, Chicago pulled together all of her diverse ideas about the suppressed role of women in art history and in society to form the first Women's Art Program. Chicago invited her friend the artist Miriam Schapiro up to Fresno to observe classes of woman exploring their history, their place in society, their personal assets, and their liabilities as professional artists. Schapiro suggested moving the program down to the newly opened California Institute of the Arts in Valencia, where her husband, painter Paul Brach, was dean. In 1971, Chicago and Schapiro launched the Feminist Art Program at Cal Arts. It proved deeply influential for artists of both sexes and inspired a plethora of similar programs at art schools and universities around the country.

In Los Angeles, it led to the founding of Womanhouse, where female artists could exhibit their work without the pressures to conform that came from commercial galleries, which rarely showed their work in any case.

A Museum at Last

W hen the trustees of the Pasadena Art Museum, led by Harold Jurgensen, promoted Hopps from curator to director in 1964, they lost the best of him. Hopps was most effective as an artists' liaison, able and willing to bring the latest developments into view at the museum. As director, he had less time to organize shows, so he hired as curator James T. Demetrion, who had been at UCLA with him and was teaching art history at Pomona College in Claremont, California. Like Hopps, Demetrion had had no previous museum experience. In fact, lack of experience had become something of a qualification for new hires at the museum. Energetic charm made do in the absence of a conventional bureaucracy. When photographer Jerry McMillan was hired to work on catalogs and other publications for the museum, Hopps handed him a set of keys so that he could work whenever it suited him.

Hopps organized a few shows, including a survey of Alexei Jawlensky, drawn from the Galka Scheyer collection, and he imported the Guggenheim's Kandinsky retrospective and MoMA's Schwitters retrospective, to which pieces were loaned by painter and photographer Kate Steinitz, who had met the artist in 1918 in their mutual hometown of Hannover, Germany. These were big commitments yet, as director, his primary role was to raise funds and build the permanent collection.

To that end, Hopps arranged exhibitions of work owned by trustees and museum supporters: Contemporary Selections from the Mr. and Mrs. Robert Rowan Collection, May 25 to June 27, 1965; Contemporary Selections from the Edwin Janss Collection, July 20 to September 5, 1965; Contemporary Paintings Lent by Mr. and Mrs. Frederick Weisman, November 25 to January 9, 1965; and another Contemporary Selections from the Mr. and Mrs. Robert Rowan Collection, February 25 to March 3, 1966.

Hopps had advised all of these collectors on their choices, both recommending artists and sometimes recommending specific works. The museum also showed the collection of Ed Janss's brother, William Janss, a trustee of the San Francisco Museum of Art, who owned works by Hans Hofmann, Robert Motherwell, and Willem de Kooning, from January 26 to February 28, 1965. Did he hope that works from these collections would be donated to the museum to build a permanent collection? No doubt.

"I did the gallery work because the art that the California artists and I wanted to look at, we couldn't see in Los Angeles in the late 1950s, early 1960s," he said later.[1] Hopps brought that outlook to the museum, hoping to endow Los Angeles with works by the Abstract Expressionists who had been his early heroes and the color-field painters, as well as the already valuable art of Robert Rauschenberg and Jasper Johns.

One reason that the tiny Pasadena Art Museum attracted so much attention for its inventive, if modest, exhibitions was that the city of Los Angeles did not have a museum devoted exclusively to art, let alone modern art. The Getty collections were housed in the oil tycoon's former residence on a bluff in Malibu. The university galleries did not have permanent collections. The Huntington had exceptional British

paintings and decorative arts—as well as a library and gardens—but little interest in art of the twentieth century.

The provincial nature of Los Angeles, so beneficial to the originality of its young artists, had long been a problem for its few cultural institutions. The L.A. County Museum of History, Science, and Art, a beaux-arts behemoth, was erected south of the downtown district near the University of Southern California in 1913. The program of traveling art exhibitions tended to be conservative and the galleries were given over regularly to groups such as the California Watercolor Society. Upon entering the rotunda with its stained-glass dome, one walked past the dinosaurs and dioramas to reach the art. This discouraged one group of Japanese curators from loaning Buddhist art since it could not be shown in proximity to dead animals.

Nonetheless, the collections grew through the largesse of Los Angeles's swelling ranks of wealthy individuals. William Preston Harrison donated fine nineteenth- and twentieth-century European and American paintings. German-born William Valentiner had been a curator of decorative arts at the Metropolitan Museum of Art, a founder of *Art in America* magazine, and director of the Detroit Art Institute when he was hired in 1946 as codirector of the L.A. County Museum. Thanks to his convincing personality, publisher William Randolph Hearst contributed a warehouse of decorative arts, Renaissance sculptures and tapestries, and Greek, Roman, and Egyptian antiquities. Crowded into small galleries and overflowing the storage areas, these collections were the reason that the city needed a new general art museum to be modeled after the Metropolitan Museum of Art in New York.

Valentiner laid the groundwork for a museum where visitors would not have to walk around T. rex to see the Renaissance paintings, but before he could start in earnest, he left to become director of the first J. Paul Getty Museum, still in the tycoon's house, but with the goal of building an appropriate structure for collections of antiquities and decorative arts. Valentiner's successor was Richard Fargo Brown, grandson of William George Fargo, who had cofounded Wells, Fargo and Company. With a doctorate in art history from Harvard University, Brown pursued the plan to build a separate art museum. He appealed to the L.A. County Board of Supervisors and wealthy

individuals. In 1961, after Brown was made museum director, the county donated seven acres of land along the Miracle Mile, a wide stretch of Wilshire Boulevard lined with department stores such as Ohrbach's and the May Company. Alas, the parcel also harbored the infamous La Brea tar pits. Before construction could begin, archaeologists had to inspect the excavation for fossils and bones. Engineers then covered the tar with a three-foot-thick, two-hundred-foot-long floating slab of concrete that led *Time* to refer to the new museum as the "temple on the tar pits."

In the late 1950s, the feeling that Los Angeles was a city that had finally come of age and required cultural institutions to enhance her new stature was felt among its most prominent citizens, most significantly Dorothy Buffum Chandler, wife of Norman Chandler, publisher of the *Los Angeles Times*. (Their son Otis Chandler also became publisher.) She undertook an intensive campaign of raising funds to build a permanent hall for the L.A. Philharmonic. Thanks to her $19 million, land donated by the county, and $13.7 million in bonds guaranteed by the county, the Dorothy Chandler Pavilion became the crown jewel of the downtown Music Center, a cultural shopping mall designed by Welton Becket with pavilions dedicated to dance, theater, and orchestral events. It opened in 1964 largely due to her ability to raise funds from friends in her own circle of the established wealthy living around Pasadena and Hancock Park, yet she also tapped the new-money people from Hollywood and the Jewish community on the west side.

A similar strategy was required for LACMA. As an outsider, Brown was finding it difficult to raise funds from the city's established communities, and he appealed to those who had new wealth and social aspirations. Norton Simon had spent millions earned by his Hunt Foods conglomerate to compile a diverse art collection ranging from Tiepolo to Degas; Edward W. Carter helmed the Broadway-Hale department stores and collected quality seventeenth-century Dutch still lifes and landscape paintings. Though neither collector had been educated in the realm of fine art, they had proved dedicated in their connoisseurship and had built exceptional collections. Their involvement in the capital campaign proved successful. When the museum opened, Peter Bart hailed it in the *New York Times* as "an alliance of

California's 'old families' with the 'new tycoons' of the post war boom."[2]

Choosing an architect was the first battle of the titans. Brown suggested the brilliant Modernist Ludwig Mies van der Rohe. Howard Ahmanson, who had commissioned artist Millard Sheets to design forty of his Home Savings and Loan buildings and create mosaic murals for their facades, suggested that Sheets should design the museum. Brown was outraged but, as Ahmanson's donation was major, his opinion had to be considered. As a compromise, Los Angeles architect William L. Pereira was given the job. Simon was a key vote, and two years before, he had commissioned Pereira to build a library and art gallery for the city of Fullerton, where Hunt Foods and Industries was located.

Pereira was known for the neoclassical gloss he used to lighten the rigors of late modern architecture, such as his design for CBS's Television City. He came up with a plan similar to that of the Music Center in Los Angeles or, for that matter, Lincoln Center in New York. Built for $11.5 million, three separate pavilions appeared to float on a plaza with reflecting pools and fountains. (According to Pereira's widow, Bronya Galef, the architect installed the water element to emphasize a separation between the pavilions and their donors, who were arguing constantly with one another.) Each pavilion bore the name of a primary donor: Howard Ahmanson; Leo S. Bing, the late husband of donor Anna Bing; and Barton Lytton, a brusque personality who had built a savings and loan empire. When his banks collapsed in 1965, Lytton could not fulfill his pledge and his name was replaced by that of oil magnate Armand Hammer and his wife Frances. (Lytton opened his own gallery called Lytton Center of Visual Arts in the lobby of one of his bank buildings on Sunset Boulevard at Crescent Heights, across from Schwabs. Director Josine Ianco-Starrels, daughter of Dadaist Marcel Ianco, showed the work of a great number of contemporary artists. In 1977, Lytton's daughter, Timothea Stewart, opened a gallery of her own at 669 North La Cienega Boulevard, where the Nelson and Mizuno galleries had been located.)

Only a small plaque at LACMA acknowledged Norton Simon, whose collection of one hundred paintings of extraordinarily high quality, many acquired when he bought the entire inventory of the

late art dealer Lord Joseph Duveen, was on loan to the galleries in the Ahmanson Building. Simon disapproved of the self-promotional nature of these "naming opportunities" and, desirous of control, was frustrated by the attitudes of his fellow trustees. In 1971, he resigned from the board and began looking for a new home for his collection.

From the outset, these rich, opinionated, self-made men sought to run LACMA as if it were one of their companies. Brown, frustrated by the erosion of his own role, resigned before the building was completed to accept a position as director of the Kimbell Art Museum in Fort Worth, Texas. Brown's mild-mannered deputy director, Kenneth Donohue, was promoted into the job, and LACMA began consolidating its reputation as a museum with an inexperienced but meddlesome board of trustees.

Before Brown's departure, however, he made the commitment of hiring a curator of modern art. Maurice Tuchman, a student of the brilliant art historian Meyer Schapiro and curator at the Guggenheim Museum in New York, had never been to California before flying in for his interview with Simon and another trustee, Taft Schreiber, then vice president of the Music Corporation of America. Tuchman was shocked by the rudeness of both men who, he said, "interrogated" him at Simon's home. He was even more shocked to be offered the job, which he accepted and dominated for the next thirty years.

For many living in postwar Los Angeles, where dozens of screenwriters and others in the arts were blacklisted because of the work of Senator Joseph McCarthy and the House Un-American Activities Committee, modern art was associated with Communism, a notion kept alive by an active John Birch Society. William Brice's painting of a mortar and pestle shown at the 1948 annual exhibition was said to symbolize a grinding device for the seeds of Communism. As late as 1954, when County Museum curator James Byrnes was offered a small Jackson Pollock painting for the collection at $500, trustees tried to block the purchase. They finally relented on the condition that he keep the painting in his office to be exhibited to the public only for educational purposes.[3]

LACMA's first important modern art collection came as a gift in 1967 with the bequest from trustee David Bright of twenty-three major paintings by Picasso, Fernand Léger, Joan Miró, and others. The

new LACMA, a general museum with collections of Asian and pre-Columbian art, as well as European and American painting, would embrace modern art but not without numerous challenges.

Like most transplants from New York, Tuchman felt a responsibility to alleviate what he considered a provincial attitude by exhibiting art from Manhattan. His debut exhibition, New York School: The First Generation, Paintings of the 1940s and 1950s, was a critical and popular success. At the same time, Tuchman could scarcely avoid the simmering feelings of neglect among the younger Los Angeles artists. He responded with a number of shows: Peter Voulkos, the ceramic sculptor who had mentored Bengston, Mason, Price, di Suvero, and a host of others, had his work shown there in spring of 1965. Then the paintings of Irwin and the ceramics of Price were shown together. Others would follow; one of the most memorable was the retrospective of Ed Kienholz's sculptures.

Bringing in the Trash: Ed Kienholz's Revenge

L ittle more than a decade after Kienholz had arrived in Los Angeles with a dream of becoming an artist, he was being celebrated by the city's first official art museum. Grateful? Not really. Ever the hustler, Kienholz insisted on being paid a percentage of the tickets bought to his show. Not even Warhol had thought of that. The artist raked in quite a sum thanks to the headline-grabbing drama surrounding his 1964 sculpture, *Back Seat Dodge '38*.

Increasingly, Kienholz's sculptures were based on his own memories and experiences, as evidenced by *Roxy's* and *The Beanery*. As he went through the difficult divorce from his wife Mary, he recalled a teenage sexual escapade in his Dodge. "It was an old car that my father had when I was a kid. I borrowed it one night and went over the hill to dance. This girl was out there, and I enticed her into the car. We got some beer and pulled off in the tules someplace and did

some intimate and erotic things. We sat there and drank beer and had a nice time. And I couldn't remember her name later. It just seemed wrong to me in a way. Like what a miserable first experience of sex most kids go through. I mean, the back seats of cars."[1]

With Kienholz's single-mindedness, he scoured the city until, in Santa Monica, he found the model of a 1938 Dodge owned by his father. A young man about to go into military service wanted thirty-five dollars for it and offered to bring it over for a test-drive. He was flabbergasted when Kienholz said it was not necessary as he planned to cut the car into pieces to make a sculpture. His assistant, Fran Balzar, brought Kienholz to pick up the car but on the way to the body shop, her new Ford broke down. "So this poor old Dodge, on its way to the graveyard of art, is pushing this new Ford down the freeway," Kienholz recalled.[2]

In an automotive garage, Kienholz rebuilt the car and, in the backseat, installed a cast model of Fran's partly clothed body along with a chicken-wire male model with an obvious erection. They were joined by a single head because they were locked in "a single-minded objective, called mutual orgasm."[3] Kienholz liked to create stories in his tableaux so he had a watch engraved "To Our Son Harold" for the male figure and a gold pin with the name "Mildred." For him, they became characters with identities. "It worked just as I thought it would, because you see the reflection of you in the car, and there was Harold and Mildred in there, and it was all finished and all flocked, and it was all beautiful. I really almost felt like crying because Harold and Mildred had become real in the process of making them—real enough that I felt like I'd betrayed them by making them subject to the will of anybody that wanted to take the handle and open the door."[4]

Opening the handle of the car door is exactly what every visitor to LACMA had in mind. Theatrically lit with music playing from the radio and empty beer bottles littering the floor, the young couple grappled in sexual union oblivious to the voyeuristic thrills elicited among the museum-going public.

As *Roxy's* was also on display, it wasn't long before the L.A. County Board of Supervisors decided to use Kienholz's sculptures to rack up political points with conservatives. County supervisor Warren Dorn led the censorship charge. The artists and supporters fought back

with bumper stickers: "Help Stamp Out Dornography" and "Dorn Is a Four-Letter Word." Kienholz himself held a press conference in the LACMA boardroom that won over most of the media. To the surprise of many, museum director Donohue and the trustees stood behind Kienholz and their new curator Tuchman, and the sculpture remained in the show.

The board of supervisors accepted a stilted compromise whereby docents were posted to open the car door and reveal the scene to consenting adults and to shut it firmly against the curious eyes of anyone under the age of eighteen. An enlarged platform was placed under "Five Dollar Billy" in *Roxy's* to keep viewers a respectable distance from the reclining whore. As a result of all the publicity, the exhibition drew record attendance.

Kienholz's social commentaries embedded in tableaux were a perfect fit for the overheated political sensibilities of the late sixties. Farsighted Pontus Hultén, director of the Moderna Museet in Stockholm, purchased for the museum *The State Hospital*, Kienholz's 1966 sculpture portraying institutionalized mental patients handcuffed to stacked bare cots.[5]

The State Hospital was the first piece completed with the aid of Kienholz's fourth wife, Lyn Kienholz, a slim, fine-boned blonde who had been introduced to him back in 1961 while working as a receptionist at Ferus. They met again five years later, after both had divorced their previous spouses, and went on a date at Edna Ferber's Fog Cutter restaurant with Tuchman and his wife Blossom. Many dates later, Kienholz took her to Hope, Idaho, to meet his parents, who approved of her down-to-earth personality. Driving back to Los Angeles, Lyn recalled, "Shortly before the border of Washington, he said, 'You have until we get to Spokane to decide whether you want to marry me.'"[6] They were married for seven years. Lyn assisted him in his studio and helped raise his two young children. After a year, she suggested she might return to her previous career in theater. Kienholz snapped, "When you marry me, I become your career."[7]

They went fishing and hunting in Idaho and California, but their adventures were not confined to the wilds. In 1968, they made a trip to the East Coast to see friends. In a shop, they purchased a Tiffany glass lamp and had it wrapped carefully to carry in the cabin of their

TWA flight back to Los Angeles. Airline officials refused to let them bring it into the cabin but promised it would be handled carefully by the baggage handlers. It was smashed to pieces.

A furious Kienholz demanded compensation, but TWA refused to take responsibility. After a few days, Kienholz returned to the airport and carefully took the measurements of a desk in the TWA lost-and-found department. He went home, wrote a statement of his lamp's worth, and returned to TWA with a large fire ax. Kienholz was a beefy, imposing presence. After warning everyone to stand back, he chopped the lost-and-found desk into pieces. He had estimated that the desk, and the hassle of getting it replaced, was worth about the same amount as his lamp. Far from covert, he had a photographer with him who documented the flying wood chips, the people screaming and running, and the flustered attendants. Police were called but TWA did not have him arrested, out of a well-placed fear that the publicity would worsen matters and probably make Kienholz a folk hero to all who had had their baggage mishandled or lost by an airline. Kienholz felt vindicated. As Hopps put it, "I've never seen anyone work so hard for retribution when he felt he was wronged."[8]

Gemini GEL

With an art magazine, a museum, and some seventy mid-town galleries in Los Angeles, collectors started to feel a proper art scene was coming together, and no one was more energetic in their support than the Grinsteins, a couple who were small in stature but large in their enthusiasm. Stanley Grinstein shared his zest for modern art with Sidney Felsen, his friend and Zeta Beta Tau fraternity brother at the University of Southern California. After graduating, they continued to be friends in part due to their mutual interest in art. Grinstein took over his father's downtown surplus company and transformed it into one that sold, leased, and serviced forklift trucks. Felsen went into accounting. Both men were geared for such conventional careers but yearned for more creative endeavors.

In 1952, Grinstein married Elyse Schlanger, who had been a

student with him at USC. Felsen was their best man. As a young couple, the Grinsteins joined the Westside Jewish Center board and its art committee. Elyse got to know artists personally as she picked up work that they donated for holiday charity sales. Stanley was a member of the men's support group at Cedars-Sinai Medical Center, where the art committee was led by painter Ed Biberman. (He was the uncle of Jeremy Strick, who would later become director of the Museum of Contemporary Art.) They made modest purchases of modern art from dealer Bud Holland, who came annually from Chicago to sell to the Los Angeles collectors. In 1962, Elyse and Stanley joined the L.A. County Museum of Science, History, and Art's newly formed contemporary art council.

After moving from midtown Carthay Circle into a sprawling Spanish-style house in Brentwood in 1965, the Grinsteins started hosting legendary parties. "The house shaped our life," recalled Elyse. "If we hadn't had it, we couldn't have had all these great parties and we couldn't have had all the great houseguests: Man Ray, Allen Ginsberg, Bob Rauschenberg, Frank Stella."[1]

Over the course of the same decade, 1955 to 1965, Sidney Felsen, a fastidious man with a sartorial sophistication exceptional at that time in Los Angeles, worked as a CPA for a small firm and then for the giant company Arthur Young. He spent weekday evenings and weekends taking painting classes. After taking a ceramics course at the art center in Barnsdall Park, he found that to be a better fit for his interests and carried on with it at Chouinard in the early 1960s. At times, Grinstein would come along to watch his friend and chat with the other artists. By then, Felsen had left Arthur Young and assumed the business of another accountant. He was not terribly excited about his work but in 1960, at a party at the Grinsteins, he had met a recently divorced beauty with three young children. He married Rosamund Faibish later that year, and in 1961 they had a daughter, Suzanne.[2] They bought a house on Fifth Street and La Jolla Avenue in the same, largely Jewish, neighborhood where he was raised. Felsen had a family and meant to honor his obligations.

Then, after attending a workshop given by a European print publisher in 1965, he suggested to Grinstein that they consider publishing contemporary art prints. The Grinsteins invited to their annual

Christmas party printer Ken Tyler, who had opened a lithography studio behind the Art Services framing shop founded by Manny Silverman and Jerry Solomon.

Tyler had been a technical director at the Tamarind Institute, a teaching facility founded in Los Angeles in 1960 by artist June Wayne. Funded by the Ford Foundation, Taramind was a nonprofit center to train printers in lithography, which had all but died as an art form in the United States. Kay Tyler, Ken's wife, served as curator. The Tylers left Tamarind to execute projects by individual artists, but their new company, Gemini Ltd., was struggling. Tyler agreed to become a master printer for Felsen and Grinstein, and their joint venture was renamed Gemini GEL, or Graphic Editions Limited.

Grinstein and Felsen each put in $10,000 (about $70,000 today) to start the business. In those early years, Gemini was a family operation. Rosamund worked as shipping clerk, carefully packing each print to be mailed, but soon became the de facto registrar, keeping track of the quantity and quality of the prints. They felt that the key to profitability was in selecting well-known artists whose prints could be sold through their galleries in New York and elsewhere. After being put off by such heavyweights as Rothko and De Kooning, they were able to land Josef Albers, as Tyler had worked with him on a previous project and the Grinsteins owned one of his paintings.

Albers, seventy-eight, was teaching at Yale and didn't want to travel but designed an edition of eight colored squares bordered by white lines. He mailed Tyler one-half of a cardboard with each color and retained the other half. Tyler matched the colors in the prints and flew with them back and forth to Connecticut several times to get the artist's approval. Half a year later, Gemini published their first edition. Felsen went over to the La Cienega offices of *Artforum* and handed the design for their first full-page ad to "a kid," who was the art director: Ed Ruscha. When the magazine came out that fall, Gemini was overwhelmed by some three hundred requests. The prints were offered at $125 or the prepublication price of $100. "We sold a lot," recalled Felsen.[3]

In 1966, the L.A. County Museum of Art held Dadaist Man Ray's first American retrospective, which was organized by Jules Langsner. (The show had a profound effect on Bruce Nauman.) Ray, born

Emmanuel Radnitsky in Philadelphia, had moved to Paris in 1921. Displaced in 1940 by World War II, Ray relocated to Los Angeles for eleven years. He met dancer and artist's model Juliet Browner shortly after he arrived, and they were married in 1946 in a double wedding with Surrealists Max Ernst and Dorothea Tanning. The Rays had moved back to Montparnasse in 1951 and were excited to be back in Los Angeles for the exhibition. They stayed at the Grinsteins' house, and parties were held in their honor. In exchange, Ray executed three lithographs for Gemini featuring photographs of his hands in tones of black and gray to resemble his so-called Rayograms. These photograms that he named after himself were made by placing any object, including his hand, on a piece of photographic paper and exposing it to light in the darkroom to create pictures of shapes without using a camera. Of the three lithographs, one was printed on Plexiglas. Once again, they were advertised in *Artforum* and sold briskly.

Encouraged, Grinstein and Felsen approached Sam Francis, the successful abstract painter who had moved to Santa Monica in 1961. He enjoyed playing the role of godfather to younger artists; Ruscha worked as his assistant for a time and recalled that when it came time to get paid, Francis would peel off a few of the thick roll of hundred-dollar bills that he carried in his pocket. Part of this largesse extended to Single Wing Turquoise Bird, a collective that included Fluxus artist Jeffrey Perkins. Francis funded the group's psychedelic light shows for rock bands playing at clubs around Los Angeles. Francis also supported the fledgling Gemini by creating a lithograph of primary colored splashes and drips. Again, it sold well.

However, the artist who effectively propelled their operation to profitability was Robert Rauschenberg. He was known for the prints that he had made for Tatyana Grosman's Universal Limited Art Editions press on Long Island. Rauschenberg had been coming to Los Angeles since 1962 to show with the Dwan Gallery and had created sets for and performed with Merce Cunningham's dance troupe on tour there. Through Douglas Chrismas, who showed his work at his Ace Gallery in Vancouver, Rauschenberg met Ken Tyler. In 1967, he agreed to create something unique for Gemini.

Rosamund recalled, "Bob, of course, is always interested in doing

something new and innovative, and anybody who would present him with an idea of something he had never done before, that was the most interesting thing."⁴ And the very premise of Gemini, she continued, was that "whatever the artist wanted to do, no matter how difficult it seemed, Gemini would do it. . . . We were very adventurous."⁵

Rauschenberg told Felsen that he wanted to make a portrait of his inner self and asked if he knew anyone who could X-ray his entire body. As it happened, another of Felsen's fraternity brothers, Jack Waltman, was a physician who offered to take a series of X-rays to depict the entire torso. (There was no machine on the West Coast that could take an X-ray more than six feet in length.) Rauschenberg stacked the X-rays vertically and added various other details, including a drawing that he found on a curb of a child carrying a rocket booster that led to its title: *Booster.* The largest fine-art print ever made at that time, it was a groundbreaking achievement for the nascent publisher. Individual works by Rauschenberg had become relatively expensive so Gemini offered the print at $1,000. Again, it sold briskly. (Since, it has sold at auction for $250,000.)

Rauschenberg, handsome and extroverted, became great friends with the Felsens and the Grinsteins. He spread word of the publishing venture among all of his cronies in New York. After that, it was fairly easy to convince the top echelon of Pop and hard-edge abstract artists to come out to Los Angeles, all expenses paid, to make prints. "We're a support system, not a co-creator," said Felsen. "Each artist is the captain of the ship while he or she is here."⁶

Jasper Johns, Rauschenberg's former lover, went there to produce the Color Numeral Series. Stella, Oldenburg, and Ellsworth Kelly all made prints over the next few years. "Very important artists had gotten very famous very quickly, and there was a lot of excitement about beginning to collect, and many people were not able to buy paintings and sculpture by these particular artists, so prints, being multiples, enabled them to be able to afford to get works by these artists," said Rosamund.⁷

The Gemini founders, priding themselves on their relationships with the Los Angeles artists, also published prints by Altoon, Ruscha, and Goode in 1967. As Gemini grew more successful, Kienholz,

Hockney, Nauman, Berman, and Davis were invited to make prints. In 1976 Frank Gehry designed an edgy building of plywood and aluminum for the publisher on Melrose Avenue.

Bicoastal friendships were forged at the Brentwood parties where the Grinsteins served an informal buffet of cheeses, sausages, and breads with a full bar, which meant that guests occasionally wound up in the pool. "We had the New York artists of Gemini like Rauschenberg or Oldenburg and it was a kind of interaction with the local artists," Elyse said. "Richard Serra, Bob Morris, and Jasper would be sitting around the table talking. We made a point of not taking photographs. It kept everything flowing open and easy."[8]

One evening the New York Minimalist Carl Andre, who was wearing his trademark overalls, was becoming a little obstreperous with Larry Bell about the sort of art made in Los Angeles. The disarming and dapper Bell simply slipped his fingers under Andre's suspenders and said, "Carl, I'd really like to fuck you."[9]

Stanley recalled, "There was a thing out here that you didn't live in New York and if you went back there, you were a traitor. It was a badge of honor of that older group that you didn't kowtow to the New York artist. We didn't know we were so totally insulated. Richard Serra said, 'I know the difference between California artists and New York artists.' I said, 'Really? What is it?' He said, "When New York artists make a work of art, they think how is it going to fit into the continuum, who is going to write about it, who is going to publish it and how many pictures. When L.A. artists make art, they just make art about how they feel.'"[10]

While the remark was clearly meant to be insulting, Stanley was unfazed. "I thought, you know, that is true. Artists here were out of that continuum of what happened after Matisse, Cézanne, Picasso. But you think about Billy Al taking pieces of tin and banging them up, or the Light and Space artists. These things were independently thought up out of the continuum and I think that is pretty interesting."[11]

John Coplans had moved to Los Angeles around the inception of Gemini and observed the influences firsthand, saying it was "enormously important."

"For the first time, the so-called mythical figures of the East

became ordinary figures in the West," he explained.[12] On the other hand, excitement over the East Coast artists often eclipsed the cachet of the Ferus group. Irving Blum recalled, "Did that make for bad feeling? Yes. Did that make for resentment? Yes. Did that make for hostility? Yes. Yes. Yes."[13]

Between Form and Function:
Frank Gehry

I n 1964, architect Frank Gehry walked out of the Danziger Studio that he had designed and saw a tall, muscular character wearing dark glasses and staring intently at the gray concrete structure. Though the architect had met Ed Moses before, he greeted him with surprise. The artist had come to pay compliments to Gehry for the radical elegance of the graphic design studio, which stood like a grace note of Modernism along a stretch of Melrose Avenue crowded with old Spanish buildings and low-rise stucco shops.

The building was a breakthrough for Gehry, completed just two years after he had started his own firm. Off and on in the 1950s and early 1960s, he worked for Gruen and Associates. Gehry described Victor Gruen, who designed many of the postwar shopping centers in Southern California, as "a Viennese guy who trained me to be perfect."[1]

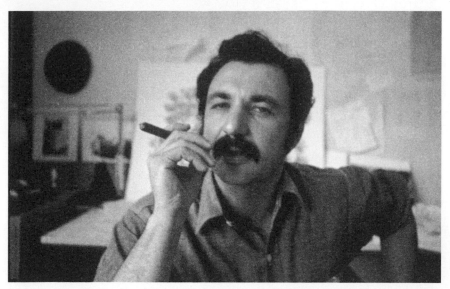

Frank Gehry
Photograph courtesy of Frank Gehry

Born in 1929, as Frank Goldberg, in Toronto, Canada, he moved with his Polish Jewish parents to Los Angeles in 1947 because of his father's poor health. Gehry drove a truck part-time to pay for his classes at L.A. City College and then at USC, where he took a course in ceramics. The instructor, Glen Lukens, suggested he enter the school of architecture. He got an A in his first course but a teacher said, "This isn't for you." Gehry recalled, "I was devastated but I didn't give up."[2]

Gehry was trained by the reigning Modernists who dominated the architecture department and was duly influenced by the city's exceptional residential architecture by Frank Lloyd Wright, Rudolf Schindler, Richard Neutra, Pierre Koenig, John Lautner, and others. Many had built homes under the impetus of the Case Study House Program devised by John Entenza for *Art and Architecture* magazine between 1945 and 1966.

For the first decade of his career, Gehry toed the Modernist line but, at age thirty-five, he found himself in the throes of a fundamental shift. In 1964, he divorced his wife of twelve years, Anita Snyder. It had been her suggestion that he change his name from Goldberg

to Gehry to avoid confronting the anti-Semitism that was rumored to percolate through the ranks of the Los Angeles establishment. Having been married since the age of twenty-two, he was ready for a new chapter. "I was let out of the cage," he said.[3]

The 1964 Danziger Studio was commissioned by designer Lou Danziger and his wife Dorothy. Danziger, who had studied with Alvin Lustig at Art Center School, as it was then called, in Pasadena, had built his considerable reputation by applying the principles of Modernism to graphics. Gehry designed a pair of two-story buildings, for living and for work, that faced each other and were protected from the street by a high wall. The three elements were covered in blue-gray stucco that appeared industrial yet elegant. Inside, Gehry left wood framing and ventilation ducts exposed for the first time in his career.

The building earned little praise from fellow architects but seized the attention of the Ferus artists, who became his new friends. "I was in awe of what they were doing," he said.[4] Like them, he decided to embrace the creative possibilities unique to Southern California. "California was about freedom because it wasn't burdened with history. The economy was booming because of the aircraft industry and movie business, and things were going up quickly. Everybody could make whatever they wanted. . . . That's what democracy is about. Democracy didn't say everybody has to have taste."[5]

Learning of Gehry's anxiety over his pending divorce, Ed Moses introduced him to the famed psychoanalyst Milton Wexler. Wexler was renowned in Hollywood for treating actors John Cassavetes, Ben Gazzara, and Peter Falk, as well as artists such as Moses himself and John Altoon. He had prescribed a medication for Altoon that stabilized his bipolar condition to the point where he had remarried and was painting regularly. Wexler's approach to group therapy was so successful that many of his patients became friends with one another. Producer and director Sidney Pollack, who befriended Gehry at Wexler's, made the 2005 documentary *Sketches of Frank Gehry*. According to Gehry, Wexler helped him complete his divorce. "She wanted out of it as much as I did but neither of us knew how to. You're in limbo. . . . Milton taught me how to do it, how to split."[6]

Gehry left his wife and two daughters and moved into a building

that he owned on Highland Avenue in Ocean Park near many of the artists. He began visiting them in their studios and incorporating some of their ideas in his architecture. While designing the Joseph Magnin store in Costa Mesa, he started experimenting with light and the use of glass around a central skylight-atrium. "Larry [Bell] helped me with how to hang it so it wouldn't break, how to film it, how to light it. We were on the same wavelength."[7]

Other influences came from Bengston. "Billy Al would change his studio, it seemed like, every other week," Gehry said. "He moved the bedroom somewhere and built desks and chairs. Bell was doing some of that and Irwin. . . . It wasn't something they would sit down and design. It was just stream of consciousness and I loved that. I was looking at how to express that immediacy in architecture."[8]

Bell had not covered the plumbing pipes in his bathroom with plaster but with glass. Moses had applied a similar solution to the dining room of art collector Laura Stearns by extending the glass of a window over the exposed studs in a wall. These examples led Gehry to leave the studs exposed in his work and to start using chain-link fence as a building material.

Through the art world, he met collector Ed Janss Jr., who commissioned the first house that Gehry designed on his own. Not unlike the Danziger Studio, high-ceiling rooms opened onto a courtyard and garden at the back. Gehry honored Janss's two great passions by maximizing kitchen space for cooking and major walls for paintings.

The artists became Gehry's new family. Lonely during the first months after his divorce, he would have dinner on Thursday nights at the Hollywood home of John Altoon and his second wife, Babs. Billy Al Bengston and Penny Little would join them and afterward, they would go to Barney's to meet the other artists.

Gehry was not new to Barney's. Gehry's uncle Willy had worked for the gangster Mickey Cohen, who was a regular. When Gehry had moved to Los Angeles as a young man, Willy had brought him to Barney's to drink. One memorable night, Willy got into a fight with Lawrence Tierney, the actor who played the title character in the 1945 movie *Dillinger.* (Willy also took Gehry to his first brothel when still a virgin.)

Babs Altoon was a good cook and loved to entertain crowds of

hungry friends. When the Altoons rented a disused Laundromat on the boardwalk in Venice, Gehry renovated the interior but could not remove the concrete median where the machines had been installed, so he transformed it. "We used it as a stage," he said. "Ben Gazzara came over and read the cookbook as though he were doing *Othello*. We had phenomenal times."[9]

Not averse to the occasional joint, Gehry joined Bell, Altoon, and Moses in an impromptu rock band, Five Bags of Shit. The fifth artist might be Ken Price or Sam Francis. James Turrell hung out but did not play. Gehry said, "My instrument was bicycle handlebars that had a ringy-ding bell, then I graduated to a toilet plunger in a pail."[10]

Gehry was short, with a wild array of curly black hair. His obvious intelligence was modified by a self-deprecating sense of humor and a generous nature. He soon became the newly available bachelor in town and went out a few times with Ann Marshall. Then he fell hard for the striking blonde Donna O'Neill, who was married to Richard O'Neill, scion of an established Southern California family and owner of a vast land-grant property south of Los Angeles. "I was madly in love with her," Gehry admitted.[11]

The O'Neills kept an apartment in Hollywood behind the Blarney Castle, a bar and restaurant that they owned. During a party there, "everybody got drunk as skunks." Gehry recalled. "Donna was dressed in black like Carmen from the opera."[12] The group decided to have dinner at Martoni's, a short drive west on Cahuenga Boulevard. Donna chased after Gehry and asked, "Can I ride with you?"[13] Her husband drove on in his own car.

At the restaurant, as everyone started to sit down, Donna said she felt sick. She asked Gehry to drive her home. "I was innocent. I looked around and thought her husband should drive her home. She said, no, she wanted me to drive her," he explained.[14] When they got back to the apartment, she told Gehry, "I don't feel good. You better carry me in." Once inside, according to Gehry, she pulled him down on the bed and started kissing him. As they wrestled on the bed, Gehry was thinking that any minute her husband would be walking in the door. He carried on with no regrets. "It was one of those life-changing experiences and I got out of there before he got home," he said. "I was freaked out the next day because we were going to go

down to their ranch and look at a site. They wanted me to do something." Gehry called Moses at dawn and told him the story. The artist laughed and told him not to worry about Richard O'Neill: "They do that, those guys," Moses chuckled knowingly.[15]

The next day, Gehry sheepishly went to the ranch to meet them. They discussed the building project and Richard O'Neill left. "She grabbed me again," Gehry said. "We became really close. She came along at a time when I needed that desperately. We hung out for about six months. I fell hopelessly in love with her and I didn't know what to do. So I pulled myself out of it, but as I pulled out, she came for more. It got really complicated. She was a free spirit."[16]

His passion was made manifest in the O'Neills' hay barn, one of his first buildings to break free from orthogonal form. Telephone poles supported a corrugated steel trapezoidal roof tilted between two diagonal corners. Despite the simplicity, the metal reflected the color of the sky while the angles echoed the shape of the terrain. It inspired a similar design for a house Gehry later created for artist Ron Davis in the hills of Malibu. (When Davis could not qualify for a loan, Janss underwrote the mortgage and the artist paid him back.)

Gehry had designed the barn as part of an ambitious overhaul of the O'Neills' main house, guesthouse, stable, and pool at their ranch. "It was a labor of love," Gehry conceded.[17] By the time the barn was completed in 1968, however, Richard must have learned of their affair since the rest of the project was canceled without explanation. The barn remained a lonely testament to love. Gehry said, "He would make fun of me. He said it was too expensive, though it cost two thousand dollars to build. He didn't want to pay me. He must have known what was going on. He had me by the shorts and he loved that. But we never talked about it."[18]

London Calling, L.A. Answers

I n 1966, Irving Blum brought the London art dealer Robert Fraser to the Pop art–laden home of Dennis and Brooke Hopper. Fraser stayed for a couple of weeks and then went with them to Tijuana because Dennis wanted to show him the Mexican folk art that he believed was the equivalent of the African art collected by Picasso and other early modern artists. Fraser and Dennis were snorting cocaine, which had not yet become popular. On the trip, Brooke recalled, Fraser also gave them speed. "We all got crazy, completely raving mad, and were unable to go to sleep for about three days. . . . The drug scene was beginning but it hadn't hit the mescaline stage, and certainly hadn't hit the cocaine stage. Robert had a lot to do with that, in my opinion. He was a very seductive character."[1]

Fraser was impressed by the Ferus artists and from January 29 to February 19, 1966, mounted Los Angeles Now at his Mayfair gallery

featuring Ruscha, Hopper, Bell, Berman, Foulkes, and Kauffman, along with Bruce Conner and Jess Collins, who lived in San Francisco. It was quite an advanced show for the London of that era.

Ruscha recalled that Fraser had come to his studio and bought a number of drawings that he then sold to John Lennon. "I was just floored that someone from so far away would come and buy my work," he said.[2] Yet, he had few illusions that Fraser was a businessman. "It wasn't his interest. He wanted the fun and games of it, means to the end, to be in the hoopla."[3]

Some of the artists went over for the opening. Hopper, who promptly had an affair with designer Pauline Fordham, was stunned by the atmosphere in London, saying it was "the most exciting time I'd ever seen, or have seen since."[4] After a few days, however, he grew noticeably paranoid, looking out Fordham's windows for evidence that the FBI was following him.

Hopper, along with Conner, filmmaker Kenneth Anger, and actor Sid Caesar, dropped acid with Fraser at his flat while watching their experimental films. Fraser's drug use escalated. Close to two years later, at Keith Richards's house, Fraser and Mick Jagger were arrested for possession of heroin, a stunning event given their fame and status. Richard Hamilton turned the newspaper photograph of the pair, handcuffed and trying to hide their faces while in the back of the squad car, into a print called *Swingeing London*. (It was Hamilton who did the image-free cover of the Beatles' so-called White Album.)

While in London, Larry Bell became friendly with the artist Peter Blake, who was codesigning, with his wife Jann Haworth, the unforgettable cover for the Beatles' *Sgt. Pepper's* album. Superficially, it appeared to be a collage but in fact was a wildly elaborate stage set composed of cutout photographs of figures and actual people, plants, and props. Blake took a photograph of Bell wearing black-and-white striped trousers and inserted it into the crowd of people. He added Los Angeles characters Wallace Berman, Lenny Bruce, Simon Rodia, and Aldous Huxley.

Two years later, it was Ken Price's turn to enjoy the limey limelight when he had a show at Kasmin Gallery. He stayed for six months at a flat owned by Don Factor and experienced European museums for the first time. When he returned to Los Angeles, instead of joining

the increasingly frenzied scene, he married a woman who lived up to her name: Happy. Though he maintained a studio in the Mildred Avenue building where Bengston lived, the couple moved to Taos in 1971.

Back in Los Angeles, the Sunset Strip may not have been as wild as London's Kings Road but there was plenty of action. In 1966 Ruscha documented every seedy and seductive detail in his book of photographs *Every Building on the Sunset Strip*. Mary Lynch Kienholz was friendly with members of the Byrds through their manager Jim Dickson, who had married Diane Varsi, the actress who had hitch-hiked south with her to a new destiny. Though divorced from Ed, Mary retained friendships with the Ferus artists, and many became part of the Byrds' dedicated fan base. "We danced until we were dripping with sweat," Mary said. "It was the first time that thing had happened in that everybody was physically involved in music as opposed to jazz clubs where you would sit on a chair with scotch and a cigarette."[5]

Ciro's, as Dennis Hopper recalled, had been the most glamorous of nightclubs for decades, hosting Dean Martin's wedding in 1949 and featuring other Rat Pack performers before black-tie-and-gown-wearing audiences until it closed in 1959. "There wasn't a place you could get dinner on the Sunset Strip unless you wore a tie and a jacket in the fifties," Hopper said, "and then, a few years later, we were all in T-shirts and jeans."[6] After the club was renamed It's Boss and reno-vated to support rock acts, it became the center of the Strip in 1965 with the Byrds' extended gig as their versions of "Mr. Tambourine Man" and "Turn! Turn! Turn!" soared on the charts.

Kauffman recalled, "They were there for like a month and it was a party night every night. They were nice guys, very friendly. They were pretty good so we'd dance. It was like our own club."[7] The art-ists engaged with young, hip Hollywood—the Hoppers, Peter and Jane Fonda, Jack Nicholson, Dean Stockwell, and Toni Basil.

The first wave of groupies started to show up. Pamela Des Barres hitchhiked from her home in the Valley over Laurel Canyon Boule-vard to the home of the best-looking Byrd, Chris Hillman. Hillman drove a Ferrari he had purchased with the first of the big money from record royalties. David Crosby was driving through the canyon

on a Triumph motorcycle given him by Peter Fonda. They hung out with Bob Dylan at Fred C. Dobbs—converted from the old-guard Chez Paulette—partaking of celery stuffed with peanut butter. It was there that Eve Babitz first met Stephen Stills and Ann Marshall. She brought Hopps there as they pursued their irregular love affair, both of them increasingly strung out on amphetamines. "I knew he was married but what could I do? Speed makes me able to walk through anything and not be hurt by it," she said later.[8] Young and in thrall to the fiction of Colette, Babitz avoided heartbreak by keeping a number of lovers around at the same time.

Babitz's sister, Mirandi, had opened an eponymous clothing boutique on the Strip known among rock's new elite for its custom fashions, which is how Mirandi came to measure the inseam of a beautiful young man with pouty lips named Jim Morrison. Eve seduced him at first sight after seeing the Doors play a small club on the Strip called London Fog. "Being in bed with Jim was like being in bed with Michelangelo's David, only with blue eyes. His skin was so white, his muscles were so pure, he was so innocent," she later wrote in *Esquire* magazine.[9] A pudgy kid who had lost thirty pounds after discovering drugs in the summer of 1965, he had grown out his curly hair and channeled his UCLA studies in film and poetry into lyrics for his fellow band members to follow with their jazz and classical music training. The darkness of the music was counter to the romantic, folk-derived sounds of the Byrds and Buffalo Springfield, signaling an end to the communal optimism of hippies hanging on the Strip.

The Crescendo, an old jazz joint where movie stars had congregated, followed the trend on the Strip and was converted into a rock club, the Trip—its sign hung upside down—owned by Elmer Valentine and raspy-voiced Barry McGwire, known for his hit "Eve of Destruction." It was the site, on May 3, 1966, of Warhol's Exploding Plastic Inevitable, complete with films, a light show, Nico, and the Velvet Underground. The Mothers of Invention opened and were cheered as local heroes. The Velvets' under-rehearsed and chaotic music was greeted with boos. Lou Reed responded by calling Frank Zappa a "two-bit pretentious academic." John Phillips of the Mamas and the Papas, a couple of the Byrds, Ryan O'Neal, and Jim Morrison were in the audience. Sonny liked it but Cher left, saying of the

Velvets' raw music, "It will replace nothing, except maybe suicide," a remark the group found so hilarious they added it to future posters.[10] The following night, the Velvets were even less popular. There were only five people in the audience: the Grinsteins, the Felsens, and UCLA art historian Kurt von Meier.

Though the band was booked through May 18, on the third night, the sheriff's office shut the club down for disturbing the peace. A sign on the door directed patrons to go see Johnny Rivers at the Whisky a Go Go, which shared the same owner. To get paid, according to union regulations, the Velvets had to remain in town so they stayed at the Castle, an imitation medieval stone lodge in the hills owned by actor Jack Simmons that was popular with rock bands. Bob Dylan had just stayed there with Edie Sedgwick.

Warhol himself fared better by filling Ferus with helium-filled silver Mylar balloons that floated like clouds against his yellow wallpaper screened with the pattern of a Day-Glo pink cow's head. It was similar to the show he had mounted at Castelli and was inspired by Ivan Karp, who said to the artist, "The only thing that no one deals with now these days is pastorals. My favorite subject is cows." Warhol grasped the notion and said, "New Cows! Fresh Cows!"[11]

In November 1966, the Doors performed in New York for the first time. Warhol and Gerard Malanga went to see them at the popular disco Ondine. "When we walked in, Gerard took one look at Jim Morrison in leather pants just like his and he flipped. 'He stole my look!' he screamed, outraged. It was true enough—Jim had, I guess, picked it up from seeing Gerard at the Trip," Warhol recalled.[12] The Doors played Ondine on a few more occasions. Morrison would stand at the bar drinking screwdrivers and taking downers. "He'd be totally oblivious—and the girls would go over and jerk him off while he was standing there," Warhol said.[13] While in New York, Morrison agreed to star in Warhol's first "blue movie"—to have sex with a girl in front of the camera—but when the time came, he never showed up.

When the Byrds were playing the Trip in 1966 with the Paul Butterfield Blues Band, Babitz became obsessed with the talented English bluesman. She dressed up and danced close to the stage at the Trip and at the Whisky but to no avail. She finally drove down to

Huntington Beach to hear them but had to accept that her big-busted beauty was not Butterfield's type. That evening, Buffalo Springfield was playing in the club down the street and, after finishing their set, had come to hear Butterfield's band. Stephen Stills was loving it, but the rest of his band wanted to start the hour-long drive back to Los Angeles. Babitz offered, "I'll drive you home but you have to let me do your album cover."[14]

Stills became her lover and, sure enough, Babitz created the cover of their second and most successful album: a collage inspired by Joseph Cornell, whose work Hopps had introduced to her. "Walter's house was full of Cornells," she recalled.[15] Hopps also told her to see the Cornell show in New York, where she took acid, got lost in his intricate collages, and decided to make a composition of an angel, flowers, and a view of water for the album cover. "It was the best thing I ever did," she said.[16] When the mind-blowing result of this decision landed on the desk of Nesuhi Ertegun, brother of Ahmet Ertegun, who had signed Buffalo Springfield to Atlantic Records, he called Babitz for an explanation. At the mere mention of Cornell, he grew very excited. Apparently, he had been collecting the work of Cornell for years.

Stills wrote many of the Buffalo Springfield songs, including the 1967 hit, "For What It's Worth." Dressed in military jackets, with Stills sporting a cowboy hat, the band performed it on *The Smothers Brothers Comedy Hour.* Tommy Smothers mugged with a pistol as Stills sang, "There's a man with a gun over there." The Buffalo Springfield appearance was just one example of the Smothers Brothers' determined attempt to bring the counterculture into commercial television, and this was in no small part due to the input of Mason Williams.

In 1964, after his three-year marriage to Sheila Massey ended in divorce, Williams moved back to Los Angeles and lived with Ed Ruscha in the Vestal Avenue house for a year until he was able to rent a nearby apartment in Echo Park. He was playing guitar and singing his offbeat songs at the Troubadour. Artists such as Glenn Yarbrough and the Kingston Trio were singing and recording his folk songs. As the folk scene gave way to electric rock, Williams began writing comedy for Roger Miller and the Smothers Brothers.

While in the navy, Williams had watched his childhood friend Ruscha become a significant player in the contemporary art scene as

well as a family man. Ed and Danna Knego were married in 1967 at a wedding chapel in Las Vegas. This commitment did not dampen Ruscha's sense of humor. A month before the wedding, he placed a full-page ad in *Artforum* with a black and white photograph of him sleeping in an ornate bed between two pretty young women. The caption read, "Ed Ruscha says goodbye to college joys."

Within the year Edward Joseph Ruscha V was born. He was nicknamed "Frenchy" by Larry Bell, who said Ruscha "is such a Frenchy sounding name." When Danna told Ed that she was pregnant, they were visiting his brother Paul in New York City. He was smoking a cigarette, and at the news he put it out and never smoked again— except for the night that Frenchy was born, when he celebrated with friends at the Classic Cat, a burlesque bar with topless waitresses on the Sunset Strip. At age twelve, the son rejected "Frenchy" in favor of "Eddie."

Williams enjoyed his own triumph that year when his guitar instrumental, "Classical Gas," became an improbable hit record. The wacky humor that he shared with Ruscha was perfect for the combination of variety acts and comedy on CBS's *The Smothers Brothers Comedy Hour.* From 1967 to 1969, he earned $50,000 a year as the

head of a group of writers that included Rob Reiner, Leigh French, and Steve Martin, a comic that Williams respected so much that he initially paid him out of his own pocket.

Williams experienced the heady and speedy success possible in Hollywood. From Echo Park, he had moved to Tommy Smothers's guesthouse at the top of Kings Road. Then he rented Paulette Goddard's former Beverly Hills residence, where he lived with Nancy Ames, a Washington debutante-turned-folk-singer who cowrote the *Smothers Brothers* theme song with him. Their collaboration on "Cinderella-Rockefella" sold six million copies in 1968. Then he bought a house off of Mulholland Drive that had once belonged to Howard Hughes. He hired Ruscha, still renting the house in Echo Park, to help with storyboards for the show.

Williams and Ruscha would prowl the clubs on the Sunset Strip and the art cinemas on Western Avenue and Melrose that showed foreign films such as Fellini's *8½* and Truffaut's *Jules et Jim*. Tommy Smothers called Williams "the great gleaner" because he could translate that material into sketches or ideas for musicians or actors to book on the show.

With the extra cash from his Hollywood-sized paycheck, Williams started to execute a few art projects of his own, including a life-size paper reproduction of a Greyhound bus from a black-and-white Max Yavno photograph. It stood behind him as a backdrop while he played the Grammy-winning "Classical Gas" on *The Smothers Brothers Comedy Hour* yet survived as a work of art. In an edition of 2,200, it sold for thirty-five dollars folded up in its own box and was included in the Word and Image exhibition at the Museum of Modern Art. When shown at the Pasadena Art Museum in 1967, a special thirty-seven-foot room was designed to contain it. "As you walked in the door, the bus started and wrapped around and ended exactly at the doorway," said Williams.[17]

Williams committed a $5,000 work of Conceptual art a few months later when he hired V. E. Noble, the famed skywriting pilot, to fly above the Mojave Desert at dawn tracing puffy white lines in the shape of a stem and leaves with the sun itself as the glowing blossom of a sunflower. It measured two miles by three miles, certainly

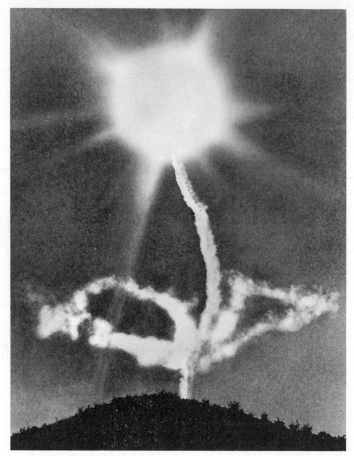

Mason Williams, Sunflower, *1967*
Photograph courtesy of Mason Williams

making it one of the largest works of art and the shortest in duration: forty seconds. "The idea wasn't to see it, really," said Williams. "The idea was for people to hear about it and say, 'Yes.'"[18]

Williams and Ruscha, who had spent their childhoods listening to records or the radio together, mutually appreciated the slippery relationship between words and meaning, puns, palindromes, and double entendres. Ruscha considered words for their appearance, sound, and significance while Williams approached language with the poetic fervor of a songwriter. They frequently provided pictures or ideas for each other but their strangest collaboration had to be the day that

Williams drove a 1963 Buick at ninety miles per hour as Ruscha threw his friend's typewriter out the window. Former roommate Patrick Blackwell took photographs of the machine as it flew through the air, hit the tarmac, bounced, and crumbled. To Williams's dismay, his housekeeper consigned the shards of metal and ribbon to the trash but the photographs survived as a Ruscha, Blackwell, and Williams book called *Royal Road Test*. The act qualified as performance art but Williams never had such aspirations. "I was living the life of an artist but did not think of myself as an artist," he said. "It was a time when art was lived as a lifestyle."[19]

These forays led him to suggest that CBS executives incorporate art ideas into *The Smothers Brothers Comedy Hour*. He added his "Classical Gas" sound track to a three-minute film of three thousand works of art, from cave painting to Picasso, compiled by UCLA film student Dan McLaughlin. It concluded with the statement: "You have just had all the Great Art of the World indelibly etched in your brain. You are now cultured."

Williams recalled, "I think I took influences from Ed's world of art, and I was the primary troublemaker on the show."[20] He engineered comedian Pat Paulsen's pseudo-presidential campaign by hiring former governor Edmund Brown's consultant and demanding debates. In keeping with the late sixties, the show's writers grew more eccentric and political, satirizing mainstream America and criticizing the country's involvement in the Vietnam War. At that point, Williams and the Smothers Brothers ran afoul of CBS executives. As CBS attempted to dictate appropriate fare for prime-time entertainment, the Smothers Brothers tried to push the boundaries of acceptable speech on the medium. On April 4, 1969, one week before the end of the season, CBS threw the show off the air. The Smothers pitched a fit, accusing CBS of infringing on their First Amendment rights. They would not appear on CBS again for twenty years, though they continued to perform live and Williams continued to work for them. They often appeared at events protesting censorship in the media, but Williams retreated from celebrity in the 1970s. "I wanted to be more like God. In the beginning, God had a creative life. Along came religion and he had a career."[21]

Love-ins and Outs

B y 1968, Rudi Gernreich was considered such a notable fig-
ure that he was included in a photograph staged by Los
Angeles County bureaucrats of the city's cultural elite. On
the steps leading to the entrance of the L.A. County Museum
of Art, he posed with artists, designers, critics, and curators. Altoon,
Bengston, Kienholz, Ruscha, and Kauffman posed with Tuchman,
Coplans, and others.

Gernreich had brought his alternative model, the leggy beauty
Léon Bing, who had replaced Peggy Moffitt after she and William
Claxton moved to London. Bing was wearing the same plastic tunic
that she had worn on the cover of *Time*, with a clear plastic panel
running down the front from collar to hem. Some of the artists were
standing next to their paintings, and Bing recognized the big canvas

with the word "Spam" and the chiseled, intense artist holding it. She insisted Gernreich introduce her to Ruscha. After that, as she put it, "It was on."[1]

Ruscha, who had just completed his now-famous screen print of the Hollywood sign in a searing orange sunset, could not resist the advances of the long-legged cover girl. Their torrid affair continued for the next four years. Bing said she was surprised that such a cool character could be "such an ardent and inventive lover."[2] They made love about four times a week in his studio on Western Avenue in Hollywood. She introduced him to her friends in the music and film scene, bringing him to the home of her good friend Mama Cass Elliot of the Mamas and the Papas, where joint papers were imprinted with the Louis Vuitton logo, and had sex with him in the swimming pool. She brought him to producer Harry Cohn Jr.'s ranch in Joshua Tree, a place of remote beauty about one hundred miles east of Los Angeles, where the artist later built a house and bought extensive acreage. She gave him engraved business cards: Ed-werd Rew-shay, Young Artist. He gave her a gunpowder drawing of the word "Slap," a reference to the professional's term for a model's heavy makeup. He introduced her to his artist friends and asked her to pose for his photographic novella of Mason Williams's story "Crackers," which he later made into the 16mm film *Premium*.

In both, Bing is the date of a nattily dressed Larry Bell riding in Mason Williams's own 1933 Pierce Arrow, driven by Tommy Smothers wearing a chauffeur's uniform. Gernreich makes an appearance as a hotel bellhop. Bell escorts Bing to a seedy, cheap hotel room where she undresses and gets into a bed covered entirely with lettuce. To her surprise, Bell douses her with salad dressing and announces that he must leave to get crackers. Premium Saltines, of course. He then goes to an exquisite, expensive hotel room and enjoys his crackers while alone in bed. This whole adventure could have been considered a warning. When Bing's affair with Ruscha came to an end, he gave her a painting of words in ketchup red on a yellow background: "Listen, I'd Like to Help Out, But—." Ruscha and Danna Knego divorced then later remarried.

Mason Williams was not married and was ever more popular.

With his hazel eyes, dimpled chin, an income of $500,000, and ultra-hip friends, he recalled having about forty girlfriends between 1969 and 1970 and thinking, "Man, that is out there."

"The joke I have is that people say, 'You have had about 10,000 girlfriends.' I say, 'That's ridiculous. It couldn't be more than 6,500.'"[3]

The Hoppers' marriage, however, couldn't take the strain of the late sixties. After six years, as Dennis's drug use and infidelity took their toll, Brooke left him. He had taken to terrifying the children—her two sons from a previous marriage as well as their daughter—by chasing them around the house with a six-shooter in each hand. Brooke had to drive them to her friend Jill Schary's house to stay until Dennis passed out. The separation was bitter. Most of their sizable art collection was sold or kept by Brooke so Dennis was left with few assets, apart from a barely coherent script that he had written with Peter Fonda called *Easy Rider*. Brooke did not bother asking for any percentage of that project, she was so certain that it would be a flop. (Costing $340,000 to make, it grossed $30 million in the United States alone.)

The availability of the birth control pill, approved for use in 1960, a growing awareness of the erotic desires of women, and widespread experimentation with drugs accelerated rampant sexual freedom. In the spring of 1967, Griffith Park was the site of several love-ins. The Doors played the February love-in and some six thousand flower children congregated for the Easter event.

By then, the so-called studs of Ferus were minor celebrities who attracted groupies just like rock stars. Kauffman, who would marry seven times and have countless girlfriends, attended the Easter love-in and fell under their spell. Vivian Kauffman recalled, "It was a boys' club and I think it was pretty difficult to live with those people. They had to be so concentrated, they led very selfish lives, and all the women were left in the wake."[4] Vivian divorced Kauffman in 1967 and went to work for Blum. (She remained friends with Kauffman, however, and often invited him to dinners that she made for visiting artists, such as Carl Andre and Frank Stella, while working for Blum. She later married PAM trustee and collector Robert Rowan.) Robert Irwin and Nancy Oberg divorced for the second time. Ed and Avilda Moses divorced. Larry and Gloria Bell divorced in 1971.

The greatest shock in the art world, however, was the divorce of Walter and Shirley Hopps.

After three years as director, Hopps was spending as little time at the Pasadena Art Museum as he had at Ferus. Curator James Demetrion noticed that in the last six months of 1966, he would be at the museum just two or three days a month. "It was a problem in terms of morale for staff—very loyal people who felt let down, you might say."[5] As one wag put it, he was a presence but he wasn't present.[6]

Neither was Hopps at home since he was often with other women. Kauffman recalled, "Walter cheated on Shirley. She caught him a couple of times. I think Shirley found him in bed with a girl and Walter jumped up and said, 'This girl is very mixed up and I was counseling her.'"[7]

Shirley was dismayed. "I heard him say we had an open marriage and I didn't know what he was talking about," she said.[8] "He disappeared all the time. Many a time I would not know where he was for two or three days. He was really involved in drugs—uppers and downers—and that is how he managed. He was always behind so he'd work twenty-four or thirty-six hours straight through on uppers and downers, none of which I knew. I never suspected because he was such a different species of person and able by his own will to do such things, you could believe he could stay up those hours."[9] She added, "Walter had limits. There is only so long you can do it. He's too erratic and needs someone to take care of him. I loved him but didn't want to have anything to do with him."[10]

Shirley left him in 1966. Despite her rise as an art historian at UC Riverside, having received her doctorate in 1964, she had remained involved in Ferus and been in regular contact with the perennially charming and well-mannered Blum, who was all sympathy for her frustrations. "You could say there was a very strong attraction to Irving. It was a question of being together all the time and Walter being away all the time."[11] Shirley preferred the library to the social whirl of the art scene, and Blum provided a nice balance. "Irving was so outgoing, it was a part of the attraction. He was comfortable with people so I didn't have to deal with it too much."[12]

Hopps, in considerable denial about his own condition, was

stunned when Shirley moved out. "I think Walter really never got over it," she said.[13]

Irving and Shirley eventually married at the Maple Drive home of Don and Lynn Factor in what Irving described as "a hippie wedding" with everyone wearing beads and flowing robes. They moved into an apartment on San Vicente Boulevard in West Hollywood decorated with the Warhol Campbell's soup-can paintings. In 1969, they had a son, Jason Ferus Blum.

Larry Bell observed one singularly odd outcome of their marriage, since his wife, Gloria, was Shirley's sister: "I've had the dubious distinction of having both Walter Hopps and Irving Blum as my brothers-in-law."[14]

During his years at the Pasadena Art Museum, from the 1963 Duchamp retrospective to the 1967 Joseph Cornell retrospective, Hopps had brought a considerable amount of attention to the museum despite his eccentric behavior. Artists adored him and accepted all his irregularities. It was due to his friendship with Jasper Johns that the tiny PAM became one of the museums to host his coveted 1965 show organized by Alan Solomon for the Jewish Museum in New York. A few days before the Johns opening, Hopps told everyone to be at the museum at nine at night to install the show coming from the Whitechapel Gallery in London. Demetrion recalled, "He strolled in after midnight, and we were there all night. Still, the show looked great."[15]

Though the Johns show came with a catalog, Hopps wanted to produce his own and told Demetrion to compile a chronology. Knowing that Hopps found writing to be extremely taxing, Demetrion inquired about the progress of the essay. Hopps reassured him that the essay was on track right up to the night of the opening reception when Demetrion arrived and was horrified to see a stack of cards featuring a reproduction of Johns's *White Flag* with a note on the back stating that a definitive catalog written by Demetrion would soon be available. "I blew my top quietly," Demetrion recalled. "I told him 'What was behind all that, ruining my reputation?' I explained to Johns, but it bothered me. I'm still not sure I'm over it. Yet, Walter was so easy to forgive, even against your will sometimes. He had a certain charisma."[16]

Hopps's true gift was his acumen in targeting talent and selecting the best work by certain artists. His cachet with artists also helped secure work for a few Los Angeles collectors at a time when there was increasing competition for the best pieces. He acted as an adviser to Pasadena real estate mogul Robert Rowan, chairman of the board of trustees at PAM, who built a noteworthy collection of color-field painters and Ferus artists. Yet Hopps had zero administrative skills. Demetrion recalled, "Walter was not able to control the financial situation, so Rowan became the main support of the museum, putting up about $50,000 a year, which was a ton of money in sixties."[17] When Don Factor joined the PAM board, he was distressed to find that Hopps "was supposed to be out doing the things museum directors do and he'd be sitting around with his artist friends. The board got fed up. . . . He . . . should never have been made director."[18]

In 1966, Hopps's amphetamine addiction led to a breakdown and he spent several weeks recovering in the psychiatric ward of Cedars-Sinai Medical Center. "From the late fifties until 1966, I was quite thoroughly addicted to speed," he said. "I've never been an alcoholic. But I'm a night person, and there were all those times I'd have to start early in the morning, going out to earn money, and I began using amphetamines."[19]

Rowan asked for Hopps's resignation, and Demetrion was promoted to acting director but invited Hopps to stay on to install his Cornell retrospective.

Peter Plagens has noted that Hopps always struck him as "the Blanche DuBois of the art world in that he depended on the kindness of strangers and always had the support of some rich person."[20] After being ousted from PAM, Hopps was awarded a fellowship at the Washington think tank Institute for Policy Studies in 1967 where he wrote a proposal to have the Washington Gallery of Modern Art taken over as the contemporary art wing of the Corcoran Gallery. Within a year, Corcoran director James Harithas resigned and Hopps was named acting director, then director, of the Corcoran. His tardiness became such an issue that his staff made pins stating "Walter Hopps will be here in 20 minutes." Hopps still found it difficult to work in an institution. In the early 1970s, when he was working at the Smithsonian's National Collection of Fine Arts, his boss, Joshua

C. Taylor, was sometimes heard to say, "If I could find him, I'd fire him."[21]

Despite Hopps's many failings, his departure from Los Angeles was felt keenly among his many supporters. It was a further blow to learn that *Artforum* was moving to New York. "There was a tremendous sense of betrayal in the L.A. art world," recalled Plagens.[22] This abandonment by the magazine that had come to embody all the aspirations of an increasingly self-confident community of artists was seen as traitorous. The artists had been pushing Philip Leider to provide more coverage of Los Angeles and less of New York. Leider recalled that Ruscha "thought that we were basically biased against West Coast artists, that we never gave them the kind of splash that we gave New York artists. He once said to me very readily, 'Look Phil, I know what you think of me. You think I'm a tenth-rate Pop artist.' And I remember just looking up, we were both at the light table, and I just looked up at him and our eyes met, and he knew and I knew. I couldn't say anything."[23]

Paradoxically, Leider's decision was the direct consequence of taking a trip to New York with Blum, who convinced Leider that he would be able to get better writers there—writers who would be familiar with the New York artists he was representing. Blum introduced Leider to Stella, Rose, Castelli, Kelly, Warhol, and Lichtenstein. "And it was as a consequence of that trip that I just wrote off Los Angeles," Leider said. "I had no longer any patience with people like Billy Al Bengston and his attitude—very strangely adolescent. If a dealer came to his studio or if a museum person came to his studio and wanted a painting for an exhibition, Billy would want rent."[24]

Such a move was never Blum's intention, and he was deeply disturbed by Leider's decision. "I kind of had the feeling that if it went East that would be the end of it, the end of it for me. As a West Coast dealer."[25] Charles Cowles accepted the verdict of his editor and moved to New York with the magazine. Ruscha flew out to New York once a month to continue as the publication's art director until 1969.

John Coplans, who had been contributing some of the magazine's more insightful articles, was hired as curator at PAM by Deme-

trion. "John was very energetic, ambitious, wrote a lot, but there was tension. I think he wanted to become director. When I left he was made acting director."[26]

Coplans clarified the ongoing problem at PAM. "I had a budget of $5,000 a year for West Coast artists, compared to a budget of $40,000 for shows of East Coast artists."[27] Despite this perpetual poverty, Coplans and Demetrion made a point of exhibiting more young Los Angeles artists than Hopps had done: Neil Williams, Dennis Hopper, Terry Allen, Paul Sarkisian, Billy Al Bengston, Judy Chicago, and the Light and Space triumvirate: Robert Irwin, James Turrell, and Doug Wheeler.

Charge of the Light Brigade: Irwin, Wheeler, and Turrell

I n January 1968, when Robert Irwin had his show at PAM, he was forty years old. His clean-cut look had given way to a beard and long hair just as his abstract paintings on the covers of jazz albums had given way to experiments with light and perception. By constantly questioning the purpose of painting, in less than a decade he had eliminated the traditional format of a canvas to spray automotive paint in thin, transparent layers of pastel over a silver-white convex spun-aluminum disc. Mounted on a clear cylinder to float some six inches away from the wall, each disc was illuminated by two floodlights on the floor as well as two on the ceiling in a symmetrical arrangement. The lights cast shadows like the petals of a flower behind the glowing disc to create "the effect of a painting with no formal beginning or end, the central area of which had a field density that operated on the eye in much the same way as a

ganzfeld," he said.[1] Another series of clear acrylic discs, sprayed opaque white at the center, gave way to translucency at the rim, "thus achieving an immediate integration of painting and environment."[2] Irwin spent hours isolated in his studio and came to each aesthetic decision through dedicated intuition and attentiveness to his own perception. An autodidact by nature, Irwin was practicing phenomenology without having undergone any course of study.

Meanwhile, two younger artists, Doug Wheeler and James Turrell, were pursuing these very same notions. The three shows at PAM started the so-called light wars, an internecine tussle over who did what first that would continue for decades to come.

Three months after the Irwin show, twenty-nine-year-old Wheeler showed "light encasements," clear Lucite rectangular boxes that were painted white on the inside front panel and sealed around the edges so that electric light emanated softly around them, "like Mark Rothkos spilling from their frames," wrote *Los Angeles Times* critic William Wilson.[3] Wheeler was pursuing a curiosity similar to Irwin's about the nature of seeing, but his was inspired by a lifelong involvement with flying airplanes.

A native of Globe, Arizona, Wheeler was in a plane from the age of twelve. His father was a surgeon who flew his own plane to get to patients in the remote areas of Arizona; his mother was a pilot as well. By the time Wheeler enrolled at Chouinard in 1962, he had a pilot's license of his own and legitimately sported the fashionable dark aviator sunglasses. Tall and slender, with curly brown hair and mustache, he had applied to the school in person but without a portfolio. After knocking out a few freehand drawings for the admissions department, he was accepted on the spot. He was initially interested in design and his teacher Don Moore set up interviews with two New York advertising agencies. Both offered him a job but by then he had decided to pursue painting. He was still a student when his all-white paintings with glossy white squares in the four corners won him LACMA's Young Talent Award. He had married a classmate, Nancy Harrington, and needed the money but didn't want the award, fearing he would be pigeonholed. "I was idealistic."[4] The following year, Wheeler created a series of light paintings by wrapping neon tubing around the back of a stretched canvas so illumination seeped out from the edges.

Doug Wheeler with Zero and his Bellanca, ca. 1969
Photograph courtesy of the artist

 Because he was at Chouinard when Irwin was teaching there, it
has been assumed that Wheeler was his student, but that was not the
case. He never studied with Irwin but did invite the older artist to his
studio to see his light paintings, which were inspired by the subtle
changes in the atmosphere that can be seen only when flying. Irwin
was enthusiastic about the work and mentioned his name to Arnold
Glimcher at New York's Pace Gallery.

 Glimcher, who already showed Irwin and Bell, gave Wheeler
$1,000 with no strings attached in 1967. After a painful divorce from
Harrington, Wheeler moved into a vacated dime store in Venice, not
far from Irwin's studio. Wheeler was already bored with his encase-
ments and was using his large studio to create room-sized environ-
ments of disorienting homogenous light called ganzfelds. Wheeler
was excited to show the results of his research to Glimcher and his
director, Frederic Mueller. He recalled, "The main room was three

thousand square feet, coved at the floor and ceiling, with a skylight so it looked like a ganzfeld with a line of phosphorous sprayed near eye level. Under UV light, you could feel a fogginess around the perimeter of the walls, like flying through an inversion layer. Anyway, the Pace boys, Glimcher and Fred Mueller, walked right through it to see the encasements. And then they left. I was devastated. They didn't seem to notice. Later, the meter reader came to the door and had to come through the space to get to the meter. He walked in and said, 'Oh, Wow!' He saw it and the Pace boys didn't see it. I didn't want to be with those guys. They couldn't even see it."[5]

Before either Irwin or Wheeler had shown at PAM, James Turrell was given a show at the end of 1967. Turrell was a twenty-four-year-old graduate student in studio art for a semester when Coplans was teaching at UC Irvine. (Turrell later completed his master's degree in art at Claremont Graduate School in 1973.) Coplans had seen Turrell's first experiment with a slide projector projecting light without an image as well as some rudimentary experiments with the headlights of passing cars in his small studio in the Mendota Hotel in Santa Monica. A native of Pasadena, Turrell had had a scientific inclination when young—his father was an aeronautical engineer who had died when Turrell was ten; his mother had trained to be a doctor. At Pomona College, he majored in mathematics and perceptual psychology but took art history courses from Demetrion, who taught there for a year before going to PAM. A Quaker by faith, the stocky Turrell was a long-haired and bearded conscientious objector throughout the Vietnam War.

At PAM, Turrell showed *Afrum (White)*, which appeared as a three-dimensional cube hanging in the corner of a darkened room that was created by light beamed from a xenon projector. The floating box of light, neither sculpture nor painting, was, in fact, an entirely new manifestation, but Turrell had no doubts about its legitimacy. "One of the advantages of growing up in California is that you're not under pressure to repeat the past. I never even had a *thought* that what I was doing wasn't art."[6]

John Coplans, who had been a pilot in the Royal Air Force, empathized with these three artists working with the substance and

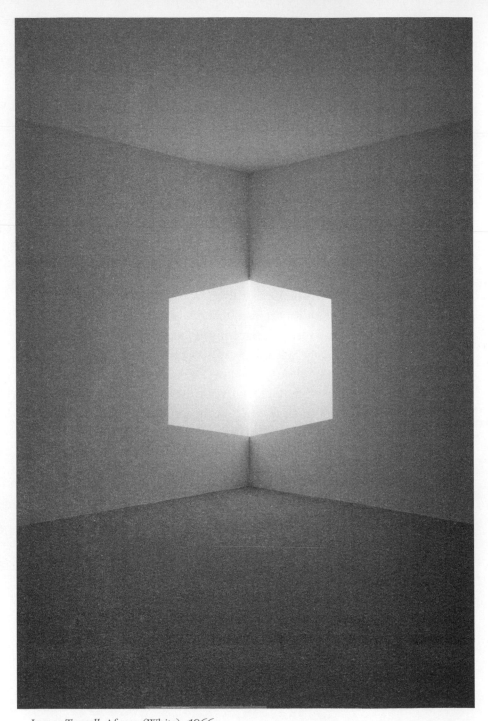

James Turrell, Afrum (White), *1966*

Collection of the Los Angeles County Museum of Art, purchased with funds provided by
David Bohnett and Tom Gregory through the 2008 Collectors Committee;
Digital Image © 2009 Museum Associates / LACMA / Art Resource, NY

perception of light. He took Jasper Johns to Turrell's studio. "Much to my embarrassment, Jasper stood in front of a Turrell piece for what seemed to me half an hour looking at it, and I'm sitting there thinking, he's probably too embarrassed to say that he can't make anything out or he doesn't like it. Then he turned around to Turrell and said, 'Can I buy this piece?'"[7]

Count Giuseppe Panza di Biumo, an Italian collector who went against the prevailing wisdom of the era to buy Los Angeles artists in depth, had bought works by Irwin, and he commissioned one of Wheeler's light installations for his castle in Varese. A few years later, he commissioned a similar work by Turrell. Count Panza wrote, "Los Angeles is a new city without roots in the past, a place where everything seems temporary and where everything can suddenly change. You have a sense of instability and loss of identity; you feel the need to find something unchangeable and more important than becoming."[8]

With all three artists manipulating the subtle effects of light, a question of precedence came to the fore: Who had had the idea first?

Jan Butterfield wrote the first general book on the subject, *The Art of Light and Space*, and summed up the problem: "It is a little-known fact that the all-important 1967–68 Pasadena exhibitions (one-man shows by Irwin, Turrell, and Wheeler) were originally intended to be one three-man show, but it soon became apparent that there simply was not enough room for all of them to exhibit at the same time. Had the one show taken place as originally planned, the 'who did what first' battle over dates would have been avoided."[9]

As a result, over the next few years, the younger artists felt competitive with each other and with Irwin. But by then, the field had grown crowded with Laddie John Dill's neon tubes supported by drifts of sand, Maria Nordman's work with fire and smoke installations, Hap Tivey's scrims, Ron Cooper's resin wall boxes, and Mary Corse's paintings covered with light reflective white paint. Even Ed Moses got into the act when he had the ceiling removed from Riko Mizuno's gallery to create a room flooded with light. When the ceiling was to be reinstalled, Irwin volunteered to add a few skylights so that the lovely natural light would be perpetual; it was enjoyed by the subsequent art dealers who rented that space: Larry Gagosian, Timothea Stewart, and Rosamund Felsen.

Irwin had grown through his earlier friendships with younger artists so he invited Wheeler to join him in the research for the Art and Technology exhibition cooked up by Tuchman at LACMA whereby collaborations were facilitated between artists and various corporate sponsors. (It was conceived on the heels of the Experiments in Art and Technology promulgated by Rauschenberg and Billy Kluver in New York in 1965, an enterprise that was so controversial it was surprising that Tuchman wanted to revisit the idea.) Wheeler refused so Irwin invited Turrell. They were introduced to Dr. Ed Wortz, head of the laboratory monitoring the environmental control systems for NASA's manned space flights. Though Wortz had no previous interest in art, he was thrilled by the curiosity of the two artists, calling it "love at first sight." The threesome spent days in an anechoic chamber depriving themselves of all sensory stimulation for hours. When they emerged, everything that they saw appeared entirely transformed. They experimented with ganzfelds, surrounding themselves with a pure white surface so that the eye could focus on no object, like being inside a giant Ping-Pong ball. They learned to focus each eye independently and to be conscious of the images received separately. They took copious notes and collated documentation, and they were beginning to translate these experiences into some sort of participatory installation when, in August 1969, Turrell stopped showing up for their meetings or returning their calls. He later denied that the sessions had any effect. "I don't know that anything really startling came out of the whole thing," he said.[10] Turrell maintained that he had not continued because of the project's focus on technology over the role of spirituality. Yet, his work would come to rely increasingly on technology as he used projected sources of light.

Irwin chose ever more reductive strategies of eliminating extraneous details from his art. After 1970, he refused to allow his work to be reproduced since photographs could not capture its experiential nature. A couple of years later, he gave up his studio altogether. Wheeler moved in.

Irwin and Wortz continued their dialogue and their friendship. "The biggest product of the Art and Technology thing is the effect we had on each other. I radically changed Ed's life, and he radically changed mine," Irwin mused.[11] Soon after, Wortz left the space pro-

gram and became a gestalt psychotherapist at the Los Angeles Buddhist Meditation Center. Many of his clients were artists. Meanwhile, Irwin's process of questioning had come to mirror the protocols of science and experimentation. His aesthetic decisions seemed to be based on feeling, not logic. "The critical difference is that the artist measures from his intuition, his feeling. He uses himself as the measure, whereas the scientist measures out of an external logic process."[12]

Fantastic Plastic Lovers:
DeWain Valentine, Peter Alexander,
and Helen Pashgian

There is Dustin Hoffman as he stands on the patio of his parents' tasteless Los Angeles house, anxiously listening to his father's friend doling out advice. "Plastics," he says. "There is a great future in plastics." One of the most memorable and comical scenes of *The Graduate*, it was a moment that captured the absurdity of postwar Los Angeles prosperity. By-products of the local aerospace industry, plastics did unfortunately become the miracle material of the future. After being declassified by the army and navy, acrylic and polyester resin were suddenly available to hobbyists, surfers, and, of course, artists.

The phenomenological inquiries of Irwin, Wheeler, Turrell, and others were contiguous to the movement that included the prismatic glass boxes of Bell and the luminous vacuum-formed wall reliefs of

Kauffman. John Coplans described it as "finish fetish," a term high-jacked in the most derogatory manner by unfriendly critics. It underscored the fact that these Los Angeles artists were obsessed with precision, something their New York counterparts found risible. As Dave Hickey wrote in his essay "Primary Atmospheres," "In a moment when Clement Greenberg was advocating febrile sensibility and Michael Fried was demanding that works of art ignore our presence, California Minimalism created a gracious social space in its glow and reflection; it treated us amicably and made us even more beautiful by gathering us into the dance."[1]

When Kauffman and Moses shared a studio, they went to a nearby doughnut stand where Kauffman was fascinated by the appearance of the contained nectarine color. This is exactly how his vacuum-formed plastic wall reliefs appeared, as unorthodox supports for sensual, vibrant fruity colors. In *Artforum*, Jane Livingston wrote, "In a way that enlarges upon the intelligible illusionistic duality in Larry Bell's rhodium-coated glass boxes, Kauffman's works demonstrate that austerity is not necessarily the measure of success in detail-less object art. . . . His plastic paintings are enormously seductive."[2] The following year, Kauffman's show at the Pace Gallery was reviewed by Robert Pincus-Witten, who found the exquisiteness of West Coast art, specifically that of Kauffman, to be "really about the flaunting of the most unrepentant narcissism. Lest there be any confusion let me add that I regard this as a positive achievement."[3]

DeWain Valentine, who grew up in Colorado, first encountered plastics in a junior high shop class when a teacher showed him how to polish acrylic scraps. Once he discovered polyester resin, he heated it in his mother's oven to forge plastic jewels. However, at the University of Colorado art school, where he studied with Richard Diebenkorn and Clyfford Still, he was told "you can't make art out of plastic." He got the same response when he went to Yale on scholarship, where he studied with Philip Guston.

Valentine, who wore boots and a Stetson like a Western cowboy, then moved to Los Angeles "specifically because of Kauffman, Bell, and Price." He had left a more lucrative job teaching in Colorado to teach a plastics course at UCLA extension. "I got fired twice," he remembered.[4] Learning from trial and error, he became

Craig Kauffman, Untitled, *1968*
Photograph courtesy of Frank Lloyd Gallery, Santa Monica

the consummate technician, experimenting with polyester resin for-
mulas in order to cast clear, clean sculpture on a massive scale, such
as a perfect ten-foot disc the color of the sky. Built like a wrestler,
with wavy blond hair, blue eyes, and a turned-up nose, Valentine had
the physical strength to control the large quantities of heavy liquid
resin. Keeping meticulous notes on formulas, he gained such renown
for his accuracy and color that the Santa Monica firm Hastings Plastics
actually produced a DeWain Valentine resin. "All sculpture is exte-
rior," he said. "I wanted to make pieces you could see through to the
other side. I wanted the most perfect surface so you didn't get hung
up on the surface, or on any scratch that might catch your eye."[5]

The ocean was a powerful draw for Valentine, who set up his
studio next to Bell's in Venice. Polyester resin was used by surfers to
coat their boards, which is how Peter Alexander discovered its
potential. An art student at UCLA, Alexander recalled looking at the
resin in a Dixie cup while glazing his surfboard. He cast the resin as a
transparent cube about the size of a hat box and containing puffy
white clouds. When Bengston saw it, he advised some collector friends

Peter Alexander,
Green Wedge,
1970
Courtesy of Peter
Alexander

to buy it, and Alexander's career was launched. From a well-to-do family in Newport Beach, Alexander had a mop of brown hair and patrician features. He had studied architecture at the University of Pennsylvania and worked for Richard Neutra, the architect known for his glass-walled houses, as well as for architect William Pereira. After weeks of work on his first project for Pereira, Alexander was told that the client had changed his mind and the design would not be used. Exasperated, Alexander decided that he could not continue to work under such conditions and returned to school to study fine art. Yet, his earlier training remained evident as he cast architectural wedges and pillars of polyester resin in grades of oceanic color. He captured the experience of translucency—what he saw while surfing inside a swell. "It was not an art material," Alexander said. "One benefit of being in L.A. was that nobody took anybody out here very seriously so you could enjoy those materials because you were free."[6]

Alexander's brother, Brooke, had moved to New York and become an art dealer. "Not being in New York was a disadvantage from the

point of view of commerce but an advantage in terms of having a good time," he said. "I remember Minimalism vividly. I had trouble with the rhetoric that went along with it. We are not Minimalists, though there may be a similarity in geometry. Disappearance was the most appealing part to me."[7]

Helen Pashgian was a third-generation Pasadenean, but her parents rented a house during the summers at Crystal Cove near Laguna Beach, not far from Alexander's house, and the two met as children. Her initial interest in the quality of light came, she believed, from the hours she spent as a small child looking at tide pools populated by small abalone and other sea creatures. A handsome, athletic woman, she surfed on large balsa wood boards around San Onofre State Beach by crawling under the fence around Camp Pendleton.

After finishing her undergraduate degree at Pomona College, she went east to study art history at Columbia University and Boston University. A distant relative of Oliver Wendell Holmes, she felt a connection to her East Coast family, but after seven years, she returned to Pasadena to become an artist. She tried to capture the liquid light in translucent washes of paint on canvas but it was her discovery of polyester resin that made her transition to sculpture possible. Through trial and error, she learned to pour resin in the forms of balls, boxes, and spheres and she exhibited them at the Felix Landau Gallery.

All of these artists created polyester resin sculpture that appeared to be made by machine, an art in keeping with the futuristic reputation of Los Angeles. In fact, each piece was handcrafted with extreme care, and the work was meant to be experiential, erasing boundaries between painting and sculpture.

One challenge was faced by all. When the resin came out of the mold, it had to be sanded by hand for hours and hours to achieve an unblemished surface. "It *is* about finish fetish," Pashgian emphasized. "If there is a scratch that is all you see. The point isn't that I want to see through it but to see into it, but that is why we have to deal with finish!"[8]

Enter Jack Brogan, who had had experience working for the U.S. Atomic Energy Commission in Knoxville, Tennessee. "I knew how to machine resin," he said.[9] Irwin met Brogan by chance at the Lucky

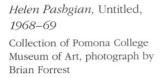

Helen Pashgian, Untitled, *1968–69*

Collection of Pomona College Museum of Art, photograph by Brian Forrest

You Mexican restaurant in West Los Angeles. Brogan was a jack-of-all-trades who suited perfectly the needs of artists trying to use complicated new technologies and materials. The word got out, and Brogan was soon on call for most of the Venice artists. "It gave you the freedom to do things you had no idea of until you tried doing them because you could always call Jack," Alexander admitted.[10]

Alexander and Pashgian were invited to be artists in residence at the California Institute of Technology in Pasadena and have a show at Caltech's gallery. Pashgian had completed a five-foot-diameter sphere of pale resin but couldn't complete the sanding in time for the opening. She called Brogan. "Jack and his staff picked it up, took it to Venice, and polished it all night and brought it back the next day to be ready for the show," she recalled.[11] The enormous piece was perfect—so perfect that it was stolen out of the gallery and never recovered.

Plastic may have been anathema to old-guard observers who saw it as being, well, plastic. But within a few years, there were so many exhibitions of artists exploring the use of acrylics and resins that, in 1972, CalArts held The Last Plastics Show, organized by and featuring Judy Chicago, DeWain Valentine, and Doug Edge and including work

by Peter Alexander, Helen Pashgian, Vasa, Greg Card, Fred Eversley, Richard Amend, Terry O'Shea, Ron Cooper, and Ed Moses.

"That whole Light and Space thing," Plagens said. "From highly tailored plastic and glass and metal objects to phenomenological, altered architectural environments—that was like the whole art world. There was a sense in L.A. of, 'We got this, and this is what makes us different,' and 'We got this and they don't got this in New York.'"[12]

Odd Man In: John Baldessari

I n 1967, when Coplans was arranging shows for the Light and Space artists, as they were being called—a potentially damning term veering a little too close to "lightweight and spacey"—he visited the vacated movie theater that served as a studio for John Baldessari. Leaning against the walls were a number of off-white canvases bearing enlarged grainy black-and-white photographs of dumb suburban streetscapes, each captioned with its equally ordinary location. Though Warhol was silk-screening news photos on canvas and Ruscha was painting words and photographing parking lots, Baldessari's pictures seemed to Coplans to be uniquely devoid of aesthetic consideration.

Baldessari had driven around his run-down hometown of National City, a suburb of San Diego, taking photographs at random of stucco buildings, traffic lights, and street signs by aiming his camera out the

John Baldessari, Econ-o-wash . . . , *1966–68*
Courtesy of John Baldessari

window of his truck. He developed the pictures directly onto photo-emulsion that he spread on canvas but without any attention to composition. The artist hadn't even painted the captions but had hired a sign painter to do lettering such as "Looking East on 4th and Chula Vista." He said, "It seemed more like the truth. Landscape paintings are idealized. Telephone poles, telephone lines—that's real. I wasn't traipsing around the woods looking for the perfect spot. I was making art out of where I was."[1]

Intentionally mundane and informational, they were the beginning of his involvement in Conceptual art, an inquiry into what might constitute visual art in the age of mass media and capitalist expansion. Coplans was arguably the area's most progressive critic and curator but, without much preamble, he looked around in utter bewilderment and said, "I can't show these."[2]

Baldessari accepted this rejection as he had the many that preceded it. A few years earlier, he had loaded his paintings into the

back of his father's pickup truck and driven around to different Los Angeles galleries. "I came back with my tail between my legs," he recalled. At Ferus, Blum took a look at his paintings and sniffed that they "were not exactly his cup of tea."[3]

Then there was the problem of Baldessari himself. Unlike the artists of the Cool School, Baldessari was painfully shy, slightly stooped to disguise his six-foot, six-inch frame, with shaggy brown hair, beard, and mustache; he wore heavy square-rimmed glasses. Though he was of the same generation as the Ferus gang, he was a late bloomer with none of their bravado.

Baldessari's introspective nature was partly the result of being raised by European immigrants in a conservative small town near the Mexican border. His Austrian father was a laborer who had met his Danish mother in San Diego, where she was working as a private nurse to a wealthy couple. Educated and interested in culture, she read, played the piano, and insisted that her son take music lessons. His parents grew vegetables and fruit trees in the large backyard of the house they bought with money earned by salvaging old building materials to sell. Born in 1931, Baldessari was enlisted to help his father. "I remember as a child . . . taking apart faucets and reconditioning them, painting them, and taking nails out of lumber. . . . I sometimes think that has a lot of bearing on the art I would do. Looking at maybe two hundred different kinds of faucets, all generically the same, but seeing all the variations. Always looking at things like, 'Why is this faucet better than that faucet?' "[4]

After graduating from Sweetwater High School in National City, where his classmate was singer Tom Waits, he enrolled at San Diego State College and got his undergraduate degree in art education so that he would have a teaching credential. Thinking he might have a future in art history, he enrolled at UC Berkeley for a year, but they had no program on contemporary art. He learned how to use the library and returned to San Diego State.

In 1954, he got his first break. An instructor had him enter his still life in the National Orange Show at the San Bernardino State Fair. His painting was reviewed in *ARTNews* by critic Jules Langsner. "I was floored," Baldessari recalled.[5] He joined the legions of high school art teachers who painted in their spare time. "My life consisted of sending

in slides, then sending in paintings, then getting the paintings back. I did reasonably well. Artists from Southern California, Artists from California, Artists from the Southwest, Artists from the Northwest, Artists from the Western States: I was in all of those shows. But I didn't know how paintings got into galleries or museums, because none of my models—my teachers—were showing in galleries or museums. I knew there was information I didn't have, but I didn't know how to get access to that information."[6]

In 1957, Baldessari enrolled in a UCLA summer course taught by Los Angeles's most celebrated artist, Rico Lebrun. At the end of the class, Lebrun had everyone look at Baldessari's nonobjective painting collaged with paper and asked, "Have you ever thought about being an artist?"

Baldessari answered, "No. Not really."

Lebrun continued, "What do you do?"

Baldessari said, "Teach."

Lebrun insisted, "Well, you really ought to think about it."[7]

With that, he introduced Baldessari to Herbert Jepson, who taught drawing at Otis. "He was really inspirational to a lot of artists—and to me. I mean, he was limited, but I didn't know he was limited until later. I mean it was enough for me at the time," Baldessari said.[8]

He also met Voulkos but was interested in the fact that Voulkos brought European art magazines for his students to read. Even at that stage, Baldessari sought answers in books and magazines. "All my art information was imported," Baldessari recalled. "I've always had this theory that a lot of . . . changes in art history come about from misinformation. Reproduction, and not understanding somebody's work and spinning off from there in a completely oblique fashion that probably wouldn't have happened if he or she saw the original work."[9] Certainly, this wound up being a force in Baldessari's own art.

Jepson's training paid off when Baldessari's painting was included in a group show where it was singled out by a critic who wrote, "It's nice to know that someone in L.A. knows how to draw."

"That was it," said Baldessari. "I stopped drawing and dropped out of school."[10]

He went back to National City in 1961, married a schoolteacher, Carol Wixom, had two children, and taught art. While accepting of

what seemed to be his destiny, he started taking photographs as notes for his paintings. He also made his way to the 1963 Warhol show at Ferus and the Duchamp retrospective in Pasadena. "I was very impressed by that. A big impact. I mean, actually seeing that stuff instead of, you know, reading about it."[11]

In 1964, he was selected, along with Voulkos and Irwin, to be a member of a jury for the Fourth Annual California Painting and Sculpture awards. These rather amateur operations had been considered the substance of culture in the area for decades, but these three artists felt it was time to instill a measure of professionalism. Together, they rejected every single work so that none of the applicants received an award.

After years of showing slides to galleries, Baldessari was finally scheduled for a solo show in 1965, but the gallery went bankrupt. Suddenly, he felt liberated: "I gave up all hope of showing and thought, 'What the hell? Since nobody cares, why do I have to cosmeticize everything by translating it into painting? Why can't I use straight information? Straight photography?"[12] This was the epiphany that changed his career and his life.

A year later, Baldessari had himself photographed standing in front of a palm tree by a suburban tract home. He processed the negative on a large stretched canvas and beneath the blurry black-and-white photograph added the word "Wrong." The palm tree appeared to be growing out of his head so it was the wrong sort of composition. Living in the suburbs was wrong. Compared to the "studs," he was wrong.[13] Acceptance of his status as total outsider had led him to question the very nature of what might constitute a work of art.

His work was conceived in the context of the obsession with craft that characterized the pristine wall reliefs of Kauffman, the glass boxes of Bell, and the minuscule dots of color painstakingly painted on white panels by Irwin. Nothing could be further from finish fetish than Baldessari's decision in 1966 to hire a sign painter to letter texts in black capitals on off-color canvases. The simplest of these stated "Pure Beauty," an astute choice for a work entirely divorced from the artist's hand. No craft went into the making of this art—and, furthermore, Baldessari was confronting his viewers with

*John Baldessari with a
brandy glass in each hand,
rifle, and Christmas tree*
Photograph courtesy of Klaus
Vom Bruch, 1975

an outrageous demand. It was down to them to decide the meaning
since this assertion of "pure beauty" was absent from the painting
while being the putative goal of much artistic effort over the centuries.

Nicholas Wilder and New York dealer Richard Bellamy had come
to see these works but, like Coplans, had no idea what to make of
them. Fluxus poet and critic David Antin, Baldessari's colleague at UC
San Diego, was his sole supporter and recommended him to Molly
Barnes.

Barnes had opened a gallery on North La Cienega Boulevard
after giving up her pursuit of a bicoastal love affair with Willem de
Kooning and, in 1968, she gave Baldessari a two-week slot in Octo-
ber between regularly scheduled shows. Coincidentally, Joseph
Kosuth, another budding Conceptual artist from New York, had his
first show that same night at Riko Mizuno and Eugenia Butler's Gal-
lery 669 right down the block. Jane Livingston reviewed both shows

in *Artforum*. She noted that Kosuth wanted to strip away from his art everything but the idea and that he exhibited dictionary definitions of the word "Nothing," while Baldessari was also interested in elimination of "aesthetic encumbrances." Baldessari's gray canvas bore black text stating "Everything is purged from this painting but art, no ideas have entered this work."[14]

Despite their similar pursuits, Baldessari and Kosuth did not bond. Kosuth was irritated that Livingston had compared their work. In his book *Art After Philosophy and After*, he denigrated his Los Angeles counterpart by writing that "the amusing pop paintings of John Baldessari allude to this sort of work by being 'conceptual' cartoons of actual conceptual art."[15] Baldessari protested, "I think of humor as going for laughs. I see my work as issuing forth from a view of the world that is slightly askew."[16]

Nonetheless, Baldessari's work was funny. As a riposte to the motorcycle-riding and wave-surfing artists of Ferus, he had himself photographed from the back while wearing a denim jacket bearing a skull over paintbrushes, instead of crossed bones, and the gibe "Born to Paint." When asked to contribute a work to a show at the Nova Scotia College of Art and Design in 1971, he sent an assignment to the students to write on the gallery walls "I will not make any more boring art."

Baldessari moved up to Los Angeles permanently in 1970. To mark a complete break with the past, he hauled each of his earlier paintings out of a packing case and gleefully kicked his foot through it. Portraits of friends, studies of pine trees, landscapes, still lifes, a few abstractions—thirteen years of accumulated work was destroyed. He took the ruins to a mortuary to be cremated, noting with irony that the young man helping to burn his life's work once had been an art student. The ashes, in a book-shaped urn, were interred behind a bronze plaque: "John Anthony Baldessari, May 1953–March 1966."

"I stopped painting because I feared I might be painting for the rest of my life," he said. "After a certain period of time, one knows how to make beautiful things."[17] He hoped to break "the stranglehold of what art is or could be. . . . I just believed art could be more than painting."[18]

In 1965, Walt Disney began the process of merging Chouinard Art

Institute, whose founder's health was failing, with the Los Angeles Conservatory of Music to create what he called an interdisciplinary "Caltech of the arts." In 1969, California Institute of the Arts opened temporarily in Villa Cabrini Academy, a former Catholic girls school in Burbank. In 1971, the Modernist campus designed by the architectural firm Ladd and Kelsey opened in Valencia, a suburb to the north of Los Angeles.

Baldessari was hired to establish a department of "Post-Studio" art, a term borrowed from Carl Andre, where he made it his business to import guest lecturers from Europe and New York to overcome the dominance of the Ferus-influenced aesthetic. Though Baldessari did not even visit New York until 1970, he strongly encouraged his students to move there. David Salle took that advice. Mike Kelley did not. Both had tremendously successful careers as artists. Those that stayed formed a second-generation nucleus of artists who remained in Los Angeles for reasons similar to their teacher. "A sense of permission," Baldessari explained. "There's a daffy quality of 'Why not?'"[19]

Musing on the difference between New York and Los Angeles, Baldessari added, "I remember taking mescaline with Bob Smithson and Tony Shafrazi and walking around West Broadway and Canal just laughing our heads off. And Bob drank. We all drank enormous amounts. . . . [It was] very much in the air about who did what first—this really linear sort of art history. I remember one night talking about some idea and everybody looking up and saying, 'Yes, but how would that fit into art history?' I felt, who the fuck cares, you know, you just do it. But you didn't have that attitude in New York."[20]

Ferus Fades to Black

L ooking back, Blum said, "The artists that were there leaned on the gallery; the gallery leaned on that tight group of artists. We were very much in a vacuum, we were very alone—at least I can remember feeling that. . . . It had all kinds of problems but it had all kinds of lovely aspects."[1]

In the early years of Ferus, Blum good-naturedly agreed with his artists to hold periodic meetings to discuss the policies of the gallery. The artists held enough sway at that point to give thumbs-down to inviting Richard Diebenkorn to join the gallery. He may have been their friend and neighbor but as far as they were concerned, he represented Northern California figure painting and, therefore, the past.

At another meeting the artists were adamant about not offering discounts to collectors. Blum argued that the gallery would be at a great disadvantage since most dealers offered courtesy discounts of

at least 10 percent. The artists held firm. A few weeks later, financier Joseph Hirshhorn, who had sold his uranium-mining interests for $50 million in 1955, strolled into Ferus and offered to buy a number of pieces. Blum calculated the total sum and presented it to Hirshhorn, who asked for the usual discount. Blum said, " 'No, Mr. Hirshhorn, this is essentially a cooperative situation. We very often adhere to the ideas of the artists, and in this instance, their attitude . . . has to do with stating a figure and maintaining absolutely that figure in the face of any offer.' He said, 'Well, yes, I understand what you're doing. Good luck!' And out he went."[2] After that, Blum convinced the artists that their idea wasn't workable.

All along Blum continued to buy works by his artists. They were relatively inexpensive. As late as 1967, Blum said he bought ten Stellas for $10,000. "A lot of people don't realize that . . . the jump came between 1967 and 1970," Blum said. "Prior to 1967, all those people . . . Andy even, could have been bought very cheaply."[3] After 1967, Blum recalled, "I began to make sums of money that had eluded me up until that time."[4]

By then, Blum had closed Ferus. Arnold Glimcher suggested to Blum that they go into business together since Bell, Irwin, and Kauffman all showed at the Pace Gallery in New York. In 1967, Ferus Pace Gallery opened with great fanfare on North La Cienega Boulevard, but the situation soon proved unworkable. "I discovered that [Glimcher] was really interested in me not so much to buy work by people like Stella, Lichtenstein or Johns—people I was very interested in— but rather to sell people out of his stable like Ernest Trova . . . and Louise Nevelson. And that didn't interest me enormously."[5] After several months, Blum dissolved the partnership.

In a despondent mood, Blum was having his usual breakfast at the stone-fronted Schwabs coffee shop on Sunset when Kienholz walked in and asked what he was going to do. Blum told him that he'd been offered a job as an agent at William Morris. Kienholz snorted, "Irving, you're not an agent. You're an art dealer. Open another gallery." Blum thought, "He's exactly right."[6]

When the Irving Blum Gallery opened just a few doors up from the original Ferus at 811 North La Cienega in January 1968, Blum exhibited Ruscha's monumental and cheeky painting of the new L.A.

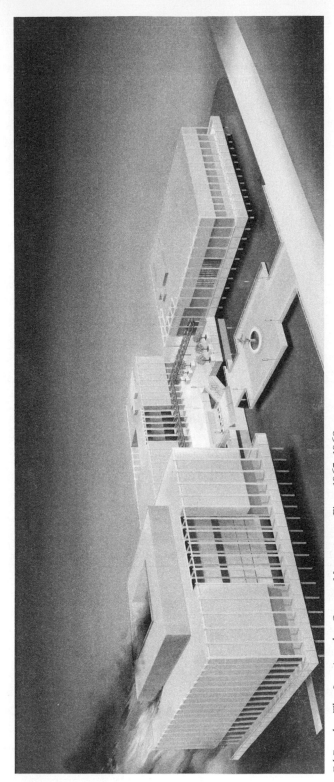

Ed Ruscha, The Los Angeles County Museum on Fire, *1965–1968*

Hirschhorn Museum and Sculpture Garden, Smithsonian Institution, Gift of Joseph H. Hirshhorn, 1972, photograph by Lee Stalsworth

County Museum being consumed by flames. The announcement, designed to look like a Western Union telegram, called it "the most controversial painting to be shown in Los Angeles in our time."

Hirshhorn happened to be in Los Angeles and came by the gallery. He was in negotiations to erect his eponymous museum in Washington, D.C., and offered to buy Ruscha's entire show. This time, Blum added 30 percent when calculating the total. Hirshhorn asked for a bulk discount and he was promptly granted 30 percent off. And that is how one of Ruscha's most distinctively L.A. paintings came to reside in the collection of the Hirshhorn Museum when it opened on the National Mall in 1974.

Shortly after this show, Ruscha and Joe Goode were shown together at the Balboa Pavilion Gallery in Newport Beach, from March 27 to April 21, 1968. Though neither had even a passing acquaintance with a horse, they dressed up as cowboys and were photographed on horseback for the exhibition announcement. Ruscha's mother, Dorothy, described them in the catalog as "masters of the evasive," but it did underscore their status as artists of the West.

The year 1968 seemed to be the pinnacle of international curiosity about Los Angeles contemporary art, with The Los Angeles 6 exhibition at the Vancouver Art Gallery that spring featuring Bell, Irwin, Kauffman, Kienholz, and Davis, who all went to Factors clothing store and got Borsalino fedoras to wear on their trip. The prestigious summer international exhibition Documenta IV in Kassel, Germany, featured Bell, Irwin, Davis, Hockney, and Kienholz. It was Kienholz's first trip to the country where he would come to live after 1973. It was a time of ubiquitous protests, and a few weeks after the opening, students staged a sit-in and used his *Roxy's* installation as a lounge for drinking red wine, an endorsement of its veritable closeness to real life. Meanwhile, in Dusseldorf, Konrad Fischer Gallery showed Bruce Nauman.

The success was made more poignant for them after hearing that Marcel Duchamp, the artist who had been so inspirational, had died at eighty-one on October 2, 1968. A month later, in *Artforum*, Jasper Johns wrote that Duchamp "moved his work through the retinal boundaries which had been established with Impressionism into a field where language, thought and vision act upon one another . . .

heralding many of the technical, mental and visual details to be found in more recent art."[7]

Meanwhile, LACMA had organized three more exhibitions of Ferus artists, beginning with Wallace Berman's collages, from April 30 to June 2, 1968. Though he refused gallery representation, Berman continued to make art using a Verifax machine, the forerunner of a photocopier, to print a photograph of a hand holding a transistor radio, repeated in the pattern of a grid, each appearing to be transmitting a different image. Some were funny, some erotic, some mystic. Compared to the serial prints of Warhol, Berman's work was heralded as the link between Beat and Pop, and the show traveled to the Jewish Museum in New York.[8]

Though Ferus had ceased to exist, the gallery's role in the city's history was celebrated further in a November 1968 LACMA exhibition: Late Fifties at Ferus. It featured the abstract painting that most of the artists had rejected in pursuit of their radically streamlined aesthetics. Despite the fact that he was having a show of his own at LACMA, the ever blunt Bengston wrote a critical article for *Artforum* citing all the works that were missing and those that were included improperly in the show.

Two weeks later, Bengston's retrospective opened at LACMA with a catalog designed by Ruscha. The sandpaper cover referred to Bengston's notoriously abrasive personality while Don Bachardy's drawing of the mustachioed artist graced the frontispiece. Frank Gehry agreed to design the exhibition, and since the museum had very little money for materials, he asked to see what they had lying around in storage. A pile of dirty old plywood was converted into the framing of Bengston's exhibition—though the museum director Kenneth Donohue later made him paint the wood—and Gehry bought a dummy of a motorcycle rider, dressed him in Bengston's clothes, and placed him with his motorcycle at the entrance to the show. LACMA curator James Monte organized the show, which traveled to the Corcoran Gallery, where Hopps then reigned.

All of these shows canonized an era that seemed to be slipping away at warp speed, a feeling that had come about, literally, with a bang. On June 3, 1968, just six years after his debut at Ferus, Andy Warhol was talking with friends at the Factory when a radical named

Valerie Solanas walked over, pulled a gun out of a paper bag, and shot him in the abdomen. Though she had had few dealings with Warhol, the mentally disturbed author of the SCUM manifesto (Society for Cutting Up Men) claimed that "he had too much control of my life."[9] She also wounded critic Mario Amaya and aimed at a few others before walking calmly into the elevator and leaving the building. Warhol was rushed to New York's Columbus Hospital and underwent a five-hour surgery to save his life, though he wasn't entirely certain about that at first. He could hear a television playing and the words "Kennedy" and "assassin." "I just thought that maybe after you die, they rerun things for you, like President Kennedy's assassination," he recalled.[10] He couldn't imagine that, in the ballroom of the Ambassador Hotel in Los Angeles, U.S. senator and aspiring presidential hopeful Robert Kennedy had just been gunned down, clearing the way for Richard Nixon's election in November.

Solanas turned herself in and was convicted to three years in prison. Thereafter, Warhol remained in a prison of his own, fearful of the sorts of strangers who had visited so freely over the years. "The fear of getting shot again made me think that I'd never again enjoy talking to somebody whose eyes looked weird. But when I thought about that, I got confused, because it included almost everybody I really enjoyed!"[11]

The End of the Innocence

Joan Didion opined that the sixties ended with the Charles Manson murders on El Cielo Drive, Beverly Hills, in the summer of 1969. If a frustrated-songwriter-turned-assassin could claim LSD as his inspiration, maybe it was time to reconsider the collective perspective of the sixties. On the other hand, many of the Los Angeles artists thought that they ended with the death of John Altoon. Bengston and his girlfriend Penny Little were with the Altoons at a party when the artist said that he didn't feel well and asked them to call Dr. Leonard and Betty Asher, the art collectors, whose house was close by. They rushed over and Altoon sat down on the couch, put his head back, and died of a massive heart attack. He was forty-three. Having continued with gestural abstract painting, which lost some popularity in the 1960s, he had not experienced the great career success of his friends. Yet, Altoon's funny and generous personality

marked him as standard bearer of a sort, and his passing was seen as the symbolic end of the era. Babs remembered, "There were a thousand people at his memorial service. At least."[1]

Los Angeles had changed and, in keeping with its character, would continue its physical and cultural transformations with a happy disregard for its own history. The Pasadena Art Museum trustees undertook the construction of a large modern structure by Ladd and Kelsey in Carmelita Park that opened in 1969. They were never able to raise sufficient funds to support its operation, and the museum slid into deep debt. In 1974, after years of loaning his collections to various museums and university galleries, Norton Simon bailed out the financially strapped PAM and installed his own collection there, while putting into storage the contemporary art donated by prominent artists including Warhol, Stella, and Oldenburg. A new sign on the building proclaimed its identity: Norton Simon Museum of Art at Pasadena.

By then, Blum, Dwan, Nelson, and *Artforum* had moved to New York. A major recession gripped the country, stalling the development of new art galleries. By the late 1970s, it looked as though Los Angeles, like the sixties itself, might not fulfill its promise.

However, the incursion of so many talented Los Angeles artists into the typically closed ranks of galleries and museums of New York, and the volume of attention that they received in the media in the 1960s, challenged any number of assumptions about the making and selling of contemporary art. The biggest assumption, of course, was that you had to be in New York to become an internationally recognized artist.

John Baldessari was among the first to look for critical and financial sustenance from the galleries and museums in Europe, which had begun to demonstrate consistent appreciation for the art and artists of Los Angeles. Other Los Angeles artists, with their pugnacious attitudes, followed suit. By the middle of the 1980s, the hegemony of the New York art establishment began to crumble as artists from Los Angeles as well as artists from Europe, Asia, and Central and South America came to be recognized, exhibited, and sold.

Los Angeles Times art critic Christopher Knight said, "Sixties L.A. was a bellwether. It's easy to forget that, for most of the last one hundred years, New York was commonly regarded as the only legitimate

cultural game in America. Everywhere else was the provinces. But what happened artistically in Los Angeles in the 1960s turned out to be a harbinger of changes to come: In the twenty-first century, serious and informed art production has been thoroughly decentralized around the globe. L.A., the city without a center, became the model."[2] It is telling that the most complete overview of the city's contemporary art history was organized in 2006 by France's Centre Pompidou: Los Angeles, 1955–1985: Birth of an Art Capital.

Ironically, it was the demise of the Pasadena Art Museum that inspired collectors anew as Marcia Weisman, by then divorced from Frederick, and Ninth Circuit Court of Appeals judge William Norris and his wife Merry led the charge in the early 1980s to build a Museum of Contemporary Art in downtown Los Angeles. It was one of the first museums to include artists on its board—Robert Irwin and Sam Francis—and Frank Gehry agreed to design temporary quarters in a disused city warehouse in Little Tokyo. The Temporary Contemporary proved so successful a venue for large-scale contemporary art that it remained in use though, after a $5 million donation by music mogul David Geffen, it was renamed the Geffen Contemporary. Japanese architect Arata Isozaki designed the permanent building, about half a mile west, on Grand Avenue. Ironically, in a city thought to have had overly cautious, foot-dragging collectors, MOCA wound up with the most highly esteemed contemporary art collection in the country, including a large portion of the collection of Count Panza di Biumo.

As of this writing, the Los Angeles area supports three museums dedicated to contemporary art: MOCA, the Hammer Museum at UCLA, and the Santa Monica Museum of Art, as well as the Broad Contemporary Art Museum and LACMA. In the manner of the self-made tycoons before him, philanthropist Eli Broad has launched plans to open a museum of his own collection adjacent to MOCA in the downtown district. The Pasadena Museum of California Art shows a fair amount of contemporary art. The mandate of the Getty Museum does not embrace contemporary art, but the Getty Research Institute has made it a priority to acquire and catalog archives, images, and documents related to the city's cultural history and, on occasion, to mount exhibitions, many of which have to do with modern and contemporary art

in Los Angeles. Pacific Standard Time, their ambitious initiative to fund and generate exhibitions examining all possible dimensions of modern and contemporary art, architecture, and design in Southern California, will be featured in the museums and galleries of the region for an entire year beginning in October 2011.

The city supports at least one hundred art galleries, fewer than New York, but more than any other city in this country. Though not their original intent, the artists of the sixties who chose to stay in the city and make their stand made it possible for subsequent generations of artists so that, today, the city has one of the largest populations of professional working artists anywhere—in part because of ready employment at the large number of art schools and university art departments. And, of course, the weather.

Some artists miss the sixties in Los Angeles, where art could be made with almost no financial incentive or consequence. On the flip side, as it were, auction records of the past six years demonstrate that the L.A. aesthetic, long ridiculed or ignored outside its home base, has found its audience. Significantly, the highest prices were paid for works completed in Los Angeles in the 1960s: Ruscha's *Burning Gas Station*, 1965, sold for $6,985,000, Baldessari's text painting *Quality Material*, 1967, for $4,408,000; Hockney's *Beverly Hills Housewife*, 1966, for $7,922,500, and his 1966 *Portrait of Nick Wilder* (in a swimming pool!) for $2,869,500. Nauman's *Henry Moore Bound to Fail*, 1967, sold for $9,906,000; Irwin's untitled two lines of red on tan, 1963, for $1,058,500; Bell's coated glass box, 1969, for $623,400; and Chicago's *Car Hood*, 1964, for $288,000. Kienholz's 1959 sculpture *Walter Hopps, Hopps, Hopps* sold in 1989 from the late Ed Janss Jr.'s collection for $176,000. The Hotel Green sign signed in 1963 by Marcel Duchamp and Dennis Hopper sold for $362,500.

Of course, the artists do not receive much financial gain from these sales, but validation from the market marches in tandem with validation from art history these days. The end of innocence marks the beginning of maturity.

Notes

Chapter One. 1963: Andy and Marcel

1. Shirley Neilsen Blum in *The Cool School: How L.A. Learned to Love Modern Art*, 2008 documentary by Kristine McKenna and Morgan Neville, Tremolo Productions.
2. Warhol did not come to Los Angeles in 1962 but at some point, already honing his publicity skills, he took a photographer and got his picture taken signing the cans. The Associated Press published the photograph in newspapers around the world, establishing his name overnight as the Prince of Pop. To doubters, he said, "I feel I'm very much a part of my times, of my culture, as much a part of it as rockets and television." Bob Colacello, *Holy Terror: Andy Warhol Close Up* (New York: HarperCollins, 1990), 22.
3. Blum sold the Warhols to the Museum of Modern Art for $15 million in 1996.
4. Andy Warhol and Pat Hackett, *POPism: The Warhol '60s* (New York: Harcourt Brace Jovanovich, 1980), 35.
5. Dennis Hopper, interview with author, March 20, 2006.
6. Ibid.
7. Craig Kauffman, interview with author, October 24, 2008.
8. Warhol and Hackett, *POPism*, 35.
9. Ibid.

10. Ibid.
11. Ed Ruscha, *Leave Any Information at the Signal: Writings, Interviews, Bits, Pages*, ed. Alexandra Shwartz (Cambridge, MA: MIT Press, 2002), 42.
12. Warhol and Hackett, *POPism*, 42.
13. Ibid.
14. Ibid., 40.
15. Naomi Sawelson-Gorse, "Hollywood Conversations: Duchamp and the Arensbergs" in *West Coast, Duchamp*, ed. Bonnie Clearwater (Miami Beach: Grassfield Press, 1991), 30.
16. Dickran Tashjian, "Nothing Left to Chance: Duchamp's First Retrospective," in Clearwater, *West Coast, Duchamp*, 63.
17. Ibid.
18. Warhol and Hackett, *POPism*, 43.
19. Ibid.
20. Hopper, interview with author, March 20, 2006.
21. Ibid.
22. Tashjian, "Nothing Left to Chance," 63.
23. Ibid., 82.
24. Ibid., 63.
25. Ibid., 62.
26. Eve Babitz, interview with author, March 16, 2006.
27. Oral history interview with Eve Babitz, June 14, 2000, Archives of American Art, Smithsonian Institution.
28. Babitz, interview with author, March 16, 2006.
29. Ibid.
30. Warhol and Hackett, *POPism*, 45.
31. Jules Langsner, "Los Angeles: America's Second Art City," *Art in America* 5, no. 2 (April 1963): 127–31.
32. Dickran Tashjian to author, May 4, 2008.

Chapter Two. Ferus Gallery

1. Walter Hopps, *Kienholz: A Retrospective* (New York: Whitney Museum of American Art, 1996), 27.
2. Kristine McKenna, *The Ferus Gallery: A Place to Begin* (Göttingen, Germany: Steidl, 2009), 201.
3. Even L.A. collectors were starting to buy them. Taft Schreiber, one of the founders of the Music Corporation of America, and his wife Rita bought Pollock's *Number 1* from Leo Castelli, and Mark Rothko's *Yellow and Orange* from Marlborough Galleries. Other moguls and actors followed suit.
4. Hopps, *Kienholz*, 29.
5. Walter Hopps in catalog for *The Last Time I Saw Ferus: 1955–1966* (Newport Beach, CA: Newport Harbor Art Museum, 1976).
6. Ibid.
7. Calvin Tomkins, "A Touch for the Now," *New Yorker*, July 29, 1991, 43.
8. Shirley Neilsen Blum, interview with author.
9. Hopps organized a show at the Pasadena Art Museum in 1961 of his solarized and symbolic prints.
10. McKenna, *Ferus Gallery*, 122.
11. Oral history interview with Lawrence Weschler, Los Angeles Art Community: Group Portrait, Ed Kienholz, Oral History Program, University of California, Los Angeles, 1977.

12. Ibid.
13. Hopps, *Kienholz*, 26.
14. Kienholz, oral history.
15. Ibid.
16. Ibid.
17. Ibid.
18. Catherine Grenier, ed., *Los Angeles 1955–1985: Birth of an Art Capital* (Paris: Éditions du Centre Pompidou, 2006), 62.
19. Mary Lynch Kienholz, interview with author, July 30, 2010.
20. Kienholz, oral history.
21. Ibid.
22. Ibid.
23. Gerald Nordland, *Frontier*, May 1957, reprinted in *Last Time I Saw Ferus*.

Chapter Three. Riding the First Wave
1. Kienholz, oral history.
2. Walter Hopps, "L.A. c. 1949: Dark Night-Jazz," in *Wallace Berman: Support the Revolution* (Amsterdam: Institute of Contemporary Art, 1992), 11, reprinted in Grenier, *Los Angeles, 1955–1985*, 63.
3. Kienholz, oral history.
4. Hopper, interview with author, March 20, 2006.
5. Richard Hertz, ed., *The Beat and the Buzz: Inside the L.A. Art World* (Ojai, CA: Minneola Press, 2009), 156.
6. Ibid.
7. Ed Moses, interview with author, May 5, 2007.
8. Ibid.
9. McKenna, *Ferus Gallery*, 162
10. Kienholz, oral history.
11. Ibid.
12. Ibid.
13. Ibid.
14. Ibid.

Chapter Four. Ferus Goes Forth
1. Tomkins, "Touch for the Now," 44.
2. Irving Blum, interview with author, October 18, 2005.
3. Ibid.
4. Tomkins, "Touch for the Now," 44.
5. Blum, interview with author, October 18, 2005.
6. Kienholz, oral history.
7. *The Rose*, as it is now titled, is in the collection of New York's Whitney Museum of American Art.
8. Irving Blum, interviewed by Roberta Bernstein, in *Ferus* (New York: Gagosian Gallery, 2002), 34.
9. Blum later sold Johns's *Tennyson* to collector Donald Factor and his *According to What* to collector Edwin Janss Jr.
10. Elyse Grinstein, interview with author, May 19, 2007.
11. Kienholz had moved to New York briefly in 1963. He set up a studio in the unheated building where Frank Stella, Arman, Jean Tinguely, and Niki de Saint Phalle worked. He built a separate white room in an unused part of the loft to build *Roxy's*. He said, "Fucking Arman broke the lock and set *Roxy's* out in the

main studio and started to use the room because it was small enough that you could put a heater in there and heat it. Pissed me off." Kienholz, oral history.

12. Ibid.

13. Ibid. Monte and Betty Factor were present during the Kienholz oral history and their remarks are part of the interview.

14. Arthur Secunda, *Artforum*, June 1962, 9.

15. Dagny Corcoran, interview with author, May 26, 2010.

16. Ibid.

17. McKenna, *Ferus Gallery*, 146.

18. Kienholz, oral history.

19. Blum, interview with author, October 18, 2005.

20. Ibid.

21. Ibid.

22. Billy Al Bengston, interview with author, March 13, 2007.

23. Peter Plagens, *Sunshine Muse: Art on the West Coast, 1945–1975* (New York: Praeger Publishers, 1974), 95.

24. Bengston, interview with author, March 13, 2007.

25. Ken Price, interview with author, October 4, 2008.

26. Ibid.

27. Ken Price, "A Talk with Slides," *Chinati Foundation Newsletter*, October 2005, 26.

28. Price, interview with author, October 4, 2008.

29. Ibid.

30. Ibid.

31. Ibid.

32. Ibid.

33. Ibid.

34. Bengston, interview with author, March 13, 2007.

35. Ibid.

36. Ibid.

37. Ibid.

38. Lawrence Weschler, *Seeing Is Forgetting the Name of the Thing One Sees: Expanded Edition, Over Thirty Years of Conversations with Robert Irwin* (Berkeley, Los Angeles and London: University of California Press, 2008), 35.

39. Bengston, interview with author, March 13, 2007.

40. Ibid.

41. Ibid.

42. Tom Wolfe, "The Kandy-Kolored Tangerine-Flake Streamline Baby," reprinted in *Writing Los Angeles: A Literary Anthology*, ed. David L. Ulin (New York: Library Classics, 2002), 438.

43. McKenna, *Ferus Gallery*, 223.

44. Bengston, interview with author, March 13, 2007.

45. Kauffman, Oral history interview with Michael Auping, Los Angeles Art Community, Group Portrait Oral History Program, University of California, Los Angeles, January 27, 1977.

46. Craig Kauffman, interview with author, October 24, 2008.

47. Ibid.

48. Irwin, speaking at a memorial service for Craig Kauffman at the Museum of Contemporary Art, Los Angeles, July 21, 2010.

49. Robert Irwin, interview with author, March 18, 2008.

50. Weschler, *Seeing Is Forgetting*, 34.

51. Irwin, speaking at Kauffman memorial, July 21, 2010.
52. Moses, interview with author, May 25, 2007.
53. Ibid.
54. Ibid.
55. Kienholz, oral history.
56. Ibid.
57. Ibid.
58. Ibid.
59. Weschler, *Seeing Is Forgetting*, 12.
60. Lawrence Weschler, *Vermeer in Bosnia: A Reader* (New York: Pantheon Books, 2004), 271–88.
61. Ibid.
62. Factor recalled, "L.A. was extremely conservative in those days—there wasn't even a French restaurant. There were two good restaurants in town that were filled with Hollywood people, and you couldn't get in unless they knew who you were." McKenna, *Ferus Gallery*, 109.
63. Shirley Blum Neilsen, interview with author, May 22, 2008.
64. Tomkins, "Touch for the Now," 45.
65. Ibid., 46.
66. Blum, interview with author, April 18, 2006.
67. In 1962, Hopps organized a Pasadena Art Museum exhibition of paintings by Wayne Thiebaud. The artist had such difficulty getting his work returned that he sent a plaintive card to Hopps with a drawing of himself looking sad and the word "PLEASE!!! Where are the paintings?? The people who loaned them are after me." McKenna, *Ferus Gallery*, 248.
68. Blum, interview with author.
69. Kienholz, oral history.
70. Ibid.
71. Monte Factor, interview with author, June 10, 2007.

Chapter Five. Okies: Ed Ruscha, Mason Williams, Joe Goode, and Jerry McMillan

1. Ed Ruscha, interview with author, October 11, 2006.
2. Mason Williams, interview with author, September 10, 2007.
3. Ibid.
4. Ruscha, interview with author, October 11, 2006.
5. Ibid.
6. Ibid.
7. Ibid. Ruscha had been drawing since, at age eight, he befriended the slightly older Bob Bonaparte, who listened to jazz records, drew cartoons, and claimed to be related to the nineteenth-century French general Napoléon. Bonaparte introduced Ruscha to Higgins India ink and Speedball pens and within weeks, Ruscha was drawing his own comic strips. "I'd hear a joke. Some guy would be on the street running, and another guy would say, 'What are you doing, training for a race?' And he'd say, "No, racing for a train.' So I'd run home, break this down into a little three-part cartoon strip, and make that cartoon." Ruscha cut out and saved copies of *Dick Tracy* and *Blondie* and soon got his cartoons into the school paper.
8. Ruscha, interview with author, October 11, 2006.
9. Ibid.
10. Ibid.

11. Ibid.
12. Ibid.
13. Ibid.
14. Ibid.
15. Ibid.
16. Ibid.
17. Oral history interview with Edward Ruscha, October 29, 1980–October 2, 1981, Archives of American Art, Smithsonian Institution.
18. Ibid.
19. Ibid.
20. Joe Goode, interview with author, April 10, 2007.
21. Ibid.
22. Ibid.
23. Ibid.
24. Ibid.
25. Ibid.
26. Ibid.
27. Ruscha, interview with author, October 11, 2006.
28. Ruscha, oral history.
29. Ruscha, interview with author, October 11, 2006.
30. Carolyn Wyman, *Spam: A Biography* (New York: Harcourt Brace and Company, 1999), cited in *Ed Ruscha: Catalogue Raisonné of the Paintings*, vol. 1, *1958–1970* (New York: Gagosian Gallery/Steidl, 2003), 66.
31. Though Pop was freshly minted, L.A. collectors already owned pieces by the leading artists. Hopps borrowed three Lichtenstein paintings. Melvin and Pauline Hirsch lent *Masterpiece*, 1962, a comic of a woman admiring her boyfriend's artwork; Leonard and Betty Asher lent *Roto Broil*, 1961, an advertisement for an electric cooker; Donald and Lynn Factor lent *Spray*, 1962. (They also owned Johns's *Tennyson*, the first word painting to influence Ruscha.) The only painting purchased by the museum was Robert Dowd's picture of Lincoln on a five-dollar bill, *Part of $5.00*, 1962.
32. McKenna, *Ferus Gallery*, 148.
33. Ruscha, *Catalogue Raisonné*, 40.
34. The following year, Coplans organized Pop Art, USA at the Oakland Museum, including the Common Object artists with Claes Oldenburg and Jess Collins, connecting them to predecessors Gerald Murphy and William Copley. By that time, half a dozen Pop art exhibitions had been arranged at museums in Kansas City, Houston, Washington, D.C., Los Angeles, and New York. In an essay published in *Artforum*, Coplans noted that unlike the Manhattan-centric movement of Abstract Expressionism, the Pop art movement was "widely dispersed between the two coasts." He pointed out that artists from Los Angeles and New York used the soup can or the comic strip as "painting devices which derive their force in good measure from the fact that they have virtually no association with a European tradition." "The New Paintings of Common Objects," *Artforum*, October 1963, 25–30. In 1963, Coplans's friend Lawrence Alloway, who had organized Six Painters and the Object for the Guggenheim Museum, organized a companion show for the L.A. County Museum called Six More and added the Californians Bengston, Goode, and Ruscha.
35. Goode, interview with author, April 10, 2007.
36. McKenna, *Ferus Gallery*, 149.
37. Goode, interview with author, April 10, 2007.

38. Hopps did arrange a Foulkes show at the Pasadena Art Museum in 1962. The following year, Foulkes received the first New Talent Purchase Grant from the L.A. County Museum of Art of $1,200 to provide "a year's basic subsistence to artists of outstanding promise."

39. Hertz, *Beat and the Buzz*, 88.

40. Lester Longman, "Conformity in the Arts," *Artforum*, June 1962, 19.

41. Goode, interview with author, April 10, 2007.

42. Ruscha, interview with author, October 10, 2006

43. Thomas Beller interview with Ed Ruscha, "Ed Ruscha/Thomas Beller," *Splash*, February 1989. Ruscha would later name his publishing company "Industrial Strength" and paint various canvases of the term.

44. Tom Wolfe, "Chester Gould Versus Roy Lichtenstein," in *California: 5 Footnotes to Modern Art History*, ed. Stephanie Barron (Los Angeles: LACMA, 1977), cited in Grenier, *Los Angeles 1955–1985*.

45. Eve Babitz, interview with author, March 6, 2006.

46. Ibid.

47. Danna Ruscha, interview with author, September 20, 2007. She continued to work at Hanna-Barbera but to make extra money she joined Ruscha working in the personalization department of Sunset House, a factory for kitsch gift items such as denture holders with the disturbingly cute name of "Ma and Pa Chopper Hoppers." They were paid ten cents a "hopper," which was good money because, fast and precise, they could letter enough items in a few months to pay their modest bills for most of the year.

Chapter Six. Bell, Box, and Venice

1. Larry Bell, interview with author, September 15, 2007.

2. Ibid.

3. Weschler, *Seeing Is Forgetting*, 120.

4. Douglas Kent Hall, *Zones of Experience: The Art of Larry Bell* (Albuquerque: Albuquerque Museum, 1997), 22.

5. Bell, interview with author, September 15, 2007.

6. Oral history interview with Larry Bell, May 25–June 30, 1980, Archives of American Art, Smithsonian Institution.

7. Bell, interview with author, September 15, 2007.

8. Ibid.

9. Bell, oral history.

10. Bell, interview with author, September 15, 2007.

11. Calvin Tomkins, *Off the Wall: Robert Rauschenberg and the Art World of Our Time* (Garden City, N.Y.: Doubleday, 1980), 129.

12. Bell, interview with author, September 15, 2007.

13. Ibid.

14. Ibid.

15. Bell, at Ferus panel discussion at the Pacific Design Center. January 31, 2010.

16. Bell, interview with author, September 15, 2007.

17. Ibid.

18. Ibid.

19. Moses, interview with author, May 5, 2007.

20. Blum, interview with author, October 8, 2005.

21. Bell, oral history.

22. Blum, interview with author, October 8, 2005.

23. Ibid.

24. McKenna, *Ferus Gallery*, 203.
25. Bell, oral history.
26. Ibid.
27. Kauffman, interview with author, October 24, 2008.
28. Barbara Rose, "A New Aesthetic," in *A New Aesthetic: May 6–June 25, 1967, Washington Gallery of Modern Art* (Baltimore: Garamond-Pridemark Press, 1967), 18.
29. Bell, interview with author, September 15, 2007.
30. Bengston, interview with author, March 16, 2007.
31. Randy Lewis, "Sunset Strip Soul," *Los Angeles Times*, May 20, 2010.
32. Bengston, interview with author, March 16, 2007.
33. John Coplans, "The Los Angeles Scene Today," *Artforum*, Summer 1965, 37.
34. Bengston to author, November 16, 2007.
35. Ibid.

Chapter Seven. Glamour Gains Ground

1. Hopper, interview with author, March 20, 2006.
2. Stanley and Elyse Grinstein, interview with author, May 9, 2007.
3. Ibid.
4. Bell, interview with author, September 15, 2007.
5. Lenny Bruce, *How to Talk Dirty and Influence People: An Autobiography* (Chicago: Playboy Press, 1965).
6. Barney Hoskyns, *Waiting for the Sun: A Rock 'n' Roll History of Los Angeles* (Milwaukee: Backbeat Books, 2009), 54.
7. Ibid.
8. Dennis Hopper, *1712 North Crescent Heights: Photographs 1962–1968*, ed. Marin Hopper (Los Angeles: Greybull Press, 2001).
9. Hopper, interview with author, March 20, 2006.
10. Ibid.
11. Ibid.
12. Peggy Moffitt, interview with author, July 16, 2005.
13. Blum, interview with author, October 18, 2005.
14. Neilsen Blum, interview with author, May 22, 2008.
15. Henry Hopkins in Hertz, *Beat and the Buzz,* 87.
16. Bell, interview with author, September 15, 2007.
17. Dan Jenkins, "Life with the Jax Pack," *Sports Illustrated*, July 10, 1967, SI Vault, http://sportsillustrated.cnn.com/vault.
18. Peggy Moffitt, *The Rudi Gernreich Book* (Cologne: Taschen, 1999), 19.
19. Sassoon's celebrity soared in the United States to the point that, in 1968, he was paid $5,000 for the very short cut he gave to Mia Farrow, who was then married to Frank Sinatra and about to terrify audiences in the Roman Polanski film *Rosemary's Baby*.

Chapter Eight. The Dawn of Dwan

1. Blum, interview with author, October 18, 2005.
2. Oral history interview with Virginia Dwan, March 21–June 7, 1984, Archives of American Art, Smithsonian Institution.
3. Ibid.
4. Virginia Dwan, interview with author, February 20, 2008.
5. Dwan, oral history.
6. Dwan, interview with author, February 20, 2008.

7. John Baldessari, interview with author, March 26, 2007.
8. Oral history interview with John Baldessari, April 4–5, 1992, Archives of American Art, Smithsonian Institution.
9. Dwan, interview with author, February 20, 2008.
10. Ibid.
11. Michael Blankfort, *The Michael and Dorothy Blankfort Collection* (Los Angeles: Los Angeles County Museum of Art, 1982), 13.
12. Ibid.
13. Ibid.
14. Ibid.
15. Ibid.
16. Ibid., 12.
17. Dwan, oral history.
18. Arthur Secunda, "Feitelson, Gerchik, Schifrin," *Artforum* 1, no. 2 (July 1962): 23.
19. Dwan, oral history.
20. Ibid.
21. Ibid.
22. Ibid.
23. Dwan, interview with author, February 20, 2008.
24. Ibid.
25. Ibid.
26. Dwan, oral history.
27. Ibid.
28. Ibid.
29. Dwan, interview with author, February 20, 2008.
30. It included Chamberlain's 1962 *Rayvredd*, lent by Ferus; Johns's *Flag on Orange Field*, borrowed from Ileana Sonnabend, Rauschenberg's *Coexistance*, 1961, a combine painting lent from Castelli, Warhol's *Marilyn Monroe*, 1962, from the Stable Gallery, Tom Wesselmann's *Great American Nude #10*, 1961, from the Green Gallery; and Marisol's sculpture *The Kennedys*, 1962, lent by the Stable Gallery.
31. Dwan, oral history.
32. Ibid.
33. Dwan, interview with author, February 20, 2008.
34. Ibid.
35. Mary Lynch Kienholz, interview with author, July 30, 2010.
36. Dwan, oral history.
37. Patty Mucha, "Sewing in the Sixties," *Clean Slate*, from excerpt in *Art in America*, November 2002, 85.
38. Ibid.
39. Ibid.
40. Oral History Interview with Claes Oldenburg, February 16, 1965, Archives of American Art, Smithsonian Institution.
41. Dwan oral history.
42. Oral History Interview with Claes Oldenburg, February 16, 1965, Archives of American Art, Smithsonian Institution.
43. Hopper may have influenced the arrangement, which recalled the way Nicholas Ray staged the cars with headlights on for the drag race in *Rebel Without a Cause*, a film that used L.A.'s Griffith Park Observatory to great effect.
44. Gail Levin, *Becoming Judy Chicago* (New York: Harmony Books, 2007), 124.

45. Babs Altoon opened Multiples Gallery on North La Cienega Boulevard in 1971. Dagny Janss worked for her before marrying James Corcoran in 1972. They had a son, Tim, who now lives with Tamara Kondratief, the daughter of Riko Mizuno, the art dealer who married Vadim Kondratief after his divorce from Virginia Dwan.

46. Edy de Wilde, director of the Stedelijk Museum in Amsterdam, was staying with Kienholz when LACMA curator Maurice Tuchman called to report that Burt Kleiner was going bankrupt and selling his art collection, including *The Beanery* and *The Backseat Dodge '38*. Kienholz's wife at the time, Lyn Kienholz, recalled, "Ed hung up and turned to Edy and said, 'If you were smart, you'd buy *The Beanery*.' Then he said to me, 'If *you* were smart you'd buy *The Backseat Dodge '38*.' Both Edy and I did as we were told, and bought the two works from Kleiner." Author interview with Lyn Kienholz, October 28, 2010.

47. Hopps, *Kienholz*, 33.

Chapter Nine. A Bit of British Brilliance: David Hockney

1. David Hockney, *David Hockney by David Hockney* (New York: Harry N. Abrams, Inc., 1976), 34.

2. Ibid., 39.

3. Marco Livingstone, *David Hockney* (New York: Holt, Rinehart, and Winston, 1981), 23.

4. Hockney, *David Hockney*, 43.

5. Livingstone, *David Hockney*, 21.

6. Hockney, *David Hockney*, 87.

7. Ibid.

8. Ibid., 92.

9. Livingstone, David Hockney, 69.

10. Hockney, David Hockney, 97.

11. Ibid., 98.

12. Ibid., 99.

13. Ibid.

14. Ibid., 68.

15. Livingstone, *David Hockney*, 97.

16. David Hockney, interview with author, November 6, 2010.

17. Hockney, David Hockney, 151.

18. Ibid.

19. Betty Freeman, interview with author, July 4, 2006.

20. Ibid.

21. Hockney, *David Hockney*, 104.

22. Ibid., 158.

23. J. Randy Taraborrelli, *Sinatra: Behind the Legend* (New York: Birch Lane Press, 1997), 464–65.

24. Marcia Simon Weisman, *Collecting, Sharing, and Promoting Contemporary Art in California* (Los Angeles: Regents of the University of California, 1983).

25. Richard Dorment, "David Hockney: 1960–68, Nottingham Contemporary," *Telegraph*, December 2–8, 2009.

26. Livingstone, *David Hockney*, 70.

27. Mary Lou Luther, "Looking Back at a Futurist," in Moffitt, *Rudi Gernreich Book*, 14.

28. Don Bachardy, interview with author, June 29, 2007.

29. Arthur Secunda, *Artforum* 1, no. 6 (1962). The early issues of *Artforum* often

did not state a month because the editors were not sure when they would be coming out.

30. Bachardy, interview with author, June 29, 2007.
31. Ibid.
32. Ibid.
33. Ibid.
34. Ibid.

Chapter Ten. Wilder Times with Bruce Nauman and *Artforum*

1. Katherine Bishop Crum, *Nicholas Wilder and His Gallery, 1965–1979* (New York: Franklyn Parrasch Gallery, 2005).
2. Oral history interview with Nicholas Wilder, July 18, 1988, Archives of American Art, Smithsonian Institute.
3. Joe Goode, interview with author, April 7, 2007.
4. Wilder, oral history.
5. Fidel Danieli, "The Art of Bruce Nauman," *Artforum*, December 1967, 15–17.
6. Nauman lived in Los Angeles until 1979 when he bought a ranch in New Mexico.
7. Goode, interview with author, April 7, 2007.
8. Ibid.
9. Philip Leider, "The Cool School," *Artforum*, Summer 1964, 47.
10. Weschler, *Seeing Is Forgetting*, 79.
11. Coplans, "Post Painterly Abstraction," *Artforum*, Summer 1964, 6.
12. Amy Newman, *Challenging Art: "Artforum" 1962–1974* (New York: Soho Press, 2000), 46.
13. Ibid., 295.
14. Ibid.

Chapter Eleven. The Ascendency of Irwin's Atmospherics

1. Dagny Corcoran, interview with author, September 21, 2007.
2. Weschler, *Seeing Is Forgetting*, 87.
3. Ibid., 90.
4. Ibid., 78. (Similarly, Ruscha painted the edges of his early large canvases, sometimes labeling them as though they were the spines of books.)
5. Lawrence Weschler describes U.S. political involvement on page 94 of *Seeing Is Forgetting*. It was also mentioned to me by Christopher Knight.
6. Weschler, *Seeing Is Forgetting*, 93.
7. Ibid.
8. Ibid., 95.
9. Ibid.
10. Ibid., 96.

Chapter Twelve. Set the Night on Fire

1. Ed Bereal, "In Search of Ms. America: An Autobiography of the Watts Years, 1965–75," *Art and Politics in Los Angeles*, no. 92 (November–December 1992), 18–19, cited in Grenier, *Los Angeles, 1955–1985*, 143.
2. McKenna, *Ferus Gallery*, 207.
3. Neilsen Blum, interview with author, May 22, 2008.
4. Jeffrey Kastner, "1000 Words: Peace Tower; Irving Petlin, Mark di Suvero, and Rirkrit Tiravanija Revisit the Artists' Tower of Protest, 1966," *Artforum International* 44 (March 2006).
5. Ibid.

6. Mark di Suvero, interview with author, January 24, 2008. He went on to build another large-scale sculpture on the lawn of the Pasadena Art Museum that is now on view at Storm King Art Center in New York.
7. Kastner, "1000 Words: Peace Tower."
8. Lee Quarnstrom, "Acid Test Chronicles," http://www.postertrip.com/.

Chapter Thirteen. Chicago Comes to Los Angeles
1. Levin, *Becoming Judy Chicago*, 105.
2. Ibid., 106.
3. Judy Chicago, *Through the Flower: My Struggle as a Woman Artist* (Garden City: Doubleday & Company Inc., 1975), 35.
4. Ibid., 37.
5. Levin, *Chicago*, 112.
6. Chicago, *Flower*, 36–37.
7. Levin, *Chicago*, 120.
8. Ibid., 121.
9. Ibid.
10. Despite their interest, none were asked to take part in the 1969 Art and Technology exhibition at LACMA.
11. Levin, *Chicago*, 129.

Chapter Fourteen. A Museum at Last
1. Walter Hopps interview with Jim Edwards, Pop Art US/UK Connections: 1956–1966 (Hatje Cantz, 2001).
2. Suzanne Muchnic, *Odd Man In: Norton Simon and the Pursuit of Culture* (Berkeley: University of California Press, 1998), 77.
3. Byrnes and his wife Barbara, who had an art gallery in Hollywood, bought a painting by Mark Rothko around the same time. They later sold it for enough to buy a house designed by Richard Neutra, which went up in value but nothing like as much as the Rothko they had sold.

Chapter Fifteen. Bringing in the Trash: Ed Kienholz's Revenge
1. Kienholz, oral history.
2. Ibid.
3. Ibid.
4. Ibid.
5. Other prominent European museums bought his tableaux, including *The Beanery*, which is now at the Stedelijk Museum in Amsterdam. Encouraged by such support, Kienholz himself moved to Berlin in 1972 with his fifth and final wife, Nancy Reddin Kienholz, daughter of Tom Reddin, the former L.A. chief of police. She collaborated with him to complete his artwork, which was attributed then to both of them, until his death from a heart attack in 1994.
6. Lyn Kienholz, interview with author, June 2, 2008.
7. Ibid.
8. Hopps, *Kienholz*, 24.

Chapter Sixteen. Gemini GEL
1. Elyse Grinstein, interview with author, May 9, 2007.
2. Suzanne Felsen became a jewelry designer.
3. Sidney Felsen, interview with author, October 23, 2009.

4. Oral history interview with Rosamund Felson, October 10–11, 2004, Archives of American Art, Smithsonian Institution.
5. Ibid.
6. Ruth E. Fine, "Gemini G.E.L.: Online Catalogue Raisonné," National Gallery of Art, Washington, D.C., http://www.nga.gov/gemini/.
7. Rosamund Felson, oral history.
8. Elyse Grinstein, interview with author, May 9, 2007.
9. Stanley Grinstein, interview with author, May 9, 2007.
10. Ibid.
11. Ibid.
12. Newman, *Challenging Art*, 132–33.
13. Ibid.

Chapter Seventeen. Between Form and Function: Frank Gehry
1. Frank Gehry, interview with author, September 28, 2007.
2. Frank Gehry interviewed by Sidney Pollack in his documentary film *Sketches of Frank Gehry*, 2005.
3. Gehry, interview with author, September 28, 2007.
4. Ibid.
5. Barbara Isenberg, *State of the Arts: California Artists Talk About Their Work* (New York: William Morrow, 2000), 51.
6. Gehry, interview with author, September 28, 2007.
7. Ibid.
8. Ibid.
9. Ibid.
10. McKenna, *Ferus Gallery*, 236.
11. Gehry, interview with author, September 28, 2007.
12. Ibid.
13. Ibid.
14. Ibid.
15. Ibid.
16. Ibid.
17. Ibid.
18. Ibid.

Chapter Eighteen. London Calling, L.A. Answers
1. Harriet Vyner, *Groovy Bob: The Life and Times of Robert Fraser* (London: Faber and Faber, 1999), 113.
2. Ibid., 115.
3. Ibid.
4. Ibid.
5. Mary Lynch Kienholz, interview with author, July 30, 2010.
6. Hopper, interview with author, March 20, 2006.
7. Kauffman, interview with author, October 24, 2008.
8. Babitz, interview with author, July 6, 2010.
9. Eve Babitz, "Roll Over Elvis: The Second Coming of Jim Morrison," *Esquire*, March 1991, posted in http://forum.JohnDensmore.com/.
10. Warhol and Hackett, *POPism*, 167.
11. Patrick S. Smith, *Warhol: Conversations About the Artist* (Ann Arbor, MI: UMI Research Press, 1988), 217.

12. Warhol and Hackett, *POPism*, 189.
13. Ibid., 190.
14. Babitz, interview with author, July 6, 2010.
15. Ibid.
16. Ibid.
17. Eric Bluhm, "Along for the Ride: Ed Ruscha and Mason Williams," *Art US*, May–June, 2006, 10–13.
18. "Free Mason," *Time*, April 11, 1969, 68.
19. Ibid.
20. Ibid.
21. Williams, speaking at The Getty Center, Los Angeles, January 24, 2007, Modern Art in Los Angeles: Okies Go West; An Evening with Jerry McMillan, Ed Ruscha and Mason Williams.

Chapter Nineteen. Love-ins and Outs

1. Léon Bing, *Swans and Pistols: Modeling, Motherhood, and Making It in the Me Generation* (New York: Bloomsbury, 2009), 120.
2. Ibid.
3. Williams, interview with author, September 10, 2010.
4. McKenna, *Ferus Gallery*, 174.
5. James Demetrion, interview with author, July 9, 2010.
6. Renato Danese, interview with author, August 22, 2010.
7. Kauffman, interview with author, October 24, 2008.
8. Neilsen Blum, interview with author, May 22, 2008.
9. Ibid.
10. Ibid.
11. Ibid.
12. Ibid.
13. Ibid.
14. Bell, interview with author, September 15, 2007.
15. Demetrion, interview with author, July 9, 2010.
16. Ibid.
17. Ibid.
18. McKenna, *Ferus Gallery*, 298.
19. Tomkins, "Touch for the Now," 48.
20. McKenna, *Ferus Gallery*, 190.
21. Paul Richard, *Washington Post*, March 22, 2005.
22. Newman, *Challenging Art*, 210.
23. Ibid., 99–100.
24. Ibid., 136.
25. Ibid., 138.
26. Demetrion, interview with author. "In May 1969, I went to the Des Moines Art Center, as director. Coplans went to Akron Art [Museum] after Tom Terbell, a member of the board with no experience, was given the position of museum director."
27. McKenna, *Ferus Gallery*, 190.

Chapter Twenty. Charge of the Light Brigade: Irwin, Wheeler, and Turrell

1. Jan Butterfield, *The Art of Light and Space* (New York: Abbeville Press, 1993), 21.
2. Ibid. Much was made of the relationship to the warm, sparkly quality of light

in Southern California that certainly had to be the primary influence for artists who lived near the ocean whether they were surfers or not. The larger concern, however, was perception, and to follow that line of inquiry, many of the artists were working with complex new technologies and materials in the confines of their studios. "Artists in Southern California investigating light phenomena were not reacting to the specific quality of natural light here. Most artists were working primarily with artificial light and only later did they extend their investigations to situations of controlled external light," wrote Hal Glicksman, who organized or installed numerous shows of such work at PAM and the art gallery at UC Irvine. Ibid., 15.

3. Ibid., 120.
4. Doug Wheeler, interview with author, June 4, 2010.
5. Ibid.
6. Butterfield, *Art of Light and Space*, 73.
7. Newman, *Challenging Art*, 133.
8. Giuseppe Panza di Biumo, "Environmental Art: The Art of Perception," in *The Panza Collection: Villa Menafoglio Litta Panza, Varese* (Milan, Skira, 2002), 10, cited in Grenier, *Los Angeles 1955–1985*, 187.
9. Butterfield, *Art of Light and Space*, 120.
10. Weschler, *Seeing Is Forgetting*, 131.
11. Ibid.
12. Ibid., 134.

Chapter Twenty-one. Fantastic Plastic Lovers: DeWain Valentine, Peter Alexander, and Helen Pashgian

1. Dave Hickey, *Primary Atmospheres: Works from California 1960–1970*, ed. Kristine Bell and Tim Nye (Gottingen: Steidl/David Zwirner, 2010), 15.
2. Jane Livingston, "Recent Work by Craig Kauffman," *Artforum*, February 1968, 36–39, cited in Grenier, *Los Angeles 1955–1985*, 170.
3. Robert Pincus Witten, "Craig Kauffman," *Artforum*, April 1969, 70.
4. DeWain Valentine, panel discussion at The Getty Center, May 19, 2010, Modern Art in Los Angeles: The Industrialized Gesture.
5. Ibid.
6. Peter Alexander, panel discussion at The Getty Center, May 19, 2010, Modern Art in Los Angeles: The Industrialized Gesture.
7. Ibid.
8. Helen Pashgian, panel discussion at The Getty Center, May 19, 2010, Modern Art in Los Angeles: The Industrialized Gesture.
9. Jack Brogan, panel discussion at The Getty Center, May 19, 2010, Modern Art in Los Angeles: The Industrialized Gesture.
10. Alexander, panel discussion at Getty.
11. Pashgian, panel discussion at Getty.
12. Newman, *Challenging Art*, 258.

Chapter Twenty-two. Odd Man In: John Baldessari

1. Hunter Drohojowska, "John Baldessari: No More Boring Art," *ARTnews*, January 1986, 62–69.
2. Oral history interview with John Baldessari, April 4–5, 1992, Archives of American Art, Smithsonian Institution.
3. Ibid.
4. Ibid.

5. Drohojowska, "John Baldessari," 67–68.
6. Ibid.
7. Baldessari, oral history.
8. Ibid.
9. Ibid.
10. Drohojowska, "John Baldessari," 62–69.
11. Baldessari, oral history.
12. Drohojowska, "John Baldessari," 62–69.
13. Christopher Knight in Jessica Morgan et al., *John Baldessari: Pure Beauty* (Los Angeles: L.A. County Museum of Art, 2009), 47.
14. Ibid., 49. LACMA curator Maurice Tuchman put two canvases on hold for the museum and bought one about three years later—at which point he wanted the original price of $600. He expected loyalty since Baldessari had been given a Young Talent Award, which came with a $1,200 stipend. Baldessari wondered, "Well, why didn't you give me the money for the award then, instead of six hundred dollars?" Baldessari, oral history, Archives of American Art.
15. Ibid.
16. Drohojowska, "John Baldessari," 64.
17. Ibid., 62.
18. Baldessari, oral history.
19. Drohojowska, "John Baldessari," 63.
20. Newman, *Challenging Art*, 253.

Chapter Twenty-three. Ferus Fades to Black

1. Blum, oral history.
2. Ibid.
3. Ibid.
4. Ibid.
5. Blum, interview with author, October 18, 2005.
6. Blum, interview with author, May 30, 2010.
7. Jasper Johns, "Marcel Duchamp [1887–1968]," *Artforum*, November 1968.
8. After Berman died, a posthumous show of his work was held at the Timothea Stuart Gallery. Berman's grandmother attended, and George Herms recalled guiding her around the gallery, which included a seamless room created by Doug Wheeler. A two-sided drawing by Berman was suspended. After looking at one side, Herms guided the grandmother around to look at the other side, which featured a graphic and detailed drawing of "a girl giving a blowjob to a big dick," recalled Herms. Abashed, he looked at Berman's grandmother, who shrugged and said, "You know, you could never tell what he was thinking." George Herms, interview with author, March 8, 2005.
9. Warhol and Hackett, *POPism*, 277.
10. Ibid., 274.
11. Ibid., 279.

Chapter Twenty-four. The End of the Innocence

1. Babs Altoon, interview with author, June 16, 2006.
2. Christopher Knight, interview with author, November 8, 2010.

Acknowledgments

Despite the cliché that those who remember the sixties weren't really there, I found I could rely on the memories of any number of people who definitely were. Walter Hopps had a few memories to share with me just days before his death on March 20, 2005. Irving Blum offered many stories about this glittering era. Ed Ruscha, the first Ferus artist I met after moving to Los Angeles, was and is an inspiration. Others who offered encouragement at the outset of this project were Dave Hickey, Peter Plagens, Lawrence Weschler and Christopher Knight, all of whom have written astutely about these artists and this period.

I am grateful to all the artists, dealers, collectors, their friends and family: Robert Irwin, Ed Moses, Larry Bell, Billy Al Bengston, Ken Price, John Mason, Frank Gehry, Joe Goode, Jerry McMillan, Mason Williams, John Baldessari, Dennis Hopper, Dean Stockwell, Mark Di Suvero, Claes Oldenburg, Don Bachardy, David Hockney, Gregory

Evans, Doug Wheeler, James Turrell, Peter Alexander, DeWain Valentine, Helen Pashgian, Judy Chicago, Vija Celmins, Virginia Dwan, Cecilia Dan, James Corcoran, Dagny Corcoran, Babs Altoon, Rosamund Felsen, Sidney Felsen, Stanley and Elyse Grinstein, James Demetrion, Hal Glicksman, Lyn Kienholz, Mary Lynch Kienholz, Vivian Rowan, Penny Little Hawks, Happy Price, Bridget Johnson, Doreen Nelson, Shirley Hopps Blum, Danna Ruscha, Eve Babitz, Julian Wasser, Zazu Faure, Paul Ruscha, Robert Dean, Mary Dean, Larry Gagosian, Margo Leavin, Frank Lloyd, Craig Krull, Renato Danese, Arnold Glimcher, Michael Kohn, Jean Milant, Ulrike Kantor, Shoshana Blank, Patricia Hamilton, Charles Cowles, Doug Chrismas, Kimberly Davis, Elizabeth East, Peter Goulds, Ronnie and Vidal Sassoon, Sally Drennon, Peggy Moffitt, Chris Claxton, Ann Marshall, Teri Garr, Michelle Phillips, and the beat goes on

A moment here to remember those who have died with their boots on in recent years: Henry Hopkins, Dennis Hopper, Craig Kauffman, Betty Freeman, and Patricia Faure.

I'm indebted to the colleagues who have contributed to a deeper understanding of L.A.'s cultural history including Cécelie Whiting, Michael Duncan, Thomas Crow, Kristine McKenna, James Meyers, David Pagel, Leah Ollmann, Richard Hertz, Pamela Burton, Barbara Rose, Barbara Haskell, Gail Levin, Naomi Sawelson-Gorse, Debra Burchette Lere, Calvin Tomkins, Kevin Starr, Lars Nittve, Robert Berman, Suzanne Muchnic, and Barbara Isenberg. At the Los Angeles County Museum of Art, Carol Eliel, Stephanie Barron, and Toby Tannenbaum; at the Orange County Museum of Art, Karen Moss and Elizabeth Armstrong (now at Walker Art Center); at the Museum of Contemporary Art: Paul Schimmel and Ann Goldstein (now at the Stedelijk Museum); and at Scripps College: Mary McNaughton. Thanks also to Lisa Fung and Kelly Scott at the *Los Angeles Times*, Robin Cembalest at *ARTnews*, Walter Robinson at *Artnet* and rock and roll writers Michael Walker and Barney Hoskins. Bill Lasarow's Artscene Visual Radio aired interviews with many of the artists, which are still on the internet. I thank Gail Eichenthal and Sheila Tepper at KUSC and Karen Huang, who helped with my early research thanks to the support of ArtTable. The Getty Research Institute as a whole, and Andrew Perchuk and Rani Singh in particular have been invaluable,

as have David Rodes at UCLA and Liza Kirwin at the Archives of American Art. Special thanks to Catherine Grenier for the landmark exhibition of Los Angeles art at the Pompidou Centre in Paris and the invaluable catalog. Of course, this book would not be possible without my agents, Eric and Maureen Lasher, and my thoughtful and supportive editors, Jack Macrae and Kirsten Reach. I thank them for their faith in this project. A special thank-you goes to my amazing husband, David Philp, as always.

Index

Page numbers in *italics* refer to illustrations.

About the Author

Hunter Drohojowska-Philp is the author of *Full Bloom: The Art and Life of Georgia O'Keeffe*—according to the *Los Angeles Times*, "the definitive life of O'Keeffe as long as the public continues to be fascinated with her story." Ms. Drohojowska-Philp, who contributes to *ARTNews*, ARTNET, the *Los Angeles Times*, and other publications, lives in Los Angeles.